HOLLYWOOD WIT

HOLLYWOOD WIT

AUBREY MALONE

First published February 2025

© Aubrey Malone
The author asserts his moral right to be identified as the author of the work.
All rights reserved. No part of this publication may be reproduced, stored in a retrieval system or transmitted in any form or by any means, electronic, mechanical, photocopying, recording or otherwise, without the prior permission of the publishers

ISBN 978-1-913144-68-5

Cover:

PENNILESS PRESS PUBLICATIONS
Website:www.pennilesspress.co.uk/books

Introduction

Tom Hanks once said he couldn't give a speech to save his life. Bereft of the fed line, his confidence crumbled. As against that, the effusions in the book you're now holding manifest a natural wit in most of the speakers. Indeed, if the lines in some of their films were half as good, they might have had more thriving careers.

I've called one of the sections 'Reel Life and Real Life.' It testifies to the sometimes tenuous difference between stars and the characters they play. Playing them off-screen, or even being them off-screen, leads to even more interesting scenarios as their cherished images (See 'Image') give rise to duplicity. (See 'Duplicity).

One can have good fun juggling these parameters around. I'm reminded of the idea of acting as 'the shy man's revenge'. Is it true that those of a different disposition are more susceptible to the lure of the greasepaint and the roar of the crowd than the rest of us mortals? They also seem to be able to go from diffidence to megalomania after they've sampled fame. (See 'Narcissism' and 'Egotists'). In Hollywood, like everywhere else, the distinction between inferiority complexes and superiority complexes is remarkably thin.

As for Hollywood itself, I quote Wilson Mizner describing it as a trip through a sewer in a glass-bottomed boat. This reflection also captures its doublethink. (See 'Double Standards)'. When confused people inhabit a confused town, the stage is set for fireworks. These we get in abundance in sections like insults, Putdowns, Sarcasm, Repartee, Violence, Jealousy and Feuds.

Adulatory quotes, by contrast, are thin on the ground. Maybe that's because it's difficult to praise somebody in an entertaining way. As the irrepressible Mae West once put it, 'Virtue may be its own reward, but it has no sale at the box office.' Kirk Douglas voiced the same view with his observation that virtue wasn't 'photogenic'. His own career of playing flawed characters with such resonance is a testament to this. He was less convincing as a plaster hero. One could say the same of most of his contemporaries. They lit up the lives of audiences even as they were darkening their own.

This book is also the story of the men behind the scenes, the movers and shakers, the eunuchs in the harem, the agents and the publicists, the

critics who could demolish reputations with a sweep of their pen and the producers who could build them up again when one's fifteen minutes of fame was up. Maybe this strain is best exemplified in the following reflection: 'If you woke up in a motel with a dead whore who'd been stabbed, who would you call? Sam Spiegel.'

The frequent appearances of wits like Woody Allen and Groucho Marx (his hero) will advise you of my own particular biases. Other favorites are Joan Rivers, Phyllis Diller, Rodney Dangerfield, Henny Youngman, Zsa Zsa Gabor, Ellen DeGeneres, Bette Davis, Lily Tomlin, Roseanne, Orson Welles and W.C. Fields.

Most of the outpourings emanate from a more spontaneous age than our own when stars weren't protected by their handlers or the Fort Knox-style security that now seems to surround them. Today's stars seem, if not quite bigger than their movies, somehow more exclusive than them. They call the shots on such movies and indeed on the management of their careers. Even when they're being outrageous, like a Lindsay Lohan or a Charlie Sheen or a Robert Downey Jr, there almost seems to be an element of contrivance in the wildness, as if a period in rehab is good for one's CV.

One thing hasn't changed between the Golden Age and now, however. That's the celebrity penchant for dishing the dirt. Stars may not have faces any more, as Norma Desmond alleged, but they certainly have mouths. When these click into derisive gear, even when the brain is in neutral, one is guaranteed an acid-tongued denunciation of all Tinseltown holds dear.

Were the stars bigger than the pictures? Did real life have the edge over reel life? When Wilder attended the funeral of his mentor Ernst Lubitsch he said to William Wyler, 'This is terrible – no more Lubitsch.' Wyler replied, 'Even worse – no more Lubitsch pictures.'

Ava Gardner joked about Clark Gable, 'If you said 'Hiya' to Clark, he was stuck for an answer'. This was perhaps true. Many stars of Gable's era were charismatic because of what they were rather than what they said. Gable himself admitted, 'I'm just a lucky slob from Ohio who happened to be in the right place at the right time.' But he still merits a number of quotations in the book (including that one).

Clever people often express themselves in a boring manner, whereas those not regarded as being clever have more spontaneity. Witness the example of Sylvester Stallone who said, 'People don't credit me with a brain so why should I disillusion them?'

Sam Goldwyn was a man who generally only opened his mouth only to change feet. In doing so he bequeathed us a treasure trove of delectable one-liners like 'Don't bite the hand that lays the golden egg', or 'What we need are some new clichés.' He also said, apropos Stallone's comment, 'I'd rather deal with a smart idiot that a stupid genius.'

I've divided the book into three main areas: Hollywood by Hollywood people, Hollywood by non-Hollywood people, and Hollywood people on every theme I could think of, like love, marriage, food, religion, clothing, drink and even politics. I've refrained from quoting dialogue from movies themselves except on the odd occasion

Hollywood Babylon is Hollywood 'Babble On' here – thank you Boze Hadleigh. You will read of the film world's highs and lows, the bouquets and the brickbats, the dizzy rise to fame and the equally mind-blowing fall from grace. Maybe Lee Marvin put it best of all when he said, 'They put your name on a star in the sidewalk on Hollywood Boulevard and then you walk down afterwards and find a pile of dog manure on it. That tells the whole story, baby.'

Aardvarks
Barbara Streisand looks like a cross between an aardvark and an albino rat, surmounted by a platinum-coated horse bun. (John Simon)

Absence
I treasure every moment that I don't see Phyllis Diller. (Oscar Levant)

Abortion
It serves me right for putting all my eggs in one bastard. (Dorothy Parker)

Accents
I was once sent to a voice coach to develop an Austrian accent for a stage play. After three lessons she said to me, 'There's no way I can teach you an *Austrian* accent, but if you would like to learn English, then I might be able to help'. (James Stewart)

Al Pacino plays a Scottish immigrant in *Revolution* but every time he opens his mouth he sounds like Chico Marx with a head cold. (Vincent Canby)

Accidents
You look at Ernest Borgnine and you think to yourself: Was there anybody else hurt in the accident? (Don Rickles)

Acne
In high school my acne was so bad, blind people tried to read my face. (Joan Rivers)

Acting
I always said I'd like John Barrymore's acting until the cows came home. Well, ladies and gentlemen, last night the cows came home. (George Jean Nathan after seeing him in a play)

I always find it embarrassing to hear people talking about the 'craft' of acting. It always sounds a bit wanky. You imagine people going, 'oh, get a real job'. (Emily Blunt)

Acting is boredom and whoredom. (Marlon Brando)

Acting is travelling 1500 miles to a foreign country to pretend to be someone else in front of a machine. (Robbie Coltrane)

I do my best acting on the couch. (Mae West)

Acting Styles
I dislike actors who seek to commune with their armpits. (Greer Garson on Marlon Brando)

Robert Mitchum doesn't so much act as point his suit at people. (Russell Davies)

Sandy Dennis made an acting style out of a post-nasal drip. She balanced it with a pre-frontal lobotomy so that when she wasn't a walking catarrh she was a blithering imbecile. (John Simon)

Acting Academies
I learned two things at RADA. First, that I couldn't act, and second that it didn't matter. (Wilfrid Hyde-White)

Mamie van Doren was the forerunner of the Farrah Fawcett School of acting. In other words she often acted like Mr. Ed, The Talking Horse. (Paula Yates)

Action Movies
I'd rather suck faecal matter out of the ass of a goat than appear in an action movie. (Stephen Fry)

Actors
My headmaster told me all actors were either queers or communists. (Terry Jones)

Actors believe he who is without fault should stone the cast first. (John Gielgud)

Actresses
Never marry an actress. I heard about one whose husband asked her to make up her mind and she put lipstick on her head. (Stephen Baldwin)

As a human being, Joan Crawford is a wonderful actress. (Nicholas Ray)

Glenn Close isn't an actress. She's an address. (Maggie Smith)

As an actress, Candice Bergen's only flair is in her nostrils. (Pauline Kael)

Adaptations

Darling, they've absolutely ruined your perfectly dull play. (Tallulah Bankhead after seeing *The Fugitive Kind*)

Seeing your book turned into a movie is like watching your children get raped by Cossacks. (Kathy Lette)

Alfred Hitchcock had a framed cartoon of two goats in his office. They're chewing on reels of film in a junkyard and one says to the other, 'I liked the book better.' (John Landis)

Adapting *Middlemarch* for TV was a bit like trying to get an elephant into a suitcase. (Andrew Davis)

So what if she's a lesbian in the book? We'll get around that. In the film we'll make her an American. (Sam Goldwyn)

Death Wish was from a novella by a writer called Brian Garfield. I think it sold three copies. Brian's mother bought two of them. (Michael Winner)

Admissions

I went to the movie theater and the sign said, 'Adults: $5, Children: $2.50.' I told them I wanted two boys and a girl. (Steven Wright)

Adoption

I wouldn't be surprised if Madonna made that African boy she adopted into a coat and wore him for fifteen minutes, then threw it away. (Morrissey)

Advertisements

Once you allow your face to adorn a bottle of salad dressing there's no way you can ever take yourself seriously again afterwards. (Paul Newman)

Why do I have to wear a bathing costume for a toothpaste ad? (Marilyn Monroe)

Coming soon – Ibsen's *A Dolls' House*. Bring the Kids! (Advertising sign spotted in Ohio)

I don't like TV advertising. A few seconds after Othello starts to strangle Desdemona they're trying to sell me Preparation H. (Roman Polanski)

Advice

Give him an evasive answer. Tell him to go fuck himself. (W.C. Fields)

Always marry a pretty woman. That way, when you get fed up of her, you won't have any problem dumping her on someone else. (Jackie Mason)

Don't marry on an empty stomach. (John Travolta)

Always look out for number one and be careful not to step in number two. (Jack Benny)

I told my daughter to get married, have a child, get divorced and live happily ever after. (Cher)

If all else fails, go to the dick joke. (Robin Williams)

Affairs

I haven't had as many affairs as Joan Crawford. But then, outside a cathouse, who has? (Bette Davis)

A man can have two or maybe three love affairs while he's married. After that you're cheating. (Yves Montand)

If I were to have an affair it would be with a woman by the name of Audrey. My wife is called Audrey. She'd never suspect anything if I cried out her name during love-making. (Billy Wilder)

Affection

To know Herman Mankiewicz was to like him. Not to know him was to love him. (Bert Kalmar)

Age

Thirty is a nice age for a woman – especially if she happens to be forty. (Phyllis Diller)

I was born in 1962. The room next to me was 1963. (Joan Rivers)

I wish I could tell you my age but it keeps changing. (Greer Garson)

Klaus Kinski isn't ageing well. The best thing that could happen to his career would be for him to die prematurely. (Werner Herzog)

Age cannot wither her, nor custom stale her infinite monotony. (David Shipman on Marlene Dietrich)

It is generally accepted in Hollywood that waiting for Marlon Brando to read a script and even give you a negative answer will age a man faster than trying to explain to Nikita Khrushchev why he can't go to Disneyland. (Frank Rosenberg)

I'm now at the age where I've to prove that I'm just as good as I never was. (Rex Harrison)

No, it's not great being over 50. In fact it's like going to the guillotine. (Angie Dickinson)

When James Dean was my age he was already dead five years. (John Belushi)

I was brought up to respect my elders but now I don't have to respect anyone. (George Burns at 87)

Ageism

There are only three ages for women in Hollywood: Babe, District Attorney and Driving Miss Daisy. (Goldie Hawn)

When I first went into the movies Lionel Barrymore played my grandfather. Later he played my father and finally he played my husband. If he'd lived longer I'm sure he would have been my son. (Lillian Gish)

Agents

An agent is a guy who's sore because the actor gets 90% of what he makes. (Alva Johnston)

My agent put me up for a snuff film. It's a three-picture deal. (Betsy Salkind)

At the beginning of my career I was so hard up for work I told my agent, 'Get me a job as a Venetian blind. It won't be a problem'. (Whoopi Goldberg)

The first time I tried to get a movie made in Hollywood my agent said to me, 'There are 'yes' lists and 'no' lists and you aren't even on the 'no' list. (Alain Rudolph)

A Hollywood agent says to an aspiring but so far unsuccessful screenwriter: 'I have some good news and some bad news for you.' 'Give me the good news first' asks the writer. 'Well, Tarantino loved your script so much he ate it up.' 'And the bad news?' 'Tarantino is my cocker spaniel.' (Internet joke)

I decided to be an actress at nine. My Mom was against it so when I was eleven I got my own agent. (Laura Dern)

A writer's relationship with agents can be summed up like this: We pray they don't kill us in their sleep. (Howard Rodman)

Why did the shark not attack the agent who fell into the ocean? Professional courtesy. (Nicholas Kent)

Airplanes

In order to feel safe on his private jet, John Travolta has purchased a bomb-sniffing dog. Unfortunately the dog came six movies too late. (Jay Leno)

It should have sunk along with the airplane. (Jack Lemmon on *Airport 77*)

Alcoholics

I didn't have to do too much research to play an alcoholic in *The Lost Weekend*. I come from Wales. (Ray Milland)

There's always been a lot of clutter in my home. If I ever become an alcoholic, my friends won't think anything of seeing loads of bottles around the place. They'll think it's just my housekeeping. (Phyllis Diller)

Alimony
I sometimes wonder if the fucking you get is worth the fucking you got. (Humphrey Bogart)

Alternative Careers

I'd like to have been a hanging judge. (Alfred Hitchcock)

If I wasn't an actor I'd probably be a psychopath. (Terence Stamp)

Have you thought of driving a bus, or becoming a piano tuner? (Ralph Novak to Michael Cimino after *Year of the Dragon* flopped)

Jack Lemmon had to be an actor because the only other thing he could do was play the piano in a whorehouse. (Billy Wilder)

Ronald Reagan started out as an untalented dishwasher in Tampico, Illinois. Unfortunately, he never lived up to this early promise. (Phyllis Diller)

I wasn't born to be an actor. I was born to be a beach bum in a warm country, painting bad pictures. (Rod Steiger)

Alternative Titles
The Bridges of Madison County should have been called *The Bridges of Menopause County*. (Brush Sheils)

They should have called *Pearl Harbor* Bore-a, Bore-a, Bore-a. (Desson Thompson)

Ambitions

I wanted to be a sex maniac but I failed the practical. (Robert Mitchum)

I always wanted to be a somebody but I should have been more specific. (Lily Tomlin)

I always wanted to be Brigitte Bardot. (Bob Dylan)

Steven Spielberg always wanted to be a little boy when he grew up. (Rainer Werner Fassbinder)

My ambition as a boy was to retire. (George Sanders)

The average Hollywood film star's ambition is to be admired by an American, courted by an Italian, married to an Englishman and have a French boyfriend. (Katherine Hepburn)

When other little girls wanted to be ballet dancers, I kind of wanted to be a vampire. (Angelina Jolie)

I remember my brother saying once, "I'd like to marry Elizabeth Taylor." My father said, "Don't worry, son, your turn will come." (Spike Milligan)

I'd like to devote the rest of my life to setting up a convalescent home for the rehabilitation of celibate ex-cons. (Robert Mitchum in 1991)

Analogies
Colonic irrigation was like losing your virginity. (Ben Affleck)

If someone vomits watching one of my films it's like getting a standing ovation. (John Waters)

Ali McGraw's delivery of lines in *The Getaway* was like a grade-school pupil asking to be excused to go to the bathroom. (John Simon)

Acting with Woody Allen was like kissing the Berlin Wall. (Helena Bonham Carter)

Watching John Thaw is like being embalmed alive by an arthritic with halitosis. (A.A. Gill)

Working in film is like making love to a gorilla. You don't stop when you want to stop. You stop when the gorilla wants to stop. (David Janssen)

Ancestry

A Hollywood aristocrat is someone who can trace his ancestry all the way back to his parents. (Fred Allen)

My mother was from the Caribbean. I'm a one-eyed Puerto Rican Jewish nigger who happens to be married to a white woman. When I move into a neighborhood people run in four different directions at the same time. (Sammy Davis Jr)

It was said in my family that one of my ancestors was a Salem witch. I certainly hope so. It would explain everything. (Bette Davis)

I come from a long line of actors. It's called the dole queue. (Alan Davies)

Androgyny

Ava Gardner was a true gentleman. (George Cukor)

Early in my career I made the mistake of going out exclusively with actresses and other female impersonators. (Mort Sahl)

Maggie Smith acts like Quentin Crisp in drag. (James Coco)

Raquel Welch is more like Rhett Butler than Scarlett O'Hara. (Cubby Broccoli)

Christine Jorgenson is writing her autobiography. When it's filmed, the title part will be played by Susan Hayward and Gregory Peck. (George Kirgo)

Animals

I hate to see dolphins in captivity because they're such smart animals. That doesn't mean I want a dolphin to perform brain surgery on me. Dolphins don't have any hands. It's very hard to hold a scalpel with flippers. (Ellen DeGeneres)

No dinosaurs were harmed in the making of this motion picture. (Post-credit note to *The Flintstones*).

In the US Constitution it says you have the right to bear arms. Or the right to arm bears – whichever you prefer. (Robin Williams)

The only animal that got hurt when we were making *Stagecoach* was a press agent who got in the way of a posse. Fortunately, there's no society for the prevention of cruelty to press agents. (John Ford)

All my life I've had animals of one kind or another around the house, even if it was only a small distant relative or a skunk. And believe me, there's not a great deal of difference. (Groucho Marx)

I think animal testing is a terrible idea. They get all nervous and give the wrong answers. (Hugh Laurie)

Whenever I ask people why they have deer heads on their walls they say, 'Because they're such beautiful animals'. I think my mother is attractive too, but I'd prefer a photo. (Ellen De Generes)

It's obvious that carrots are good for your eyesight. Have you ever seen a rabbit wearing glasses? (Steve McQueen)

If it's true that men are beasts, this must account for the fact that most women are animal lovers. (Doris Day)

The trouble with the rat race is that even if you win you're still a rat. (Lily Tomlin)

Animation

I loved Mickey Mouse more than any woman I've ever known. (Walt Disney)

If you want to see a comic strip you should see me in the shower. (Groucho Marx)

Walt Disney has the best casting of all. If he doesn't like one of his characters he just tears him up. (Alfred Hitchcock)

It took seventeen people to make ET, but he was still cheaper than Marlon Brando. (Steven Spielberg)

Anniversaries

This is quite an occasion for me. I've been married before, but never for a whole year. (Ava Gardner after Frank Sinatra gave her a diamond-studded ring to celebrate their first wedding anniversary)

The two things men always miss are anniversaries and toilet bowls. (Lillian Gish)

Anorexia
Where do you go to get anorexia? (Shelley Winters)

Anorexics are women who look in mirrors and see fat people. Therefore I'm anorexic. (Kathy Bates)

Anti-Semitism
The only advantage I've found in being Jewish is that I can be openly anti-semitic. (Kirk Douglas)

When I was a kid I played basketball in the church league. The ref used to call a foul as soon as I stepped out onto the court. I'd say, 'I didn't do anything'. And he'd say, 'You killed Christ'. (Adam Sandler)

Anxiety
If I knew what I was so anxious about, I wouldn't be so anxious. (Rita Moreno)

Apocrypha
If I'd jumped on all the girls I'm supposed to have, I'd never have had time to go fishing. (Clark Gable)

If all the stories you heard about me were true, I would now be speaking to you from a jar in Princeton. (Frank Sinatra)

Everyone tells me I've had such an interesting life, but sometimes I think it's been nothing but self-concern and stomach disturbances. (Cary Grant)

I'll know my career is coming to an end when they start to quote me right. (Lee Marvin)

I was accused of breaking up the relationship between Julia Roberts and Benjamin Bratt, but I wouldn't have had time. I was too busy breaking up the one between Tom Cruise and Nicole Kidman. (George Clooney)

Apologies

My mother could make anyone feel guilty. She used to get letters of apology from people she didn't even know. (Joan Rivers)

Diane Keaton wakes up in the morning and apologises. (Woody Allen)

If God doesn't destroy Hollywood Boulevard, he owes Sodom and Gomorrah an apology. (Jay Leno)

The Army

I wasn't very good in the army. I kept trying to play the rifle. (Elvis Presley)

After I enlisted in the army during World War II, Sam Goldwyn told me he was going to cable Hitler to ask him if he could shoot around me. (David Niven)

At my selection board interview I told the officer I was interested in tanks. His eyes blazed with enthusiasm. "Why tanks?" he said keenly. I replied that I preferred to go into battle sitting down. (Peter Ustinov)

Arrests

I'm so ugly, as a kid I once stuck my head out the window and got arrested for mooning. (Rodney Dangerfield)

Art

If Botticelli were alive today he'd be working for *Vogue*. (Peter Ustinov)

In Hollywood, people have Picassos and Chagall's on the wall of their houses, but they'd kill to have lunch with Chuck Norris. That's why you have movies like Howard the Duck. (David Steinberg)

Errol Flynn's idea of art would be the pictures of fruit on a slot machine. (Bette Davis)

I was on the canvas so much in my boxing days they nicknamed me Rembrandt. (Bob Hope)

Articulacy

The people in Hollywood only know one word of more than one syllable: fillum. (Louis Sherwin)

They've erected a statue to Jimmy Stewart and it talks better than he ever did. (Dean Martin)

If you said 'Hiya' to Clark Gable, he was stuck for an answer. (Ava Gardner)

Sylvester Stallone's diction, always bad, is now incomprehensible. It's as if his ego has grown so big it fills his mouth like a cup of mashed potatoes. (John Powers)

Attitude

Marlon Brando's mother was the kind of woman who saw the glass as half full in every situation in life. That was usually because she'd drunk the other half. (Stefan Kanfer)

For the first year of marriage I had a basically bad attitude. I tended to place my wife beneath a pedestal. (Woody Allen)

If you have a vagina and an attitude in Hollywood, that's a lethal combination. (Sharon Stone)

Sharon has shown us both of these too often by now. (Willy Baldwin)

Attraction

The thing that first attracted Elizabeth Taylor to me was my hangover. (Richard Burton)

The best way to attract a man immediately is to have a magnificent bosom and a half-sized brain and let both of them show. (Zsa Zsa Gabor)

I was originally drawn to Don Johnson because he seemed to be a complex guy. But after a while I realized he was just a guy with a lot of complexes. (Melanie Griffith)

Stewart Granger confided one evening at a dinner party that the only sort of woman who really turned him on was a big stout nanny. Perhaps the reason all three of his marriages ended up in divorce was because none of his wives were strong enough to lift him out of the bath. (Diana Dors)

Audiences

When you make a picture, you have to forget that anybody might ever see it. (Clint Eastwood)

When I went to see *Goldeneye* I was glued to my seat. Otherwise I would have left. (Dennis Pennis)

Let's show the movies in the street – and drive the people back to the theatres. (Nunnaly Johnson)

Ten years ago, the studio heads thought the audiences were sheep. Now they think they're snails with Down's Syndrome. (Albert Brooks)

Typical Hollywood crowd – all the kids are on drugs and all the adults are on roller skates. (Eric Idle)

I don't mean much to the *Rambo* crowd. (Woody Allen)

Elvis is pitching his act at some sort of adult audience – possibly adult chimpanzees. (*Time* magazine on Elvis Presley's performance in *Spinout*).

I don't care if *The Best Years of Our Lives* doesn't make a nickel. I just want every man, woman and child in America to see it. (Sam Goldwyn)

Auditions

I once auditioned for the part of a boy-next-door, only to be told I didn't look as if I lived next door to anyone. (Donald Sutherland)

Autobiographies

I put more energy into my autobiography than I did into my marriages. You can't divorce a book. (Gloria Swanson)

I don't think anyone should write his autobiography until after he's dead, (Sam Goldwyn)

Autographs

I know it's a bad time but while your wife's out could I have an autograph? (Fan to Steve McQueen in a department store once after his wife Neile had fainted).

The last time my father asked me for my autograph it was on a cheque. (Drew Barrymore)

Nowadays when a fan runs up to me it isn't to get an autograph but a closer look at my wrinkles. (Liz Taylor in old age)

A horse once asked me for my autograph. After giving it to him, I asked him for his. (Groucho Marx)

A nurse asked me for my autograph once when I was in a straitjacket. I wrote, "Fuck you. Sincerely, Francis Farmer." (Francis Farmer)

When they stop asking you for autographs you know your pan is losing its shine. (Bette Davis)

Avant Garde

I call my films 'experimental'. That means I haven't a clue what I'm doing. (Andy Warhol)

Aversions

I think I'm a pretty good judge of people, which is why I hate most of them. (Roseanne Barr)

My friends and I used to pass the time making a list of people we wouldn't go to bed with even if our lives depended on it. Most of my friends nominated Hitler. I chose David O.Selznick. (Marlene Dietrich)

I can't stand people who can't stand people. (Lily Tomlin)

The only thing I ever liked Hugh Grant in was Liz Hurley. (Mark Kenner)

Awards

I don't deserve this. But I have arthritis and I don't deserve that either. (Jack Benny after receiving an acting award)

You've done awfully well for a man with a speech defect. (Billy Connolly to Sean Connery at the BAFTA ceremony in 1999 as he presented him with a Life Achievement Award)

The best award I ever won, even better than my Oscar, was a Mobil Man of the Month plaque when I was a gas pump attendant in Westport, Connecticut. (Michael Douglas)

If I go to an awards dinner I'm lucky if I get my dinner, let alone an award. (Michael Winner)

I would have won the Academy Award if it wasn't for one thing. My pictures. (Bob Hope)

The Academy Awards are definitely fixed. The Best Actress Award is always won by a woman. (Groucho Marx)

Why are there three film award ceremonies – the Golden Globes, the BAFTAs and the Oscars – in such a short span of time? Is it because the actors up for awards can hire the tuxedos for the whole month? (Derek McGovern)

Reporter: Is there any award left for you to win?
Judi Dench: There's still Crufts.

Babies

They said the baby looked like me. Then they turned him the right way up. (Charles Laughton)

Several magazines have offered Ben Affleck thousands of dollars to publish pictures of his baby. Which means that the baby is the only Affleck whose pictures make money. (Conan O'Brien)

Daniel Day-Lewis says he's trying to lose 137 pounds in order to play a new-born baby in Martin Scorsese's next project. (Denis Leary)

Tom Cruise and Katie Holmes had a baby girl. It weighs seven pounds seven ounces and is twenty inches long. Wait, that's Tom. (David Letterman)

Bachelors

I'm a confirmed bachelor. I believe in wine, women and so-long. (John Travolta – before he married)

Advice to single girls: Don't look for a husband. Look for a bachelor. (Red Skelton)

Balance

I'm very balanced. I'm an exhibitionist but also a voyeur. (Woody Harrelson)

Dean Martin's idea of balance is having a glass of whiskey in each hand. (Sammy Davis Jr)

Baldness

Frank Sinatra's the kind of guy who, when he dies, he's going to heaven to give God a hard time for making him bald. (Marlon Brando)

People should always behave in a manner befitting their age. If you are 16 or under, try not to go bald. (Woody Allen)

The best thing about being bald is that you don't have to brush the dandruff off your jacket. (Yul Brynner)

Bald men are never allowed kiss in films unless they're villains, or Sean Connery. (Roger Ebert)

I'm the man with no hair who shoves people with hair around. (Otto Preminger)

Ballet

I got kicked out of ballet class because I pulled a groin muscle. It wasn't mine. (Rita Rudner)

Male ballet dancers dress so tight, you can almost tell what religion they are. (Robin Williams)

I don't dig ballet. The last time I went to one, my friends bet a lot of money on the swan to live. (Woody Allen)

Mr. Van Damme combines the balletic grace of Mikhail Baryshnikov with the acting ability of a turnip. (Christopher Tookey on Jean-Claude Van Damme in *Kickboxer*)

Beards

They thought my beard didn't look authentic in *Quo Vadis* so they made me shave it off and put on a false one. (Peter Ustinov)

Don't point that beard at me, it might go off. (Groucho Marx)

Beauty

I'm tired of all this nonsense about beauty being only skin deep. What do you want – an adorable pancreas? (Deborah Kerr)

I once entered a beauty contest. I came last – and got 361 Get Well cards. (Phyllis Diller)

You're one of the most beautiful women I've ever seen but I'm afraid that's not saying much for you. (Groucho Marx)

I've always thought that I'm not pretty enough to be thought beautiful and not quite plain enough to be considered interesting. (Glenda Jackson)

My wife was too beautiful for words but not for arguments. (John Barrymore)

Dolores del Rio was in Garbo's class as a beauty but everytime she opened her mouth she became Minnie Mouse. (John Ford)

I'm no beauty. At the beach, men mentally dress me. (Phyllis Diller)

Pretty woman my arse. (Bono's father after meeting Julia Roberts)

Beliefs

When my dad said, 'Marry a girl with the same beliefs as the family,' I thought: Why should I marry a girl who thinks I'm a schmuck? (Adam Sandler)

Everybody should believe in something. I believe I'll have another drink. (Groucho Marx)

I'm an atheist, thank God. (Luis Bunuel)

Diane Keaton believes in God. But she also believes that the radio works because there are tiny people inside it. (Woody Allen)

The Bible

Remember in The Bible where the Book of Ecclesiastes starts with 'Vanity, vanity, all is vanity'? Well that's what I think of Hollywood. Except for' Vanity' I would substitute the word 'Bullshit.' (Humphrey Bogart)

My most embarrassing failure was *The Prodigal*. I forgot was the Cecil B. deMille had an exclusive on *The Bible*. (Dore Schary)

Conrad Hilton was very generous to me in the divorce settlement. He gave me 5000 Gideon Bibles. (Zsa Zsa Gabor)

I always carry a bullet in my breast pocket. Someone threw a Bible at me once and it saved my life. (Woody Allen)

Why let 2000 years of publicity go to waste? (Cecil B deMille explaining his obsession with Biblical films)

Let's all give God a big hand. I've seen the last page of the Bible and everything turns out all right. (W.C. Fields)

They've made a new film about Moses. It looks great in the rushes. (Jackie Mason)

Bikinis

The only thing tinier than the bikini Farrah Fawcett Majors wore in *Sunburn* was her talent. (Rona Barrett)

When I go to the beach wearing a bikini, even the tide won't come in. (Phyllis Diller)

Nothing can replace the old-fashioned one-piece swimsuit. And it almost has. (Bob Hope)

Biopics

If you're hot, they'll alter the part of a black midget for you but if you're cold it's a case of, 'We're making *The Michael Caine Story* but we're afraid you're too tall for it.' (Michael Caine)

Helen Mirren won an Oscar for playing a stubborn, out-of-touch diva in *The Queen*. I believe the film is based on the life of Elton John. (David Letterman)

The way things are going, I'd be more interested in seeing Cleopatra play Elizabeth Taylor than the other way around. (Earl Wilson in 1960)

Birth

I was born in very sorry circumstances. Both of my parents were very sorry. (Norman Wisdom)

I was an unwanted child. After I was born my father spent a month trying to find a loophole in the birth certificate. (Rodney Dangerfield)

Don't tell your kids you had an easy birth or they won't respect you. For years I used to wake up my daughter and say, 'Melissa, you ripped me to shreds. Now go back to sleep'. (Joan Rivers)

Giving birth is like shitting a fridge. (Diana Ross)

Men can never experience childbirth. This is a pity. On the other hand, we can open all our own jars. (Bruce Willis)

I was destined to be an actor. The day I was born I stood up and took a bow. When the doctor slapped me I thought it was applause. (Bob Hope)

Pamela Lee had an all-natural birth at her Malibu home. Only in L.A. do you have bleached hair, silicon breasts and an all-natural birth. (Jay Leno)

We were so poor, my mother couldn't afford to have me. The lady next door gave birth to me instead. (Mel Brooks)

Birth Control

What do you call people who practice the rhythm method of birth control? Parents. (Peter O'Toole)

The best form of birth control is to leave the lights on. (Joan Rivers)

There's nothing wrong with making love with the lights on. Just make sure the car door is closed. (George Burns)

Birthdays

What would I like for my 87th birthday? A paternity suit. (George Burns)

We were so poor, I didn't have my 21st birthday until I was 48. (Rodney Dangerfield)

It took me 34 takes to nail just one line in *Minority Report* but I had a good excuse. It was the morning after my birthday. (Colin Farrell)

It's wonderful you could all be here for the 29th anniversary of my 43rd birthday. We decided not to light the candles this year. We were afraid Pan-Am would mistake it for a runway. (Bob Hope)

Bladders

The person with the weakest bladder always sits in the middle of the row at a cinema. (Mitchell Symons)

Joan Crawford cries so much, I suspect her tear ducts must be close to her bladder. (Bette Davis)

The length of a film should be directly related to the endurance of the human bladder. (Alfred Hitchcock)

Blood

I'm so old they've cancelled my blood type. (Bob Hope)

I must apologise for the lack of bloodshed in tonight's film. We shall try to do better next time. (Alfred Hitchcock)

This scene will make your blood curl. (Michael Curtiz)

So the lawyer goes up to O.J. Simpson and says, 'O.J. I've got some bad news and some good news. The bad news is that there's blood on the Bronco, blood on the driveway, blood on the socks and blood on your

Bruno Magli shoes.' OJ says, 'What's the good news?' and the lawyers says, 'Your cholesterol's fine.' (Mitch Green)

Bodies

Her body has gone to her head. (Barbara Stanwyck on Marilyn Monroe)

I used to have a great big chest but that's all behind me now. (Bob Hope)

Achilles only had his heel. I've got an Achilles body. (Woody Allen)

Robert Mitchum's chest gets wherever he's going about five seconds before he does. (Harry Waters)

My body is so bad, a Peeping Tom looked in the window and pulled the blinds down. (Joan Rivers)

At my age I refuse to wear a beeper. I don't want anything else on my body that might fall off. (George Burns)

I'm 42 around the chest, 52 around the waist, 92 around the golf course and a nuisance round the house. (Groucho Marx)

I have eyes like a bullfrog, a neck like an ostrich and long, limp hair. You just have to be good to survive with that kind of equipment. (Bette Davis)

Bond Girls

Bond girls don't remind me of any women I know. Where's the one who says, "James, I know we discovered the antidote to a rare tropical virus that threatened to destroy the earth, but why didn't you call?" (Maura Kennedy)

Jessica Simpson is hoping to be the next Bond girl. She has a pretty good shot at it because 007 was also her S.A.T. score. (Jay Leno)

Bondage

It's been so long since I made love I can't remember who gets tied up. (Joan Rivers)

I like kinky sex with chocolate. I call it S&M&M. (Roseanne Barr)

Books
From the moment I picked up your book until I put it down I was convulsed with laughter. Someday I intend reading it. (Groucho Marx)

I honestly believe there's nothing better than going to bed with a good book. Or a friend who's read one. (Phyllis Diller)

I read part of your book all the way through. (Sam Goldwyn)

My life is an open book – all too often at the wrong pages. (Mae West)

Some people wouldn't read a book even if it was banned. (Will Rogers)

I was going to send Sylvester Stallone a book for Christmas but someone told me he already had one. (Jay Leno)

Boredom
I've just spent an hour talking to Tallulah Bankhead for a few minutes. (Fred Keating)

A terrible thing happened again last night – nothing. (Phyllis Diller)

Of course I'm listening to you. Don't you see me yawning? (Louis B.Mayer)

Botox
One consequence of Botox is the fact that it's difficult for directors to cast sixty year old women any more. Because they all look forty. (Kate Winslet)

Bottoms
Doris Day's ass is so firm you could play bridge on it. (Groucho Marx)

You're sitting on it. (Alfred Hitchcock to a starlet who asked him what her best side was)

I had drinks yesterday with Marilyn Monroe. Her bottom had gone to pot and her pot had gone to bottom. (Kenneth Tynan in 1960)

The Boudoir
Being good in bed mean I'm propped up with pillows and my mom brings me soup. (Brooke Shields)

Gilbert Roland was a wonderful husband to me....in one room of the house. (Constance Bennett)

Never marry an actor. They perform in every room in the house except the boudoir – unless there's a mirror in there. (Brigitte Bardot)

Things were great between me and Frank in the bedroom. The arguments always started on
the way to the bidet. (Ava Gardner on her marriage to Frank Sinatra)

Bowel Movements
There are three stages in an actor's career. The first is when he shows up on the set and says, 'You should have seen the girl I was with last night – she was amazing'. In the second stage he's a leading man and says, 'I found the most wonderful restaurant – you wouldn't believe the fish.' By the third stage he's a character actor. Now he says, 'I had the most lovely bowel movement last night.' (Paul Newman)

The key to playing my character in *Little Big Man* was forming the notion that he hadn't had a decent bowel movement last in 46 years. (Dustin Hoffman)

In any comedy set in the Old West, if a character lowers his pants to move his bowels, he will be horrified to find he has chosen a secluded spot that is home to a rattlesnake. (Roger Ebert)

Boxers
I once tried shadow boxing, but lost. (Woody Allen)

The expanses of flesh that he exposes when he gets into boxing togs are a fair indication that most of his muscles come from punching a guitar. (Bosley Crowther on Elvis Presley in *Kid Galahad*)

I was the only boxer in history with a rear-view mirror. (Bob Hope)

Box Office
Why should I be good when I'm packin' 'em in when I'm bad? (Mae West)

I began to get worried about my film career when I realized I was second to Rin Tin Tin at the box office. (Judy Garland)

I became the world's number one box office star not because of my movies but despite them. (Burt Reynolds)

Brains

What does your brain want to be when you grow up? (Jimmy Durante)

You've got the brain of a four year old boy and I bet he was glad to get rid of it. (Groucho Marx)

If you combined all three of their brains together I doubt whether they could solve a quadratic equation. (Richard Burton on the astronauts who made the 1969 moon landing)

I used to have an open mind but my brains kept falling out. (Red Skelton)

Bras

Jean Harlow never wore a bra. One day James Cagney said to her, 'How do you hold those things up?' She replied, 'I ice 'em.' (Joan Blondell)

Dolly Parton has a yacht in Seattle and it's windy there. One day she hung up her bra to dry. She woke up in Brazil. (Phyllis Diller)

Bravery

Brave men run in my family. (Bob Hope)

I was the only director who ever made two pictures with Marilyn Monroe. Forget the Oscars. I deserve the Purple Heart. (Billy Wilder)

What's the definition of bravery? Playing leapfrog with a unicorn. (Milton Berle)

Men are brave enough to go to war but not to have a bikini wax. (Rita Rudner)

Break-Ups

My split from Phyllis George was the first of my four marriages where the cause of the break-up wasn't infidelity – but that's only because I never got caught. (Robert Evans)

Jane Fonda and Ted Turner broke up. It seems Jane found God and Ted left when he realized it wasn't him. (Robin Williams)

After I broke up with Jennifer Lopez I experienced the kind of calm you get after vomiting. (Ben Affleck)

Breaking up with Tom wasn't so bad. It meant I got to wear high heels again. (Nicole Kidman on her divorce from Tom Cruise)

Breasts

The two and only Jane Russell. (Bob Hope)

Demi Moore's breasts hang around *Striptease* like a brace of silicon albatrosses. (Mark Steyn)

Titism has taken over the country but Audrey Hepburn may single-handedly make bazooms a thing of the past. (Billy Wilder)

A fan told me once that I had the kind of breasts he could take home to his mother. (Susan Sarandon)

I asked Dylan Thomas why he'd come to Hollywood. 'To touch starlet's tits,' he said. 'Okay,' I said, 'but only one finger.' (Shelley Winters)

If I hadn't been born with them, I would have had them made. (Dolly Parton)

No picture can hold my interest when the leading man's bust measurement is bigger than the leading lady's. (Groucho Marx on Victor Maure and Hedy Lamarr in *Samson and Delilah*).

Pamela Anderson has just told her Hollywood agent she's refusing to do a film with Dolly Parton. Apparently the town isn't big enough for the four of them. (Paul Hamilton)

Breastfeeding

I was in analysis for years because of a traumatic childhood. I was breast-fed on falsies. (Woody Allen

Brevity
Brevity is the soul of lingerie. (Dorothy Parker)

I've been asked to say a couple of words about my husband. How about 'short' and 'cheap'? (Phyllis Diller)

Brides
In Hollywood, brides keep the bouquets and throw away the groom. (Groucho Marx)

Brides today are wearing their dresses shorter. And more often. (Milton Berle)

A bride is a woman with a lot of happiness behind her. (Helen Mirren)

British Films
Either John Mills or Richard Attenborough have been in every British film made since 1942. Usually in a uniform. (Robin Hamill)

British films tend to be made for a few friends of the producer's in Hampstead. (Michael Winner)

The British film industry is alive and well and living in Los Angeles. (Michael Caine)

Budgets
What do you want me to do – stop shooting now and release it as *The Five Commandments*? (Cecil B. DeMille after being informed he was running over budget on *The Ten Commandments*)

It would have been cheaper to lower the Atlantic. (Lew Grade on the huge cost of his film *Raise the Titanic*).

California
In California the flowers don't smell but the women do. (Chico Marx)

Hollywood represents the Californication of the film industry. (James Montgomery)

In California we have a different kind of police. You get stopped in West Hollywood because your shoes don't match your pants. (Robin Williams)

Camels

All camels in middle Eastern thrillers cross the road for the sole purpose of slowing down a pursuit vehicle. (Roger Ebert)

A chase scene in an Antonioni movie would be a camel walking. (Jack Nicholson)

I'd rather ride down the street on a camel than give what is sometimes called an in-depth interview. In fact I'd rather ride down the street on a camel nude. In a snowstorm, Backward. (Warren Beatty)

Camera Work

Doris Day thinks she doesn't get old. She told me once it was her cameraman who was getting older. She wanted me to fire him. (Joseph Pasternak)

Mary Pickford is so old she was around for the first close-up. (Bette Davis)

Every shot is an act of salivating homage to the incredible loveliness, the tousled charm, the innocently puckered brow, the tentatively parted lips, the unassuming muscle of Warren Beatty, the hayseed whore master. (Kenneth Tynan on *Shampoo*)

Move in close. If they can see how beautiful she is, they won't notice she can't act. (John Huston to a cinematographer when he was directing Zsa Zsa Gabor in *Moulin Rouge*).

Cannes Film Festival

I don't go to it. It's always full of all the people I'd hoped were dead. (Dirk Bogarde).

Thank you. Your money's behind the washbasin. (Terry Jones to the jury who awarded him a prize at Cannes for *The Meaning of Life* in 1983).

Cannes is where you lie on the beach and stare at the stars – or vice versa. (Rex Reed)

So where's the Cannes Film Festival being held this year? (Christina Aguilera)

Career Highs

If it wasn't for *Rocky* and *Rambo* I'd be sitting watching re-runs of *Stop or My Mom Will Shoot* with a bottle of whiskey in one hand and a pistol in the other. (Sylvester Stallone)

It took this bitch 33 years to find the right role for herself: that of a crazed lesbian icepick killer who forgets to wear her panties at police interrogations. (Howard Stern on Sharon Stone in *Basic Instinct*

Career Slumps

Her career's had more ups and downs than a lavatory seat in a co-ed dorm. (Blake Edwards on Julie Andrews)

I reached my lowest point with *The Swarm*, a film where my big line was, 'The bees are coming.' (Lee Grant)

Carpeting

I went to buy some carpeting and they were looking for fifteen dollars a square yard. I bought two square yards, went home and strapped them to my feet for shoes. (Steve Martin)

What if everything is an illusion and nothing exists? In that case I definitely overpaid for my carpet. (Woody Allen)

Cars

Hollywood houses only seem to have cars living in them. (Liv Ullman)

Nick Nolte has the body of a 20 year old. A 20 year old Volvo. (Colin Ferris)

If it has tyres or testicles, you're going to have trouble with it. (Kathleen Turner)

If you stay in Beverly Hills too long you become a Mercedes. (Dustin Hoffman)

Casting

After playing a paediatrician in *ER*, I'll never have kids. (George Clooney)

Actors are usually awful at playing drunks. Robert Newton was good at it, but then it was usually for real. (Jeffrey Bernard)

I was once offered a part in *Moby Dick* – not the title role, I was relieved to hear. (Orson Welles)

Possibly because of my shape, the role of Portia always eluded me. (Robert Morley)

I was once in a film called *The Naked and the Dead*. I played both parts. (Joey Bishop)

What is known as 'straight' parts are the most difficult to play as one has to try to be natural, which is only possible in the bathroom. (Gerald Du Maurier)

Eventually we all play bitches. (Bette Davis)

Bunuel cast me in *Viridiana* because he was impressed by a previous performance of mine as a corpse. (Fernando Ray)

I always thought I'd be particularly good in *Rome & Juliet*. As the nurse. (Noel Coward)

Catchphrases
Arnold Schwarzenegger is getting old. He's changed his catchphrase from 'I'll be back' to 'Oh, my back'. (David Letterman)

Armani or your life. (Tony Curtis)

Cellulite
I've lost the same half-stone so many times my cellulite has *déjà vu*. (Oprah Winfrey)

My cellulite has cellulite. (Shelley Winters)

Celluloid
The most positive thing in the motion picture business is the negative. (Steve Brody)

Some of my films were so bad, the celluloid should have been turned into mandolin picks. (Kris Kristofferson)

Censorship

My last picture was so good the censor actually cut some lines out of it. (Diana Dors)

We're paid to have dirty minds. (Former British film censor John Trevelyn)

They can't censor the gleam in my eye. (Charles Laughton)

I love censorship. Why shouldn't I? I made a fortune out of it. (Mae West)

Roy Rogers wasn't allowed kiss his wife Dale Evans on screen because of strict moral codes but there was no objection to him kissing Trigger, his famous white horse. (Ricky Tomlinson)

Character Actors

I never had illusions about being a beauty. I was the only 17 year old character actress in movies. (Angela Lansbury)

The problem with a lot of character actors is that they don't have any. (Raymond Burr)

I was always a character actor. The trouble was, I looked like Little Red Riding Hood. (Paul Newman)

When you're called a character actor it's because you're too ugly to be called a leading lady. (Kathy Burke)

As character actors we play all kinds of psychos, nuts, creeps, perverts and weirdoes. We laugh it off saying, what the hell, it's just a character. But deep down inside, it's you, baby. (Lee Marvin)

I don't want to be called a character actress. That means you've had it. (Bette Davis)

Charity

Jackie Gleason once donated a sweater to a charity. There are now four refugees living in it. (Bob Hope)

Elizabeth (Taylor) supported the entire Biafran War effort on her own. (Richard Burton)

Charm
A kind of Hitler without the charm. (Peter Cook on Dudley Moore)

I want you to be sure and see Hans Christian Anderson. It's full of warmth and charmth. (Sam Goldwyn)

Chick Flicks
My boyfriend won't watch anything he calls a chick flick. That's any film where the woman talks. (Maura Kennedy)

A woman's picture is where the wife commits adultery all through it and at the end her husband begs for forgiveness. (Oscar Levant)

Childhood
I wasn't loved as a child. One day my mother said to me, 'Why can't you be more like Sheila?' Sheila died at birth. (Joan Rivers)

I won't tell you how rough my childhood was but my mother washed my clothes by beating them against a rock. While I was still in them. (Bob Hope)

At four I was left an orphan. What's a four year old child going to do with an orphan? (Groucho Marx)

When I was young I used to think my family didn't like me. They used to send me to the store for bread, and then they'd move. (Richard Pryor)

When I was a boy, the Dead Sea was just sick. (George Burns)

Whenever anyone asks myself and my wife if we have any children I say 'Yes, one boy. Aged 44. (Tony Hancock)

I love children if they're cooked properly. (W.C. Fields)

My Mother loved children. She would have given anything for me to be one. (Groucho Marx)

Children
I don't like children but I like to make them. (Groucho Marx)

Warren Beatty only had children so he could meet babysitters. (David Letterman)

My children love me. I'm like the mother they never had. (Roseanne Barr)

You see much more of your children once they leave home. (Lucille Ball)

I only have two rules for my newly-born daughter. She will dress well and never have sex. (John Malkovich)

My kids hate me. Every Father's Day they give a 'World's Greatest Dad' mug to the milkman. (Rodney Dangerfield)

Most children threaten to run away from home at some point in their lives. This is the only thing that keeps many parents going. (Phyllis Diller)

I want my children to have all the things I couldn't afford. Then I want to move in with them. (Phyllis Diller)

Child Stars

If she was born in the Middle Ages she'd have been burned at the stake as a witch. (Lionel Barrymore on Margaret O'Brien)

I was born at the age of twelve on the Metro-Goldwyn-Mayer lot. (Judy Garland)

I was a 14-year old boy for 30 years. (Mickey Rooney)

Shirley Temple was adorable. What a shame she grew up. And out. (Bette Davis)

Chocolate

Hand over the chocolate and no one gets hurt. (Kathy Bates)

How can a two pound box of chocolates make you gain ten pounds? (Roseanne Barr)

Chocolate isn't a substitute for love. Love is a substitute for chocolate. (Queen Latifah)

Choices
I gave them two choices – take it or leave it. (Michael Curtiz on a deal he was trying to negotiate with Warner Brothers)

Between two evils, I always choose the one I never tried before. (Mae West)

Christmas
With all the commercialism surrounding Christmas, it's very easy to forget its real significance: the celebration of the birth of Bing Crosby. (Pat O'Brien)

How does Zsa Zsa Gabor differ from other Hollywood wives? The others wonder what to get their husbands for Christmas, Zsa Zsa wonders what husband to get for Christmas. (Oscar Levant)

Cigarettes
When I read that cigarettes were bad for me I had to give up reading. (Roger Moore)

Cigarettes are the greatest cause of statistics. (Marlene Dietrich)

Circumcision
You'll always be a fine actor but you'll never be a great one until you're circumcised. (Noel Coward to Derek Jacobi)

Corpsing on stage is a bit like being circumcised in the Grand Canyon. (Robin Williams)

After they circumcised my husband they threw away the wrong bit. (Irene Selznick)

Cities
If I close my eyes and picture Las Vegas, all I see is one big varicose vein. (Marilyn Monroe)

Hong Kong is just Manchester with slanted eyes. (Peter O'Toole)

The only thing I have against the city of El Paso is that Maxine Reynolds came from there. She was the human equivalent of chalk scratching on a blackboard. (Eddie Fisher on the mother of his wife Debbie Reynolds)

Melbourne is the kind of city that makes you ask the question, 'Is there life before death?' (Bette Midler)

Brooklyn is nothing more than boredom, baseball and bad breath. (Barbra Streisand)

Cleavage

There's hills in them thar gold. (Alfred Hitchcock on Grace Kelly's breasts in a golden dress she was wearing)

In my heyday in films the photographer put me in low-necked nightgowns and told me to bend down and pick up pails. They were not photographing the pails. (Jane Russell)

Young lady, I think you're a case of arrested development. With your development, somebody's bound to get arrested. (Groucho Marx to a bosomy starlet)

The only place men want depth in a woman is in her *décolletage*. (Zsa Zsa Gabor)

Clichés

If a movie features three female leads, one of them will die during childbirth. If there are five or more female leads, an additional one of them will contract a terminal disease. (Andy Ihnatko)

In every movie scene which includes a bag of groceries, the bag will invariably contain a long, skinny, French baguette. And exactly 8.5 inches of it will be exposed. (Michael Pilling)

In any movie where there's a cocktail party featuring a map of a new real estate development, a wealthy property developer will be found dead inside an expensive automobile. (Roger Ebert)

We need some new clichés. (Sam Goldwyn)

Climaxes

I'm looking for a story that starts out with an earthquake and works its way up to a climax. (Sam Goldwyn)

If women ran the porn industry, the climax of the movie would be when the man shouts, 'I was wrong!' (Tom McCudden)

Closet Queens

Lily Tomlin has been in and out of the closet more times than my hunting jacket. (Rock Hudson)

Clothing

He dressed like a Geography teacher. (Jeremy Clarkson on Steve McQueen)

Whenever I wear something expensive it looks stolen. (Billy Connolly)

Sean Connery likes to dress casually. If you persuaded him to wear a suit for a business meeting you'd probably discover he had no socks on. (Ursula Andress)

If women dressed for men, the stores wouldn't sell much – just an occasional sun visor. (Groucho Marx)

You ought to get out of those wet clothes and into a dry martini (W.C. Fields)

I may wear mink but I think blue jeans. (Brigitte Bardot)

Eternal nothingness is fine if you happen to be dressed for it. (Woody Allen)

Nowadays you can't tell if a girl is wearing a high mini-skirt or a low lobster bib. (George Burns)

I put on a peek-a-boo blouse. Everyone peeked, then booed. (Phyllis Diller)

Liz Taylor wears stretch kaftans. (Joan Rivers)

If my jeans could talk, they'd plead for mercy. (Phyllis Diller)

Cocaine

The only reason cocaine is such a rage today is because people are too lazy to roll joints. (Jack Nicholson)
Cocaine isn't habit-forming. I should know, I've been using it for years. (Tallulah Bankhead)

I saw a film once where the director had a $750,000 cocaine budget for the cast. All the money was on the screen. (John Cleese)

Cocaine is God's way of telling you you're making too much money. (Robin Williams)

I'm looking for an old-fashioned girl, by which I mean one who powders her nose from the outside. (Dudley Moore)

Coitus Interruptus
'Cut!' is a very cold shower. (Kathleen Turner)

I went to a meeting for premature ejaculators. I left early. (Red Buttons)

Napoleon was no doubt a brilliant soldier but from the way he treated Josephine he was quite obviously one of the early French male chauvinists. If only she'd turned the tables on him, today we could all quote his now-famous sentence as, 'Not tonight, short-arse.' (Diana Dors)

When my mother didn't want to have sex with my father, she showed him a picture of me as a deterrent. (Rodney Dangerfield)

Cold Fish
An iceberg with an accent. (Andy Warhol on Jeremy Irons)

Kissing Laurence Harvey was like kissing the side of a beer bottle. (Capucine)

Groucho Marx had the compassion of an icicle and the generosity of a pawnbroker. (S.J. Perelman)

Grace Kelly looked like she could be a cold dish with a man until you got her pants down and then she'd explode. (Gary Cooper)

The failure of *Avalanche* and *Darling Lili*? Well one had a glacier and the other had Julie Andrews. I guess the audience couldn't tell the difference. (Rock Hudson)

Joan Collins
A lot of people have made money out of me. I've decided I'm going to be one of them. (Joan Collins)

Joan Collins is a commodity who would sell her own bowel movement. (Anthony Newley)

Joan Collins has everything: incest, adultery, wife swapping and lesbianism. And that's just in her dressing-room. (Milton Berle)

Joan Collins likes men so much we call her The British Open. (Eddie Fisher)

She looks like she combs her hair with an egg-beater. (Louella Parsons)

Joan Collins has all the assurance of someone dealing herself a fifth ace in a card game with children. (Louis Stanley)

Boze Hadleigh: 'They say Joan Collins improved the status of actresses over fifty.'
Bette Davis: 'How? By playing a slut?'

Colours

If brides wear white as a sign of chastity on a wedding day, why do grooms wear black? (Lily Tomlin)

I asked my husband to restore my confidence. I told him my boobs were gone, my stomach was gone. I asked him to say something nice about my legs. 'Blue goes with everything' he said. (Joan Rivers)

I always wear black. It makes shopping easier. (Yul Brynner)

I won't believe in colour television until I see it in black and white. (Sam Goldwyn)

How I dislike Technicolour, which suffuses everything with stale mustard. (Edward Marh)

Comedy

I used to struggle to make ends meet when I started out in stand-up comedy. I wouldn't have had anything to eat if it wasn't for the stuff the audiences threw at me. (Bob Hope)

His genius was in comedy but he had no sense of humour. (Lita Grey on her ex-husband Charlie Chaplin)

I find Charlie Chaplin's films about as funny as getting an arrow through the neck and then discovering there's a gas bill tied to it. (Richard Curtis)

The secret to all comedy writing is: Write Jewish and cast Gentile. (Robert Kaufman)

Commandments

You can't get a divorce in New York unless you can prove adultery. It's weird, because the Ten Commandments say, 'Thou shalt not commit adultery'. But New York State says you have to. (Woody Allen)

Thou shalt not weigh more than thy refrigerator. (John Goodman)

The main principle of my film is 'Thou shalt not kill – too many people'. (Alfred Hitchcock)

I plead the Fifth Commandment. (Sam Goldwyn)

Thou shalt not commit adultery – unless you're in the mood. (W.C. Fields)

The first nine commandments for a director are, 'Thou Shalt Not Bore'. The tenth is, 'Thou Shalt Have the Right of Final Cut'. (Billy Wilder)

Thou shalt not covet thy neighbour's house unless they have a well-stocked bar. (W.C. Fields)

Comparisons

I told my girlfriend she reminded me of a film star. Lassie. (Brendan O'Carroll)

She has a nipple like Eartha Kitt's head. (George Jessel on a big-breasted starlet)

Glenda Jackson is about as good as computer poetry. (John Simon)

Directing Cher is like being in a blender with an alligator. (Peter Bogdanovich)

Kathleen Turner is okay in stills but when she moves around she reminds me of someone who works in a supermarket. (Ann Sothern)

Hosting the Academy Awards is like being married to Larry King. You know it's going to be painful, but it will also be over in about three hours. (David Letterman)

I may never be a Meryl Street, but then she'll never be a Dolly Parton. (Dolly Parton)

Compatibility

There's an ideal woman for every man in the world – and he's damn lucky if his wife doesn't find out about her. (Joey Bishop)

I didn't want to marry her: she didn't want to marry me. It was obvious we were meant for each other. (Eddie Fisher on Connie Stevens)

Bonanza isn't an accurate description of the West. It's a 50 year old father with three 47 year old sons. You know why they get along so well? They're all the same age. (Barry Levinson)

Zsa Zsa Gabor once told me that she and Conrad Hilton, her millionaire ex-husband, had only one thing in common: his money. (David Niven)

I've got the income, and she's pattable. (Conrad Hilton)

Compensations

Don't be angry. I kill lots of other people too. (Clint Eastwood to a woman who accused him of killing so many Mexicans in his films)

We never stopped arguing, but he was good in the feathers. (Ava Gardner on her marriage to Frank Sinatra)

If you lose weight to keep your ass, your face goes. But if the face is good, the ass isn't. I'll choose the face. (Kathleen Turner)

I don't mind bad reviews. I usually just cry my way to the bank. (Liberace)

Competitiveness

It's hard to upstage vomit. (Jon Voight on Dustin Hoffman after he threw up during a scene in *Midnight Cowboy*)

Our marriage works because we both carry clubs of equal size. (Paul Newman on his relationship to Joanne Woodward)

One of my co-stars went on to be a nun. I didn't date her, I didn't want to get in competition with God. (Elvis Presley on Dolores Hart)

Isn't God good to me? (Louis B. Mayer after hearing of the death of his rival Irving Thalberg)

Dustin Hoffman wants you to be good, but not as good as he is. (Meryl Streep)

Compromise
In any 50-50 deal I struck with him I knew he was going to get the hyphen as well. (Hal Wallis on Elvis Presley's manager Tom Parker)

Confusion
In *The Island of Dr. Moreau* it's difficult to figure out if Marlon Brando is playing the doctor or the island. (Milt Green)

Madonna and Sean Penn were the beauty and the beast. But which was which? (Joan Rivers)

I'm never sure if I dream in Hungarian or English. (Zsa Zsa Gabor)

Consistency
You could always depend on Errol Flynn: he always let you down. (David Niven)

Contemporaries
My mother was in the same class as Alastair Sim, that extra-ordinary sinister-looking, sad-eyed actor with the voice of a fastidious ghoul, who starred in comedies like *The Bells of St. Trinians*, in which he played the headmistress. (Ronnie Corbett)

I wouldn't be caught dead with a woman old enough to be my wife. (Tony Curtis)

Contraception
I know what oral contraception is. I asked this girl to go to bed with me and she said no. (Woody Allen)

Women used to have a different kind of morning after pill when I was growing up. It was called 'Throwing Yourself down the stairs'. (Joan Rivers)

Contracts

The first thing I look for in a contract is days off. (Spencer Tracy)

It took longer to make one of Mary Astor's contracts than it did to make her pictures. (Sam Goldwyn)

A verbal contract isn't worth the paper it's written on. (Sam Goldwyn)

Robert De Niro has the Meryl Streep Clause in his contracts: He must receive 70% of all movie awards. (Charles Grodin)

Marilyn Monroe was smart for only ten minutes in her life. That was how long it took her to sign a contract for Twentieth Century Fox. (Anne Baxter)

Contrariness

My purpose in life does not include a hankering to charm society. (James Dean)

Not to upset people in my films would be an obscenity. (Roman Polanski)

I'm proud to say that I've now been offending three generations of cinemagoers. (John Waters in 2008)

Does the word 'nightmare' mean anything to you? (James Woods upon being asked for his view of Sean Young)

Conundrums

Can a vacuum love another vacuum? That's the question posed by *Falling in Love*. (Pauline Kael)

Does Wood float? Not when it's Natalie. (Albert Munnery)

I would characterize myself as someone who would not like to characterize myself. (Warren Beatty)

If Jesus was a Jew, how come he has a Mexican first name? (Billy Connolly)

Cooking

All the world's top chefs are men, so the question I want to ask is: 'How come most of them claim they can't cook?' (Diana Dors)

The only thing I can cook is eggs. (Angelina Jolie)

I've never been much for cooking. Toast is a stretch for me. (Johnny Depp)

My cooking isn't cordon bleu. It's cordon noir. (Phyllis Diller)

I miss my wife's cooking – as often as I can. (Henny Youngman)

Being married to a beautiful girl is expensive because you also have to employ a cook. (Sammy Davis Jr)

A perfectionist is a man who, if he was married to Marilyn Monroe, would expect her to cook. (Phil Silvers)

Every time I find a girl who can cook like my mother she looks like my father. (Tony Randall)

Co-Stars

Some of my best leading men have been horses and dogs. (Elizabeth Taylor)

I'd rather have a cannibal as a co-star. (Anthony Perkins on Joan Crawford)

Acting with Laurence Harvey is like acting by yourself – only worse. (Jane Fonda)

I would rather drink latex paint than be in a movie with Steven Seagal. (Henry Rollins)

The first time I saw George Burns onstage I could see that he had what it takes to become a big star: Gracie Allen. (Bob Hope)

I'm glad Deborah Kerr got to star opposite Burt Lancaster in *From Here to Eternity*. It's about time somebody got a chance to fuck her. (Joan Crawford)

I'd love to work with Barbara Streisand again. In something more appropriate.
Perhaps *Macbeth*. (Walter Matthau after *Funny Girl*).

I'd let my wife, children and animals starve before I'd subject myself to working with Bette Midler again. (Don Siegel)

Richard Harris once told me he would love to work with me. That surprised me as we'd started together in *Camelot*. (Robert Morley)

After working with Dustin Hoffman I made myself a promise never to make a film with anyone smaller than his Oscar. (Laurence Olivier)

Yes I have acted with Clint Eastwood. Or rather I have acted opposite Clint Eastwood. (Geraldine Page)

Filming with Barbra Streisand is an experience which may have cured me of making movies. (Kris Kristofferson)

Costume Epics
When I played Marie Antoinette I was glad to learn she was a party animal. It meant I didn't have to wear corsets all the time. (Kirsten Dunst)

I suppose I must don my breastplate once more to play opposite Miss Tits. (Richard Burton on acting with Elizabeth Taylor in *The Taming of the Shrew*)

Dinah Shore is the only person who ever left the Iron Curtain wearing it. (Oscar Levant)

Getting the costumes right in *Cleopatra* was a bit like polishing the fish knives on the Titanic. (Julian Barnes)

The highest point of drama in most costume epics is when someone says 'Pass the salt.' (Wesley Burrowes)

If the public don't see me in a pair of trousers soon they'll think I don't have any. (John Gielgud)

My main achievement in *Excalibur* was managing to rape King Arthur's mother wearing a full suit of armour. (Gabriel Byrne)

Couch Casting

Why would anyone want to cast a couch? (Gene Wilder)

You can only sleep your way to the middle. (Dawn Steel)

I was auditioning for a part once and I was told the guy was likely to tear my dress off. "Don't worry, I said, 'I'll wear an old dress.' (Shelley Winters)

Did you hear about the actress who landed a part by signing on the dotted couch? (Milton Berle)

Coughing

Hollywood is the only place in the world where you can wake up and hear the birds coughing in the trees. (Joe Frisco)

I don't like doing romantic scenes early in the morning. How can you say 'I love you' to somebody when you haven't stopped coughing yet? (Shirley MacLaine)

Acting is merely the art of keeping a large group of people from coughing. (Ralph Richardson)

If a character coughs for any length of time in a film, say five seconds or more, he's almost certain to be dead before it's over. (Stephen Boyd)

Countries

They love me in Japan, but unfortunately I don't want their love. I want their money. (Hugh Grant)

The Soviet Union is the only country in the world where the artist is held in such esteem that he is frequently put in prison to prevent him leaving. (Peter Ustinov)

Every country gets the circus it deserves. Spain gets bullfights. Italy gets the Catholic Church. America gets Hollywood. (Erica Jong)

Couples

The bland leading the blonde. (Hedda Hopper on Burt Reynolds and Loni Anderson)

When I got married, my mother-in-law said the bride and I made a lovely couple - apart from me. (George Burns)

Courtship

I still chase women – but only when they're running downhill. (Bob Hope at 70)

Trying to get a girl into bed is always hilarious. They invariably say, 'But I hardly know you.' To which my standard reply is, 'Believe me, when you get to know me better, you won't like me at all. I'm at my peak now. I suggest we do it before things go downhill. (Michael Winner)

A girl can wait for the right man to come along but in the meantime that doesn't mean she can't have a wonderful time with all the wrong ones. (Cher)

During *Notting Hill* I asked Julia Roberts to go out with me. I figured if she married Lyle Lovett, we all had a chance. (Rhys Ifans)

To succeed with a woman, tell her you're impotent. She won't be able to wait to disprove it. (Cary Grant)

If he says 'Your place or mine?' say, 'You go to your place and I'll go to mine'. (Phyllis Diller)

Crime

Crime pays. The hours are good and you also get to travel a lot. (Woody Allen)

Credibility

Brief Encounter strained credibility to the extreme. The notion that a marriage could withstand such temptation! And, more importantly, that the trains would run on time. (Desmond Bond)

Credits

In the old movies the credits came down so fast you felt the director of the film was running for a train. In the new movies we already have the

plot of a three-act play before you know who's in the cast. (William Wyler)

By the time the final credits rolled, the lack of suspense was killing me. (Padraic McKiernan on *Snitch)*

Critics

Critics search for ages for the wrong word which, to give them credit, they eventually find. (Peter Ustinov)

I love criticism as long as it's unqualified praise. (Noel Coward)

If Attila the Hun were alive today he'd be a drama critic. (Edward Albee)
I, along with the critics, have never taken myself seriously. (Liz Taylor)

Don't pay any attention to critics. Don't even ignore them. (Sam Goldwyn)

Some critics are about as attractive as a year-old peach in a single girl's refrigerator.
(Mel Brooks)

Listening to the critics is like letting Muhammad Ali decide which astronaut goes to the moon. (Robert Duvall)

Milton Shulman would hang-glide to the Orkneys to give a writer a bad review. (Mike Leigh)

Criticising *Jurassic Park* is like criticizing a rollercoaster for not being Proust. (James Cameron)

How many film critics does it take to change a light bulb? Two. One to change the bulb and the other to say, 'It's not as good as the last one.' (John Malkovich)

The Crucifixion

Charlton Heston throws all his punches in the first ten minutes of *Ben-Hur* so he has nothing left long before he stumbles to the end four hours later and has to react to the Crucifixion. He does make it clear, however, that he disapproves of it. (Dwight MacDonald)

Crutches

Reality is just a crutch for people who can't cope with drugs. (Lily Tomlin)

Three things have helped me successfully through the ordeals of life: an understanding husband, a good analyst…and millions and millions of dollars. (Mary Tyler Moore)

Crying

When I cry, do you want the tears to run all the way or shall I stop them half way down my face? (Margaret O'Brien to a director)

He cried at all his weddings – with reason. (Lauren Bacall on Humphrey Bogart)

Men do cry, but only when assembling furniture. (Rita Rudner)

Cures

I have a perfect cure for a sore throat – cut it. (Alfred Hitchcock)

Dancing

When you've danced with Cyd Charisse you stay danced with. (Fred Astaire)

I could dance with you till the cows come home. On second thoughts I'd rather dance with the cows and wait till you came home. (Groucho Marx)

Clara Bow danced even when her feet weren't moving. (Adolph Zukor)

Ginger Rogers did everything that Fred Astaire did. She just did it backwards and in high heels. (Linda Ellerbee)

Dating

I know nothing about dating. When I started out I was always trying to avoid saying things like, 'You don't sweat much for a fat girl.' (Billy Connolly)

Every man I ever dated in Hollywood turned out to be gay. (Debbie Reynolds)

Boy, am I exhausted. I went on a double date last night and the other girl didn't show up. (Mae West)

Always carry a book on a date so that when you get bored you can slip into the Ladies for a read. (Sharon Stone)

Dating Warren Beatty without having sex with him is like going to Rome and not seeing the Pope. (Sonia Braga)

I date older men now. I used to demand good looks. Now all I ask for is a healthy prostate. (Joan Rivers)

I have no problem dating women my age. I just can't find any. (George Burns)

Last night Pamela Anderson released a statement confirming that she's had her breast implants removed. Doctors say she's doing fine – and that the old implants are now dating Charlie Sheen. (Conan O'Brien)

Death
For Catholics, death is a promotion. (Woody Allen)

Howard Hughes was the only man I ever knew who had to die to prove he'd been alive. (Walter Kane)

How can he do this to me after all my work building him up into a big star? (Jack Warner upon hearing of James Dean's death)

I'm not afraid of dying. I just don't want to be there when it happens. (Woody Allen)

How can they tell? (Mary Wickes after hearing Bing Crosby had died)

Either this man is dead or my watch has stopped. (Groucho Marx)

They once announced on US television that I was dead. When they rang to tell my daughter, she said I couldn't be, that she was speaking to me just twelve minutes ago in Australia. They said, 'No, he's dead all right. It was just the time difference.' (Patrick McNee)

Debuts

I'm working hard on two pictures with my new protégé: her first and her last. (Henry Koster)

My debut role was in *Annie Hall*. Unless you know my raincoat, you'll miss me. (Sigourney Weaver)

Decline

There's gotta be something wrong with Hollywood when the greatest actor in the history of the cinema is running around the pace with white hair and a Krypton suit. (James Woods on Marlon Brando in *Superman*)

I started at the top and worked my way down. (Orson Welles)

When I first hit Hollywood I really made a big splash, but in the early 1980s the phone was silent. It was as if I died and someone forgot to tell me about it. (Tony Curtis)

Things got so bad for me in the fifties that I had to make a movie with Tony Curtis. (Angela Lansbury)

Definitions

An actor's a guy who, if you ain't talkin' about him, he ain't listenin'. (Marlon Brando)

An actress is someone with no ability who sits around waiting to go on alimony. (Jackie Stallone)

Making films is like pulling hairs out of your nostrils repeatedly. (Walter Matthau)

Hollywood is like being nowhere and talking to nobody about nothing. (Michaelangelo Antonioni)

Acting is like trying to stand up in a canoe with your pants down. (Cliff Robertson)

An associate producer is the only kind of person who will associate with a producer. (Fred Allen)

A cult means not enough people to make a minority. (Robert Altman)

An epic is any movie with Charlton Heston in it. (James Agate)

A starlet is any girl under thirty in Hollywood who is not regularly employed in a brothel. (Ben Hecht)

A team effort is a lot of people doing what I say. (Michael Winner)

A celebrity is any well-known TV or movie star who looks like he spends more than two hours working with his hair. (Steve Martin)

Depression

Depression is the feeling you get when you go for a mammogram and you know in your heart that it's the last time a man will ever ask you to take your clothes off. (Brigitte Bardot)

I was once thrown out of a mental hospital because I depressed the other patients. (Oscar Levant)

I'm a depressive with a sense of humour. (Al Pacino)

Determination

I'll give Hollywood 35 years and not a minute more. If nothing happens by then I'll try some other racket. (Marshall Thompson)

Julie Andrews has that wonderful British strength that makes you wonder why they lost India. (Moss Hart)

Dialogue

There was some evidence Jennifer Lopez could act in the early days, but then they started giving her lines and ruined it all. (Brendan O'Connor)

Most of Dean Martin's throwaway lines in *The Silencers* should have been thrown away before the film went into production. (*Films and Filming*)

When Ingrid Bergman walks on screen and says 'Hello', people ask 'Who wrote that wonderful line of dialogue?' (Leo McCarey)

Diamonds

My diamonds once belonged to a millionaire – Mr. Woolworth. (Phyllis Diller)

Goodness had nothing to do with it, dearie. (Mae West to a woman who said to her, 'Goodness, what beautiful diamonds.')

Diaries

I always say, keep a diary and one day it will keep you. (Mae West)

It's the good girls that keep the diaries. The bad ones don't have the time. (Tallulah Bankhead)

In Hollywood when people die they don't say 'Did he leave a will?' but 'Did he leave a diary?' (Liza Minnelli)

Diets

I went on a diet, swore off drinking and heavy eating and in fourteen days I lost two weeks. (Joe E. Lewis)

I'm on the mirror diet. You eat all your food in front of a mirror in the nude. It works pretty good, though some of the fancier restaurants don't go for it. (Roseanne Barr)

The verb 'To diet' can only be conjugated in the future tense. (Charles Laughton)

I'm an expert on losing weight. I represent the survival of the fattest. (Alfred Hitchcock)

The second day of a diet is always easier than the first because by then you're off it. (Jackie Gleason)

My advice if you insist on slimming: Eat as much as you want. Just don't swallow it. (Harry Secombe)

Faith can move mountains. However, she's promised me she's going on a diet next week. (Sid Caesar)

I diet between meals. (Sidney Greenstreet)

Avoid any diet that discourages the use of hot fudge. (Rosie O'Donnell)

Dieting make you fat. (Victor Buono)

Difficulty

You can't direct a Charles Laughton picture. All you can hope for is to referee. (Alfred Hitchcock)

Anyone who ever worked on a picture for the Marx brothers said he would rather be chained to a galley oar and lashed at ten minute intervals. (S.J. Perelman)

Six months of Monty Clift was like a crash course in how to be a male nurse bodyguard and fellow sanatorium inmate. (Screenwriter Robert Thom)

I'm one of those people who imagined I could direct Frank Sinatra. It's a bit like being one of the girls who thought they'd get Howard Hughes to marry them. (Robert Aldrich)

I have never, with the possible exception of Claudette Colbert, worked with such a stupid bitch. (Noel Coward on Lilli Palmer)

I would only work with Joan Crawford again if I had a lobotomy first. (Director Robert Aldrich after completing *What Ever Happened to Baby Jane?*)

Dignity

I have all the dignity of a nude at high noon on Fifth Avenue. (Orson Welles)

Directions

Move those ten thousand horses a trifle to the right. (D.W. Griffith)

Please stand a little closer apart. (Michael Curtiz)

Bring me on the empty horses. (Michael Curtiz)

Well tell her to *un*faint. (Roman Polanski after being informed that an actress he intended to use for a scene had fainted).

Directors

Directors are people who are too short to be actors. (Josh Greenfeld)

I only direct in self-defence. (Mel Brooks)

A director must be a politician, a psychoanalyst, a sycophant and a bastard. (Billy Wilder)

Woody Allen is a great director. Just don't have babies by him. (Mia Farrow)

Michael Winner is a self-confessed cross between a holiday camp host and Hitler. (Matthew Norman)

If you asked William Wyler what time it was, he'd be stuck for an answer. And that was the way he directed too. My salvation was to establish a relationship with him that basically amounted to extrasensory perception. (Shirley MacLaine)

If you're an actor for any length of time at all you'll either become a director or a drunk. (Gene Hackman)

Disagreement

If you don't disagree with me, how will I know I'm right? (Sam Goldwyn)

Gary Merrill and I separated my mutual disagreement. (Bette Davis)

Never argue with your wife. It's just your word against hundreds of hers. (Jack Benny)

Diseases

I've got Parkinson's disease. I can shake a Margarita in five seconds. (Michael J. Fox)

When the doctor told me he thought I might have Alzheimer's disease coming on, I said, 'What's that?' (Milton Berle)

Corals are offering 10-1 that Sylvester Stallone, aka Rocky Balboa, wins his next big fight. Against Al Zheimers. (Derek McGovern)

Old age is the only disease you don't look forward to being cured of. (Orson Welles)

Ali MacGraw Disease' is the term one uses to refer to a movie illness where the sufferer grows even more beautiful as death approaches. (Roger Ebert on MacGraw in *Love Story*)

By the end of *Love Story*, Ali McGraw looked even better than Ryan O'Neal! (Michael Harkness)

Divorce

Divorce comes from the Latin word 'divorceum', which means 'having your genitals torn out through your wallet'. (Robin Williams)

My wife got the house, the car and the bank balance. And if I marry again and have children, she gets them too. (Woody Allen)

There's a group in Hollywood called Divorce Anonymous. It works like this. If a member feels the urge to get a divorce, they send over an accountant to talk him out of it. (Sean Connery)

It was an ideal divorce: she got the children and he got the maid. (Joan Rivers)

Why did I divorce? Because my husband was an asshole. Any more questions? (Roseanne)

The two most important causes of divorce? Men and women. (Sid Caesar)

Marriage is grand. Divorce is twenty grand. (Jackie Mason)

Dahling, this time I married a lawyer so he could handle the divorce. (Zsa Zsa Gabor)

Did you hear about the Divorce Barbie doll? It comes with all of Ken's stuff. (Sid Caesar)

Getting divorced because you don't love somebody is as silly as getting married because you do. (Zsa Zsa Gabor)

Every divorce ends with a fight over who gets the side table. (Claire Bloom)

Documentaries

I thought *Dead Man Walking* was a documentary about Keith Richards. (Oprah Winfrey)

Tess is adequate only as a documentary about 19th century dairy farming. (*Time*)

Dogs

If your home burns down, rescue the dogs. At least they'll be faithful to you. (Lee Marvin)

Any man who hates little children and small dogs can't be all bad. (W.C. Fields)

I taught my dog to beg. Last week he came home with twelve dollars and fifty cents. (Bob Hope)

The current outbreak of rabies in Hollywood is due to Hedda Hopper going around the place biting dogs. (Edith Sitwell)

I've got a miniature poodle. The minute you're about to turn, it does a poodle. (Jackie Gleason)

I was the youngest of five boys. With so many brothers, my father bought us a dachshund so we could all pet him at the same time. (Bob Hope)

I'll never forget my youth. I was a teacher's pet. She couldn't afford a dog. (Rodney Dangerfield)

My husband has the face of a saint. A St. Bernard. (Roseanne Barr)

Double Standards

If Robert DeNiro gains weight for a role it's called 'artistic dedication'. If I do it's called 'letting yourself go'. (Brenda Fricker)

Some communist – she travels by Rolls Royce. (Robert Duvall on Vanessa Redgrave)

A man can sleep around and there are no questions asked, but if a woman makes 19 or 20 mistakes – she's a tramp. (Joan Rivers)

The Draft

I was classified P4 by the draft board. In the event of war, I'm a hostage. (Woody Allen)

Draft beer, not people. (Peter Fonda)

Drag Artists

When Whoopi Goldberg wears a dress it's like drag. (Mildred Natwick)

If I was born a man I'd have been a drag queen. (Dolly Parton)

If Peter O'Toole was any prettier in *Lawrence of Arabia* it would have to have been called *Florence of Arabia*. (Noel Coward)

Dresses

Marilyn Monroe wore dresses cut so low, it looked as though she' d jumped into them and caught her feet on the shoulder straps. (Jack Paar)

If that's a mink dress you're wearing, there are a lot of foxes living under assumed names. (Groucho Marx)

Diana Dors only got to the top because her dresses didn't. (Zero Mostel)

Elizabeth Taylor has grown so ample, it has become necessary to dress her almost exclusively in a variety of ambulatory tents. (John Simon)

Raquel Welch tottered by, clad in a brown jersey dress that appeared to be on the inside of her skin. (Maureen Lipman)

You can say what you like about long dresses but they cover a multitude of shins. (Mae West)

Not only can I not fit into my dresses, I can't fit into store changing rooms. (Roseanne Barr)

I went into a dress shop and asked this broad, 'Have you got anything to make me look thinner?' She said, 'How about a month in Bangladesh?' (Roseanne Barr)

Drinking

I spent an awful lot of time in college drinking beer. When I graduated I was called 'Magnum cum Lager'. (Paul Newman)

I've known banks that gave loans to guys who wanted to open bars. Their only collateral was that I was going to drink there. (Lou Grant)

How can I tell when I've had enough to drink? Easy. When my knees start to bend backwards. (W.C, Fields)

Some years ago a couple of friends of mine stopped drinking suddenly and died in agony. I swore then that such a thing should never happen to me. (John Barrymore)

I try not to drink too much because when I drink, I bite. (Bette Midler)

I always keep a supply of whisky handy in case I see a snake – which I also keep handy. (W.C. Fields)

I never drink unless I'm alone or with somebody. (Dean Martin)

When I don't feel well I drink and when I drink I don't feel well. (W.C. Fields)

If you drink whisky straight down you can feel it going into every individual intestine. (Richard Burton)

I don't like drink. It makes me feel good. (Oscar Levant)

Drugs

Kate Moss recently warned Lindsay Lohan about the danger of drugs. Her exact words were, 'Stay away from my drugs.' (Conan O'Brien)

I tried to give up drugs by drinking. (Dennis Hopper)

Drunk Driving

If you drink, don't drive. Don't even putt. (Dean Martin)

If you drink like a fish, don't drive. Swim. (Joe E. Lewis)

Drunkenness

You're not drunk if you can like on the floor without holding on. (Joe E. Lewis)

Errol Flynn claimed it only took one drink to make him drunk but he couldn't remember if it was the 18th or 19th. (Ernest Forbes)

When I played drunks on screen I had to stay sober because I didn't know how to play them when I was drunk. (Richard Burton)

My father was the town drunk. Usually that's not so bad, but ... New York? (Henny Youngman)

Anyone who can't get drunk by midnight ain't trying. (Dean Martin)

I got Mark Hollinger so drunk last night it took three bellboys to put me to bed. (W.C. Fields)

I was so drunk last night I fell down and missed the floor. (Dean Martin)

Dumbbells

After Arnold Schwarzenegger, Dolph Lundgren is a bit of a disappointment. At least Arnold looks as if he comes with batteries. (Adam Mars-Jones)

Sylvester Stallone is to acting what Liberace was to pumping iron. (Rex Reed)

Rock Hudson is the only man I know who can answer 'Yes' and 'No' to questions like 'How many films have you made?' (Jean Rook)

Earthquakes

There's' nothing the matter with Hollywood that a good earthquake wouldn't cure. (Moss Hart)

The great earthquake of 1906 destroyed my marriage certificate. Which proves that earthquakes aren't that bad. (W.C. Fields)

Most earthquakes are caused by sudden movement of Roseanne Barr. (Joan Rivers)

They say animal behavior can warn you when an earthquake is coming. Like the night before that last one when our family dog took the car keys and drove us all the way to Arizona. (Bob Hope)

Eating

I saw him eat spaghetti in a restaurant once and he couldn't even do that right. (Ernest Borgnine on Steven Seagal)

Bo Derek is the worst actress in the world. She couldn't even eat a banana on-screen in *Tarzan*. It was like she had no teeth. (Andy Warhol)

Darryl F.Zanuck is the only man in Hollywood who can eat an apple through a tennis racquet. (David Norris)

I ate so seldom as a child, when any of my family burped we said 'Congratulations' instead of 'Pardon me'. (Bob Hope)

The best way to prevent sagging as you grow older is to keep eating till the wrinkles fill out. (John Candy)

Ann Southern has lost her sense of self-discipline. She no longer believes in eating on an empty stomach. (Bette Davis)

Eccentrics

There are 127 varieties of nuts, and Mia Farrow is 116 of them. (Roman Polanski)

Hemingway always rather disconcerted me by eating the glass after he'd had his drink. (Cary Grant)

My father's a proctologist and my mother's an abstract artist. That's how I view the world. (Sandra Bernhard)

I'm the type of guy who goes to the store for a loaf of bread and comes back with a quart of milk. So I act. (Robert Mitchum)

I can count to ten, but not in that order. (Francis Ford Coppola)

Marlene Dietrich searched for sick people. When you were well she abandoned you. That's why I called her 'Mother Teresa with better legs.' (Billy Wilder)

Frank Sinatra is the most hygienic man I know. He never stops showering. It wouldn't surprise me if he washed the damn soap. (Ava Gardner)

Editing

Cut the intermission. That way, during the break, the audience won't get the chance to discuss the fact that there's no plot. (Paddy Chayefsky to Bob Fosse on the set of *Cabaret*)

A gorilla in boxing gloves wielding a pair of garden shears could have done a better job of editing *The Boyfriend*. (Ken Russell)

I handed in a script last year and the studio didn't change one word of it. The word they didn't change was on page 87. (Steve Martin)

If Robert Redford gets interested in your script, delete any scenes where he might be laughing. (Joe Eszterhas)

Egotists

After my first night with Orson [Welles] I looked at his head on the pillow and knew he was waiting for the applause. (Rita Hayworth)

Egotism is usually a case of mistaken nonentity. (Barbara Stanwyck)

One day I decided to become a genius. (Darryl F. Zanuck)

He displayed an ego of such dimensions as to make the Acropolis look like a village tavern. (Claire Bloom on Anthony Quinn)

Elbows

The only parts of my original body left are the elbows. (Phyllis Diller on her experience with plastic surgery)

Elephants

Elephants drink because it helps them forget. (Milton Berle)

I have such a good memory I even remind elephants. (Bill Cosby)

One day when I was in the jungle I shot an elephant in my pyjamas. What he was doing in my pyjamas I'll never know. (Groucho Marx)

Louis B. Mayer has the memory of an elephant and the hide of an elephant. The only difference is that elephants are vegetarians and Mayer's diet is his fellow man. (Herman Mankiewicz)

Emails

Contrary to popular belief, it's not against the law not to have an email account. (Christopher Walken)

The email of the species is deadlier than the mail. (Stephen Fry)

I was once asked if I could use email. The question was a non-starter. I cannot even use a bicycle pump. (Judi Dench)

Emigration

I left England when I was four because I found out I could never be King. (Bob Hope)

My father always felt perfectly at home abroad because he never attempted to make friends with the natives. (Robert Morley)

Endings

Every film should have a beginning, middle and an end – though not necessarily in that order. (Jean-Luc Godard)

I can't tell you the ending of the movie. I thought of it after 5. (Screenwriter Norman Krasna to Jack Warner after Warner forbade his writers to work after that time).

Critics get hate mail when they reveal too much about the endings of thrillers. Here is the ending of all thrillers: the bad guy gets killed. (Rich Elias)

Enemies

Any film with Errol Flynn as the best actor in it is its own worst enemy. (Ernest Hemingway on *The Sun Also Rises*)

It's said in Hollywood that you should always forgive your enemies because you never know when you'll have to work with them. (Lana Turner)

England and the English

England: The only country in the world where the food is more dangerous than the sex. (Jackie Mason)

The place was so English I wouldn't be surprised if the mice wore monocles. (Bob Hope)

All Englishmen talk as if they've got a bushel of plums stuck in their throats. After swallowing them get constipated from the pits. (W.C. Fields)

If you commit a crime in England, the police don't have guns so they just shout 'Stop! And if you don't I'll shout 'Stop!' again.' (Robin Williams)

England's main contribution to world cuisine was the chip. (John Cleese)

Epics

Cecil B deMille / Much against his will/ Was persuaded to leave Moses/Out of the Wars of the Roses. (Nicholas Bentley)

Because *The Bible* was directed by an Irish-American and also starred two Irishmen, Richard Harris and himself, Peter O'Toole thought it ought to be called *Sodom and Begorrah* or *The Gospel According to Mick*. (Nicholas Wapshott)

Epitaphs

I've often thought my tombstone should read, 'Here lies Paul Newman, who died a failure because his eyes turned from blue to brown.' (Paul Newman)

Ethnicity

I don't like Mexican pictures. All the actors in them look too goddam Mexican. (Jack Warner)

In every movie made with Italian-American characters, it is absolutely essential that one of them be named Vinny. (Donald Munsch)

Examinations

I was once expelled from a philosophy exam for trying to look into the mind of the pupil sitting across from me. (Woody Allen)

Excuses

I have a previous engagement which I shall make as soon as possible. (John Barrymore turning down a producer's lunch invitation)

I wasn't kissing her, I was whispering in her mouth. (Chico Marx to a girlfriend who saw him becoming intimate with someone else).

Executives

What's the last thing a movie executive says to his secretary before he leaves the office for lunch? 'If my boss calls, get his name'. (Nicholas Kent)

I know someone who wrote a World War II movie set in Germany. The studio executives said, "Could you make the Nazis nicer?" (Patricia Marx)

I wouldn't walk across the street to pull a Hollywood executive out of the snow if he was bleeding to death unless I was paid for it. (James Woods)

Exercise

Jane Fonda didn't get that terrific body from exercise. She got it from lifting all her money. (Joan Rivers)

I get a lot of exercise. Last week I was out seven nights running. (Jackie Gleason)

I get all my exercise on the golf course. Whenever I see my friends collapse, I run for the paramedics. (Red Skelton)

The best exercise I get these days is rolling my oxygen tank around like a beach ball when I get out of bed. (Marlon Brando)

If God wanted me to touch my toes, he would have put them on my knees. (Roseanne Barr)

Mickey Rooney's favourite exercise is climbing tall people. (Phyllis Diller)

Louise Brooks' favourite form of exercise was walking off movie sets. (Bette Davis)

Exhaustion

I eat all the time. Last week I had two teeth pulled. They weren't decayed – just exhausted. (Milton Berle)

Explosions

I saw the film *Pearl Harbour* and it made me wish the Japanese had bombed Hollywood instead. (Clive James)

Several tons of dynamite are set off in *Tycoon* – none of it under the right people. (James Agee)

Expressions

Marion Davies had two expressions: joy and indigestion. (Dorothy Parker)

In any posture, Lana Turner suggests she is looking up from a pillow. (*Time* Magazine)

Steve McQueen's face had that look people get when they ride in elevators. (Anatole Broyard)

Hugh Grant has two expressions: Confused, and trying to crack a joke. (Robert Downey Jr)

Extremes

Elvis Presley started his career looking like Stan Laurel and ended it like Oliver Hardy. (Ben Sennett)

All my movies were great. Some of them were bad, but all of them were great. (Lew Grade)

Chico's philosophy of life was, 'Better to have lost and lost than never to have lost at all.' (Groucho Marx)

Eyebrows

Jennifer Connelly does most of her acting with her eyebrows. (John Kelly)

Joan Crawford's eyebrows looked like African caterpillars. (Bette Davis)

The Russians love Brooke Shields because her eyebrows remind them of Brezhnev. (Robin Williams)

Eyes

When Sammy Davis kissed a woman, do you think he closed his bad eye? George Carlin)

I love eye make-up because without it I look like a turtle. (Phyllis Diller)

Eyesight

I said, 'Doctor, every morning when I get up and look in the mirror I feel like throwing up. What's wrong with me?' He said, 'I don't know, but your eyesight's perfect.' (Rodney Dangerfield)

Who picks your clothes – Stevie Wonder? (Don Rickles to a sartorially-challenged colleague)

Facelifts

Phyllis Diller's has so many facelifts, there's nothing left in her shoes. (Bob Hope)

I've had so many facelifts, the next one is going to be a Caesarean. (Phyllis Diller)

Faces

Rowan Atkinson has a face like a gerbil with lockjaw. (Terry Wogan)

Basil Rathbone's face was like two profiles pasted together. (Dorothy Parker)

George Sanders had a face which looked as though he'd rented it on a long lease and lived in it so long he didn't want to move out. (David Niven)

My face is like a rock quarry someone dynamited. (Charles Bronson)

My face is like a cross between two pounds of halibut and an explosion in a clothes factory. (David Niven)

Bette Davis' face is her best chaperone. (Joan Crawford

Failure

Nobody is allowed to fail within a two-mile radius of Beverly Hills Hotel. (Gore Vidal)

I must congratulate you on being unspoiled by failure. (Henny Youngman)

I always knew that if all else failed I could become an actor. And all else failed. (David Niven)

Failure is the only thing I've ever been a success at. (Bob Hope)

Fallen Women
My only problem is trying to find a way to play my fortieth fallen female in a different way from my thirty-ninth. (Barbara Stanwyck)

Fallen women don't get picked up. (Dorothy Malone)

Falling in Love
Warren Beatty has an interesting psychology. He has always fallen in love with girls who have just won, or been nominated for, an Academy Award. (Leslie Caron)

I fell in love with her smile but unfortunately I married the rest of her too. (W.C Fields)

Many a man has fallen in love with a girl in a light so dim he wouldn't have chosen a suit by it. (Maurice Chevalier)

Fame
Mate, I was a monster ten years ago. (Russell Crowe after an interviewer asked him if fame might turn him into a monster)

Fame is like being pecked to death by a thousand pigeons. (Bob Hoskins)

Fame is fickle. One minute you're hot, the next you're making movies in Mexico about giant cockroaches taking over the planet and telling people in some dingy bar that you used to be somebody once. (Colin Farrell)

Fame is being asked to sign your autograph on the back of a cigarette packet. (Billy Connolly)

In the future everyone will be famous for ten minutes. (Andy Warhol)

Or in Ashton Kutcher's case, ten. (Bill Maher)

Families

My dog's just like one of the family. I won't say which one. (Bob Hope)

There were so many in my family, I was eight years old before it was my turn in the bathroom. (Bob Hope)

Famous Last Words

I never should have switched from scotch to martinis. (Humphrey Bogart)

Dying isn't hard. Comedy is hard. (Edmund Gwenn)

Dear World, I am leaving you because I am bored. I am leaving you with all your worries in this sweet little cesspool. (George Sanders in a suicide note)

Codeine! Bourbon! (Tallulah Bankhead)

Fans

Congratulations. I didn't know you were married. (Charles Boyer to a debutante actor who claimed his last movie had doubled his number of fans)

There's a good part to celebrity: I can get a table in a restaurant. The bad part is when fans start videotaping me while I'm eating. (Steve Martin)

A fan club is a group of people who tell an actor he's not alone in the way he feels about himself. (Jack Carson)

Favourties

My favourite book, movie and food is *Fried Green Tomatoes*. (Jane Radcliffe)

My favourite hobby is food. (John Candy)

Cedric Hardwicke is my fifth favourite actor. The first four are the Marx Brothers. (George Bernard Shaw)

Feelgood Films
It's Oscar weekend. Among Best Picture nominees is *Letters from Iwo Jima*, which is a gut-wrenching tragedy about an army sent to die in a hopeless cause by a fanatical government. Or, as George Bush calls it, 'The feelgood comedy of the year'. (Bill Maher)

I find uplifting films depressing and depressing films uplifting. For every unlikely cunt that escapes a housing estate by becoming a ballerina, there's half a million other flat-footed fuckers who have to lump it and take a job in Greggs serving pies. (Ian Pattison)

Feet
Mae West is a large, soft, flabby and billowing super blonde who talks through her nostrils and whose laborious ambulations suggest she has sore feet. (Percy Hammond)

I see Tom Cruise is shortly to become a father so we'll soon hear the pitter-patter of tiny feet…as Tom rushes down to the shop to get nappies. (Jonathan Ross)

She's such a lousy actress they even have to dub her footsteps. (Kenneth Tynan)

Boiled down to essentials, Greta Garbo is just a plain mortal with large feet. (Herbert Krezner)

Fighting
Errol Flynn was always either fighting or fucking. (Jack Warner)

Never pick a fight with an ugly person. They've got nothing to lose. (Robin Williams)

I got tired of singing to guys I beat up. (Elvis Presley on why he quit movies)

I've read that Dirk Bogarde's cruel streak could be attributed to his fight for acceptance as an actor and a homosexual. And all the time I thought it was just because he was quite an unpleasant fellow. (Michael Hordern)

Figures

Diana Rigg is built like a brick mausoleum with insufficient flying buttresses. (John Simon)

She wore a short skirt and a tight sweater. Her figure described a set of parabolas that could cause arrest in a yak. (Woody Allen)

Everything you see I owe to spaghetti. (Sophia Loren)

It's easy for a girl to stay on the straight and narrow if she's built that way. (Milton Berle)

Mae West had an hour glass figure and a 3-minute attention span. (Cary Grant)

She had no stove in her belly. (Sidney Lumet on Grace Kelly)

A curved line is the loveliest distance between two points. (Mae West)

Too many cooks spoil the figure. (Gillian Anderson)

How do I stay in shape? I eat cotton wool and sleep with everyone on the planet. (Kate Beckinsale)

Film-Making

Film-making belongs, like all show business, to that magical world in which two and two can make five but also three. (John Grierson)

To me, making a movie means I have to get up at five in the morning and drive down the freeway, after which I arrive at a studio and someone splatters powder on my face. (Shirley MacLaine)

Film-making means inventing impossible problems for yourself and then failing to solve them. (John Boorman)

In order to make a motion picture you must have money. And in order to have money, you've got to woo people. And in order to woo people, you've got to bullshit 'em. (Sam Fuller)

The trouble with the movie business is the dearth of bad pictures. (Sam Goldwyn)

Flat Chestedness

Aurdrey Hepburn is so flat-chested she could iron her top while she was still wearing it. (Truman Capote)

When we started shooting *Roman Holiday*, Willie Wyler came up to me and said, 'If you don't mind me saying so, I think you should be wearing falsies.' I said, 'I am!' (Audrey Hepburn)

My bra died of starvation. (Phyllis Diller)

Flops

I'll spend the rest of my life disowning *1941*. (Steven Spielberg)

I once did a picture that was so bad they had to re-cut it before they put it back on the shelf. (Ed Wood)

Let's not improve this into a flop. (Sam Goldwyn)

The six people who saw what Orson Welles did to Rita Hayworth in *The Lady From Shanghai* wanted to kill him, but they had to get behind me in line. (Harry Cohn)

I haven't had a hit movie since Joan Collins was a virgin. (Burt Reynolds)

I once made a movie called *Quick, Before It Melts*. You had to catch it quick before it disappeared. (George Maharis)

Flowers

The two most important things in a relationship are red roses and white lies. (Sophia Loren)

Red roses mean love. An orchid means he's after something. (Zsa Zsa Gabor)

Focus

If it's in focus its pornography. If it isn't, it's art. (Linda Hunt)

The New Wave will probably discover the slow dissolve in about ten years. (Billy Wilder)

Food

I'm at the age where food has taken the place of sex in my life. In fact I've just had a mirror put over my kitchen table. (Rodney Dangerfield)

I never go to restaurants with elaborate menus. They always give you less food. (Jackie Gleason)

Liz Taylor likes food so much she takes mayonnaise on her aspirins. (Joan Rivers)

I stay away from natural foods. At my age I need all the preservatives I can get. (George Burns)

The first time I tried organic wheat bread I thought I was chewing on roofing material. (Robin Williams)

The cardiologist's diet goes like this: If it tastes good, spit it out. (John Goodman)

The food in that restaurant is just terrible. And such small portions. (Woody Allen)

Jack Benny lived on a diet of fingernails and coffee. (May Livingstone)

Forgiveness

Jack Warner never bore a grudge against anyone he wronged. (Simone Signoret)

The one thing I couldn't forgive my girlfriend for is if she found me in bed with another woman. (Steve Martin)

Once a woman has forgiven her man, she must not re-heat his sins for breakfast. (Marlene Dietrich)

When I'm 60 Hollywood will forgive me. I don't know what for, but they'll forgive me. (Steven Spielberg)

Fridges

When I open a refrigerator door nothing is safe, not even the pipes. (Marlon Brando)

Am I vain? When I open the fridge door and the light comes on, I do twenty minutes. (Jerry Lewis)

Taking the lock off my freezer is the only exercise I get these days. (Marlon Brando at 72)

During the hot weather I keep my undies in the icebox. (Marilyn Monroe)

Friends

Liz Taylor is so fat, she's my two best friends. (Joan Rivers)

I look on my friendship with Madonna as being like having a gallstone. You have pain and then you pass it. (Sandra Bernhard)

If I have a friend in the world it's my Great Dane bitch Zsa-Zsa. We've been absolutely inseparable for years. The only reason she didn't come with me when I went to New York recently was that she didn't have the bus fare. (Groucho Marx)

The best time to make friends is before you need them. (Ethel Barrymore)

It's the friends you can call at 4 a.m. that matter. (Marlene Dietrich)

I'm still friends with all my exes, apart from my husbands. (Cher)

Friends aren't necessarily the people you like best. They're merely the ones who got there first. (Peter Ustinov)

When you're in trouble something always turns up – and it's usually the noses of your friends. (Orson Welles)

Hollywood is a place where your best friend will plunge a knife in your back and then call the police to tell them you're carrying a concealed weapon. (George Frazier)

Fun

While a girl is waiting for the right man to come along, she can have some pretty good fun with the wrong one. (Cher)

Most of the time I don't have much fun. The rest of the time I don't have any fun at all. (Woody Allen)

Just give me a comfortable couch, a dog, a good book and a woman. Then if you can get the dog to go somewhere and read the book, I might have a little fun. (Groucho Marx)

Party fun in formal Hollywood would reach a high point when the butler brought in a rubber hot dog and everyone gathered around to watch the patsy trying to eat it. (Phil Silvers)

Funerals

Harry Cohn's funeral proved what they always say: Give the public what they want and they'll come out for it. (Red Skelton)

Funerals are the cocktail parties of the elderly. (Rupert Everett)

Genres

I'm so pleased with all this fuss over *film noir*. What a wonderful accident that someone put a name to all this stuff. We just thought the pictures were cheap. We thought the moody lighting was because we couldn't afford electricity. (Marie Windsor)

Satire is what closes Saturday night. (George S. Kaufman)

Tragedy is when I cut my finger. Comedy is when you fall into an open sewer and die. (Mel Brooks)

I wouldn't say when you've seen one western you've seen the lot, but when you've seen the lot you get the feeling you've seen one. (Katherine Whitehorn)

The last picture I did was a disaster movie. I hadn't planned it that way. (Mel Brooks)

Gifts

Send two dozen roses to Room 424 and put 'Emily, I love you' on the back of the bill. (Groucho Marx)

Girls Next Door
Doris Day is as wholesome as a bowl of cornflakes and at least as sexy. (Dwight MacDonald)

Mary Pickford was the girl every young man wanted to have – as his sister. (Alastair Cooke)

Maureen O'Hara looks like butter wouldn't melt in her mouth – or anywhere else. (Elsa Lanchester)

Take away Julia Roberts' wild mane of hair and all those teeth and elastic lips and what have you got? A pony. (Joyce Haber)

Jennifer Aniston is the sort of girl you want to take home to your mother. If you could trust your father. (Jay Leno)

What is Meg Ryan but the Goldie Hawn of the Haagen-Dazs generation? (Michael Harkness)

I never go out unless I look like Joan Crawford the movie star. If you want to see the girl next door, go next door. (Joan Crawford)

Glasses
With my sunglasses on I'm Jack Nicholson. Without them I'm fat and sixty. (Jack Nicholson)

The only reason I wear glasses is for little things, like driving my car. Or finding it. (Woody Allen)

A celebrity is a person who works hard all his life to become well known and then wears dark glasses to avoid being recognized. (Fred Allen)

Some movie stars even wear their sunglasses in church. They're afraid God might recognize them and ask them for their autograph. (Fred Allen)

Gloves
I bought a dress that fits me like a glove. Now I'm looking for one that fits me like a dress. (Phyllis Diller)

I treated her like a pair of gloves. When I was cold I called her up. (Cornel Wilde in *The Big Combo*)

Never touch shit, even with gloves on. The gloves get shittier but the shit doesn't get glovier. (Orson Welles)

Gluttony

I eat like a vulture. Unfortunately, the resemblance doesn't end there. (Groucho Mark)

John Goodman lives from hand to mouth – literally. (Judi Leaming)

I eat when I'm worried and I eat when I'm not worried. If I can't make up my mind if I'm worried or not, I eat to find out. (Oprah Winfrey)

Gluttony is not a secret vice. (Orson Welles)

God

Considering the platypus, do you think God gets stoned once in a while? (Robin Williams)

I've been advised to date older men. That just about leaves God. (Joan Rivers)

God's only problem is that he's not aware he doesn't exist. (Marty Feldman)

I sometimes worry that God has Alzheimer's and has forgotten us. (Lily Tomlin)

If there's a supreme being, he's crazy. (Marlene Dietrich)

I can't even make a leap of faith to believe in my own existence, never mind God's. (Woody Allen)

In the beginning there was nothing. God said 'Let there be light' and there was light. There was still nothing but you could see it better. (Ellen DeGeneres)

God by Woody Allen

If only God would give me some clear sign – like making a large deposit in my name at a Swiss bank.

The worst that can be said about God is that He's an under-achiever.

God is silent. Now if we can only get man to shut up.

To you I'm an atheist. To God I'm the Loyal Opposition.

The universe is merely a fleeting idea in God's mind. That's a pretty uncomfortable thought, especially if you've just made a down-payment on a house.

Goldwynisms

Sam Goldwyn was (in) famous for what we might call 'creative' English. Here are some of his most noteworthy foot-in-mouth utterances:

Don't bite the hand that lays the golden egg.

My wife has such beautiful hands I'm thinking of making a bust of them.

In the film business you have to take the bull between the teeth.

In two words: Im-possible.

It's more than magnificent – it's mediocre.

If Roosevelt was alive today, he'd turn in his grave.

We're overpaying him, but he's worth it.

Why did you call your son Arthur? Every Tom, Dick and Harry is called Arthur these days.

There's not enough sarcasm in the musical score.

When I want your opinion, I'll give it to you.

Include me out.

Golf

My golfing career? On one hole I'm like Arnold Palmer and at the next I'm Lilli Palmer. (Sean Connery)

Golf was invented by the Scottish to allow them to make meaningless noises from the back of the throat. (Stephen Fry)

Last week I missed a spectacular hole-in-one by only give strokes. (Bob Hope)

I swim a lot. It's either that or buy a new golf ball. (Bob Hope)

I was once refused membership of a golf club which didn't take actors. I sent them the reviews I got for my Bond movies and was immediately allowed to join. (Roger Moore)

When Jackie Gleason falls on a golf course he creates a natural bunker. (Bob Hope)

Give me my golf clubs, some fresh air and a beautiful partner and you can keep the golf clubs and the fresh air. (Jack Benny)

Gossip Columnists

The broads who work in the press are mainly hookers. I might offer them a buck and a half. (Frank Sinatra)

Take a black widow spider, cross it with a scorpion, wean their poisonous offspring on a mixture of prussic acid and treacle and you'll get the honeyed sting of Hedda Hopper. (Donald Zec)

Hedda Hopper once came to my table in Chasens when I was having dinner with my husband and said, 'What the hell are you doing here? I've got a headline in the papers that you've broken up with Don and are in San Francisco with Glenn Ford. How can you ruin my big exclusive?' (Hope Lange)

They should give her open heart surgery – and go in through the feet. (Julie Andrews on the Los Angeles columnist Joyce Haber)

Louella Parsons is stronger than Samson. He needed two columns to bring the house down but she can do it with one. (Sam Goldwyn)

Gossip Magazines

I love *The Enquirer* and I also like wearing fiberglass underwear. (Robin Williams)

The true objective of your typical Hollywood Don Juan isn't so much the lady's bedroom as a story in the gossip columns. (Philip Dunne)

Grandparents

My grandfather was married twice, a state which in Wales is looked upon rather like leprosy. (Ray Milland)

Becoming a grandmother is great fun because you can use the kid to get back at your daughter. (Roseanne)

Michael Winner looks like a homicidal grandmother who's just been released into the community after a lifetime weaving baskets in a high security mid-west prison. (Peter McKay)

My grandfather always said, 'Don't watch your money, watch your health.' But one day while I was watching my health, someone stole my money. It was my grandfather. (Jackie Mason)

Gratitude

I want to thank the director Guy Green, who understood the role much better than I did. (Shelley Winters in her Oscar acceptance speech for *A Patch of Blue,* in which she played an alcoholic prostitute)

I'm very grateful to my father for taking me into the house after I was born because I was a total stranger to him at the time. (Bob Hope)

Guns

I couldn't hit a wall with a six-gun but I can twirl one good. (John Wayne)

Love in movies is something that goes on between a man and a .45 that won't jam. (Alan Ladd)

Is that a gun in your pocket or are you just happy to see me? (Mae West)

I wanted to be a detective. It only took brains, courage and a gun – and I had the gun. (Bob Hope)

Thanks to the movies, gunfire has always sounded unreal to me, even when I'm being fired at. (Peter Ustinov)

Gynaecologists

I'm not saying my body is bad, but my gynaecologist wears a hard hat. (Joan Rivers)

I was in the middle of a gynaecological exam when my doctor said, 'I have a script. Can you read it?' (Sigourney Weaver)

Mary had a little lamb. The gynaecologists are looking into it. (Billy Crystal)

After seeing *Basic Instinct,* Sharon Stone's gynaecologist can now make a diagnosis by going to the multiplex and sitting down front. (*Newsweek*)

Hair

From 1949 to 1951 I became famous for my hair. It took on a life of its own. In fact, for a while my hair was more famous than I was. (Tony Curtis)

He now sports a glossy something on his summit that adds at least five inches to his altitude and looks like a swatch of hot buttered yak wool. (*Time* magazine on Elvis Presley in *Spinout*)

Did you know you have hairs up your nostrils? (Marlon Brando to his co-star Sophia Loren on the set of *The Countess From Hong Kong*)

It's an ill wind that blows when you leave the hairdresser. (Carol Burnett)

I'm confused about Hara Krishnas at the barbers. Do they just say to him, 'Leave a little on the top?' (Robin Williams)

Ashton Kutcher is to acting what Donald Trump's hair is to coiffure. (Tony Vitale)

When people ask how long it takes me to do my hair every day I always tell them, "I don't know. I'm never there'. (Dolly Parton)

Whenever I get a trendy haircut I look like a lesbian tennis player. (Hugh Grant)

Hamlet

Hamlet was all right but there were too many quotations in it. (Hugh Leonard)

I have been accused of being in too many Frankenstein films, but nobody is ringing me up to do *Hamlet*. (Peter Cushing)

I never knew a man who played *Hamlet* that didn't die broke. (Humphrey Bogart)

The only place I'm allowed do *Hamlet* is in the shower. (Sylvester Stallone)

You can't make a *Hamlet* without breaking egos. (William Goldman)

It's only a matter of time before an actor is chosen for the role of *Hamlet* by the size of his penis. (Micheál Mac Liammóir)

Hams

I'm a ham who wants to rush into every scene and chew the scenery. (Richard Burton)

There are many things I should like to say about Jack Benny but I don't believe in biting the ham that feeds you. (Sam Lyons, Benny's agent)

Louella Parsons is a reporter trying to be a ham; Hedda Hopper is a ham trying to be a reporter. (Hedda Hopper)

That fellow is such a ham I bet he wears a clove in his button hole. (Irving Lazar)

Hangovers

I've had hangovers before, but this time even my hair hurts. (Rock Hudson)

Happiness

My first husband and I lived happily never after. (Bette Davis)

Happiness to me is when I'm merely miserable and not suicidal. (Bob Fosse)

Hollywood is a place where, if you don't have happiness, you send out for it. (Rex Reed)

Happiness is good health and a bad memory. (Ingrid Bergman)

Happiness can't buy money. (Pat Hingle)

If I could drop dead right now I'd be the happiest man alive. (Sam Goldwyn)

Has-Beens

I was only 24 when I first heard the words, 'Your career is over.' (John Travolta)

A woman stopped me on the street one day and said, 'Excuse me, didn't you once used to be Cary Grant?' (Cary Grant)

Hatred

I never hated a man enough to give him his diamonds back. (Zsa Zsa Gabor)

I got more hate mail in my life than Hitler. (Barry Morse, who played Lieutenant Gerard in the TV series *The Fugitive*)

I told my psychiatrist everyone hated me. He said I was being ridiculous, that everyone hadn't met me yet. (Rodney Dangerfield)

Hats

Tom Hanks is what I'd call the Hat Pack. You know, a bunch of guys who occasionally wear hats and that's about as wild as they get. (Garry Marshall)

You could never put Gary Cooper in a small hat and get your money back. (Richard Zanuck)

It's impossible to travel faster than the speed of light, and certainly not desirable. One's hat would keep blowing off. (Woody Allen)

Hedda Hopper was a mental defective. She wore corrective hats. (Stewart Granger)

Heart Attacks

I knew a guy who had a heart attack so he got a pacemaker. His wife divorced him because she said it interfered with the TV. (Walter Matthau)

I caused my husband's heart attack. In the middle of lovemaking I took the paper bag off my head. (Joan Rivers)

What do you mean 'heart attack'? You've got to have a heart before you can have an attack. (Billy Wilder, upon hearing of Peter Sellers' coronary in 1964)

While I was filming *The Mechanic* in Italy my father had a heart attack. His doctor rang me from London and said, 'You should come back immediately'. I said, 'I can't. I'm working.' The doctor said, 'But your father could die in the next few days'. I said, 'You don't understand. This is a *movie*.' (Michael Winner)

Brigitte Bardot is just the kind of girl to take home to mother. If you want to give her a heart attack. (Tony Crawley)

Peter Sellers had four wives and eight heart attacks. In other words, two heart attacks per wife. That sounds about average. (Sid Caesar)

Heaven

There may be a heaven but if Joan Crawford is there I'm not going. (Bette Davis)

I'm hoping for a place in heaven because I've got a lot of back-up. My father was a Catholic, my mother was a Protestant, I was educated by Jews and I'm married to a Muslim. I won't lose out on a technicality. (Michael Caine)

Frank Sinatra's idea of Paradise is a place where there are plenty of women and no newspapermen. He'd be better off if it was the other way round. (Humphrey Bogart)

Hell

Maybe there's no actual place called hell. Maybe hell is just having to listen to your grandparents breathe through their nose when they're eating a sandwich. (Jim Carrey)

Hellraisers

Not since Attila the Hun swept across Europe leaving 500 years of total blackness has there been a man like Lee Marvin. (Joshua Logan)

I wish I'd been a hellraiser when I was thirty. I tried it at fifty but I got too sleepy. (Groucho Marx)

Hen-Pecked Husbands

My wife made me join a bridge club. I jump off next Tuesday. (Rodney Dangerfield)

My son's first film role was that of a man who was married thirty years. I told him to stick at it and next time he'd get a speaking part. (Henry Fonda)

The Hereafter

I don't believe in life after death, ashes to ashes or dust to dust. I certainly don't want to come back as dust. I have enough trouble with it in my house-cleaning. (Hedy Lamarr)

If man was really immortal, can you imagine what his meat bills would be? (Woody Allen)

Heroes

There are a hundred rules for being a hero but the most important one is: Never blink your eyes when you shoot. (Arnold Schwarzenegger)

In any movie situation where the hero is surrounded by dozens of bad guys, they will always obligingly attack one at a time. (Barbara Kelsey)

Heroes are never cut by glass while leaping through windows. (Daniel Alvarado)

No movie with a hero named Youngblood has ever been any good. (Roger Ebert)

In any movie where the hero knows other characters are in trouble, say because a time bomb is about to go off, he must jump into a car and drive like a lunatic across town to save them. No hero ever has a quarter for a pay phone. (Bill Becwar)

I've spent several years in Hollywood and I still think the real movie heroes are in the audience. (Wilson Mizner)

Charlton Heston

Charlton Heston is so square he could drop out of a cubic moon. (Richard Harris)

Lon Chaney was called the Man with a Thousand Faces. Charlton Heston is Chaney minus 999 of them. (Hugh Leonard)

Charlton Heston is good at portraying arrogance and ambition in the same way that a dwarf is good at being short. (Rex Harrison)

Highlights

The high point of my career wasn't winning an Oscar. It was appearing opposite an orangutan in *Every Which Way But Loose*. (Clint Eastwood)

There are lots of highlights in *Alexander the Great* but most of them are in Colin Farrell's hair. (Peter Whiting)

Hits

I haven't had a hit film since Joan Collins was a virgin. (Burt Reynolds)

After they realized *Easy Rider* was going to be a hit, the Columbia executives stopped shaking their heads in incomprehension and started nodding them - in incomprehension. (Peter Fonda)

Eddie Murphy's new movie is cynical, commercial film-making at its worst. It will be an enormous hit. (Jonathan Ross on *The Nutty Professor 2*)

In Hollywood it's not enough to have a hit. Your best friend must also have a flop. (Peter Bogdanovich)

Hobbies

Joan Crawford's favourite hobby is knitting, at least after screwing and adopting children. (Bette Davis)

The two main hobbies of people living in Hollywood are jogging and helping divorced friends move. (Robert Wagner)

Outside movies, my main hobbies are dental hygiene and spark plugs. (David Lynch)

I never married because it would have meant giving up my favourite hobby – men. (Mae West)

Hollywood

All you ever see in Hollywood is men with ponytails and women with fake knockers. (Liz Hurley)

Hollywood is a place where somebody who used to be a somebody somewhere else comes to be a nobody. (Roseanne Barr)

Hollywood is a trip through a sewer in a glass-bottomed boat. (Wilson Mizner)

There's no 'there' there. (Gertrude Stein)

Hollywood is a nice place to die but I wouldn't advise anyone to live there. (Jack Paar)

Hollywood is a place where they bring $10 million worth of intricate and highly ingenious machinery functioning elaborately to put skin on baloney. (George Nathan)

Strip off the phony tinsel of Hollywood and you'll find the real tinsel underneath. (Oscar Levant)

There are only three things you need to know to make it in Hollywood: Learn to cry, make your own salad, and die in slow motion. (Gary Busey)

Hollywood People

Hollywood people seem to have fronts and no backs. In this they're just like the sets. (Brandon de Wilde)

My first reaction to Hollywood's inhabitants was that they were bronzed, had capped teeth and wore huge dark glasses. They had faces but were minus eyes. Sunshine bled from every corner and the dazzling white buildings gave me a permanent squint. (Shirley MacLaine)

Hollywood is full of what we in Dublin call gobshites. (Pat O'Connor)

The Hollywood Ten
*Also known as The Unfriendly Ten, these were the people blacklisted by the HUAC investigation for failing to 'name names.'

I learned more about communism in the three years I was one of the Hollywood Ten than I ever learned when I was a party member. (Edward Dmytryk)

Bo Derek is from Hollywood and she was in a movie called *10*. But anytime she doesn't name names it's probably because she doesn't remember them. (Michael Harkness)

Only two of The Unfriendly Ten had talent. The rest were just unfriendly. (Billy Wilder)

Homosexuals
One can't really blame Tchaikovsky for preferring boys in *The Music Lovers*. Anyone might become homosexual after seeing Glenda Jackson naked. (Auberon Waugh)

There's no way Christopher Reeve was homosexual. He didn't even close his eyes when I kissed him in *Deathtrap*. (Michael Caine)

Rock Hudson let his gay agent marry him off to his secretary because he didn't want people to get the right idea. (Anthony Perkins)

When I told my father I wanted to be an actor he said, 'You can't – they're all homosexuals.'. So I became a welder instead. I told the other welders I became a welder to avoid being a homosexual. (Billy Connolly)

I can't think of anyone more camp than John Gielgud. When he took his Oscar home he said, 'Just what I've always wanted – a naked man in my rumpus room.' (Liberace)

Honesty

In Hollywood even the air is dishonest. (Uma Thurman)

Hookers

Working in Hollywood gives one a certain expertise in the field of prostitution. (Jane Fonda after winning an Oscar for playing a hooker in *Klute* in 1971).

I asked a hooker for sex. She said, 'Not on a first date'. (Rodney Dangerfield)

I've made so many movies playing hookers, they don't pay me in the regular way anymore. They leave it on the dresser. (Shirley MacLaine)

A hooker told me she'd do anything for $50. I said, 'Paint my house.' (Henny Youngman)

Horror

Stephen King has just written a horror book called *It*. How can that sell? 'Honey – there's a pronoun in the basement!' (Richard Pryor)

The scariest thing about this film is the thought that some people might actually go and see it. (Brian Reddin on *Blair Witch 2*)

I look like the guy next door – if the guy next door comes from the Chamber of Horrors. (Lon Chaney)

The Exorcist was a landmark movie, both scary and disturbing. It was also the first and last time a Catholic priest actually wanted to give a woman control over her own body. (Dennis Miller)

I have to get out of horror movies before I become a grotesque caricature of the hatchet-faced woman with big knockers. (Jamie Lee Curtis)

Rondo Hatton was the only horror film star to play monsters without make-up. (Denis Gifford)

Horses

I bet on a great horse yesterday. It took seven horses to beat him. (Red Skelton)

Ali MacGraw kept riding into the sunset with a man who didn't have a horse. (Candice Bergen)

I used to get postcards from John Ford from all over the world. One featured the rear end of a horse with the caption, 'Thinking of you.' (Ward Bond)

The great thing about racehorses is that you don't need to take them for walks. (Albert Finney)

I'd horse whip you if I had a horse. (Groucho Marx)

The last horse I backed was so slow, the jockey died of starvation. (Milton Berle)

The horses I follow, follow the horses. (Joe E.Lewis)

I gave 'My Way' to Frank Sinatra because I didn't want to find a horse's head in my bed. (Paul Anka)

During the early days of Hollywood everybody who was anybody played polo. They enjoyed falling off their horses, and if one of the players broke a leg, they shot him. (Groucho Marx)

They used to say Tom Mix rode as if he was part of the horse. But they didn't say which part. (Robert Sherwood)

Housekeeping

You can't get spoiled if you do your own ironing. (Meryl Streep)

When I'm cleaning the house I wear an apron, but nothing else. It makes my activities more interesting for my husband. (Nina Foch)

I'm a wonderful housekeeper. Every time I get a divorce I keep the house. (Zsa Zsa Gabor)

Houses

The first time you buy a house you see how pretty the paint is. The second time you check to see if the basement has termites. It's the same with men. (Lupe Velez)

After I won the Oscar for *My Left Foot* I bought a new house. The one I was living in had no mantelpiece and that's where I wanted to put it. (Brenda Fricker)

Homelessness is homelessness no matter where our live. (Glenda Jackson)

Husbands

Husbands are like fires. They go out when unattended. (Zsa Zsa Gabor)

My husband said he needed more space so I locked him outside. (Roseanne Barr)

A husband is just as hard to find after marriage as before it. (Carol Burnett)

Jane Fonda's first husband was that Chinese-looking director Roger Vadim. Then came Mr. Potato Nose Tom Hayden. Then that gap-toothed cable-TV presenter Ted Turner, who ruins countless films by colouring them with arbitrary pastels. (Judith Anderson)

My first husband was perfect. A perfect shit. (Bette Davis)

You mean apart from my own? (Zsa Zsa Gabor after being asked how many husbands she'd 'had').

When I came back from my third honeymoon I couldn't understand why my husband wanted to come into the house with me. I was just about to say, 'Thanks for a nice time.' (Shelley Winters)

What a husband really wants is to get extremely close to someone who'll leave him alone most of the time. (Kim Cattrall)

Any husband who says 'My wife and I are completely equal partners' is either talking about a law firm or a hand of bridge. (Bill Cosby)

Identity

I used to have a personality but I had it surgically removed. (Peter Sellers)

Marilyn Monroe's marriage to Joe DiMaggio didn't work out because he found out she wasn't Marilyn Monroe. Her marriage to Arthur Miller didn't work out because he found out she was. (Billy Wilder)

I really don't know who I am. Quite possible I don't exist at all. (Alec Guinness)

Poor Walter Winchell. He's afraid he'll wake up some day and discover he's not Walter Winchell. (Dorothy Paker)

Who the hell do they want me to play – Humphrey Bogart? (Spencer Tracy after being accused of always playing himself)

I adore not being me. I'm not very good at it. That's why I love acting so much. (Deborah Kerr)

I'm not really Henry Fonda. Nobody could have that much integrity. (Henry Fonda)

I liked myself better when I wasn't me. (Carol Burnett)

The reason I drink is because when I'm sober I think I'm Eddie Fisher. (Dean Martin)

Image
Most young people today don't know me as an actress. They know me as 'The woman in the exercise video their mother used.' (Jane Fonda)

This 'King' stuff is pure bull. I eat and drink and go the bathroom just like everyone else. I'm just a lucky slob from Ohio who happened to be in the right place at the right time. (Clark Gable)

Impatience
Instant gratification takes too long. (Carrie Fisher)

Hollywood's usual slogan is, 'I don't want it good, I want it Tuesday'. (Ruth Gordon)

The hardest part of making movies is all the time you have to sit around between takes. I always figure that's what they pay me for. The acting I do for free. (Edward G. Robinson)

I got married and we had a baby nine months and ten seconds later. (Jayne Mansfield)

Improvisation

Chevy Chase couldn't ad-lib a fart after a baked bean dinner. (Johnny Carson)

Ricardo Montalban is to improvisational acting what Mount Rushmore is to animation. (John Cassavetes)

I need a script to order a sandwich. (Rock Hudson)

Incompetence

That bitch couldn't act her way out of a brick shithouse. (John Ford on Maureen O'Hara)

I'd never make another film rather than work with Otto Preminger. I don't think he could direct his little nephew to the bathroom. (Dyan Cannon)

Michael Caine can out-act any, well nearly any, telephone kiosk you care to mention. (Hugh Leonard)

Genevieve Bujold has all the power of a dying gnat. I could whisper louder than she screams. (Richard Burton)

The only time Gary Cooper was ever in trouble was when he tried to act. (Fred Zinneman)

I'm no actor and I've got 64 films to prove it. (Victor Mature)

Indecision

In 1940 I had a choice between Hitler and Hollywood. I preferred Hollywood, but just a little. (Rene Clare on his decision to leave France during World War 1)

For a while my wife and I pondered whether to take a vacation or get a divorce. We decided that a trip to Bermuda is over in two weeks but a divorce is something you have forever. (Woody Allen)

I'll give you a definite maybe. (Sam Goldwyn)

Indians

For this scene we need to get some Indians from the reservoir. (Sam Goldwyn)

It's a great shock at the age of five or six to find that in a world of Gary Coopers you are the Indian. (James Baldwin)

George Raft and Gary Cooper once played a scene in front of a cigar store and it looked like the Indian was over-acting. (George Burns)

Infidelity

I couldn't stand my husband being unfaithful. I am Raquel Welch – understand? (Raquel Welch)

Your idea of fidelity is just being in bed with one man at a time. (Dirk Bogarde to Julie Christie in *Darling*)

It's bloody impractical to have to love honour and obey. If it wasn't, you wouldn't have to sign a contract. (Katharine Hepburn)

I haven't had any open marriages, though quite a few have been ajar. (Zsa Zsa Gabor)

I have great-looking kids. Thank goodness my wife cheats on me. (Rodney Dangerfield)

I'm a woman who's unfaithful to a million men. (Greta Garbo)

When I said I didn't sleep with married men, what I meant was happily married men. (Britt Ekland)

Why go out for hamburger when you can have steak at home? (Paul Newman)

Since I got married I haven't looked at another woman. My wife put me off them. (Bob Hoskins)

Insomnia

Sleep is the best cure for insomnia. (W.C. Fields)

I'm trying to sleep off my insomnia. I subtract sheep. (Groucho Marx)

When I can't get to sleep I don't count sheep, I count lovers. By the time I reach 38 or 39 I'm gone. (Miriam Hopkins)

Inspiration
Boys, I've got an idea. Let's fill the screen with tits. (Hunt Stromberg)

At acting school I was asked to remember some childhood trauma to get into a Method mood for a class. All I could come up with, buried deep in my subconscious was the rather unenthralling tale of losing a Fry's Chocolate Cream on a river bank when I was two years old. (Ewan McGregor)

Insults
I bet your father spent the first half of his life throwing rocks at the stork. (Groucho Marx to a woman he thought ugly)

Jayne Mansfield projects sex about as subtly as Dr. Kinsey. (Tom Wiseman)

She has the voice of an unstrung tennis racquet, a figure of no describable shape and the face of an exhausted gnu. (John Simon on Angelica Huston)

He's full of shit and fury, signifying nothing. (Charles Laughton on Henry Fonda)

Why don't you bore a hole in yourself and let the sap run out? (Groucho Marx)

I like you better the more I see you less. (Jack Warner to an aspiring actress)

He looks as if his idea of fun would be to find a nice damp grave and sit in it. (Richard Winnington on Paul Henreid)

I always admired you as an actor before you became a film star bollox. (Flann O'Brien to James Mason)

Joan Rivers has such a big mouth she can eat a banana sideways. (Rodney Dangerfield)

Acting with Jeff Chandler was like acting with a broomstick. (Maureen O'Hara)

My great-aunt Jennifer lived to be 102. When she was dead for three days, she looked better than you do now. (Monty Woolley to a colleague)

There sits a man with an open mind. You can feel the draught from here. (Groucho Marx)

Cedric Hardwicke had all the personality of an old tortoise hunting for lettuce. (Rachel Roberts)

Robert Redford is adorable but when they enriched that handsome hunk of white bread they left out the mythic minerals. (Richard Schickel)

The only good things about *The Snows of Kilimanjaro* were Ava Gardner and the hyena. (Ernest Hemingway)

Intelligence

No one ever went broke in Hollywood underestimating the intelligence of the public. (Elsa Maxwell)

You don't have to be smart to be an actor. Ronald Reagan was one. (Cher)

The only bright thing about most men is the seat of their pants. (Mae West)

You think you know fuck everything and I know fuck nothing. Well, let me tell you, I know fuck all. (Michael Curtiz)

Interruptions

Keep quiet. You're always interrupting me in the middle of my mistakes. (Sam Goldwyn)

Excuse me for interrupting but I actually thought I heard a line I wrote. (George S. Kaufman at a rehearsal for *Animal Crackers*)

Don't talk to me while I'm interrupting. (Jack Warner)

Interviews

Interviewing Warren Beatty is like asking a haemophiliac for a gallon of blood. (Rex Reed)

That one. (James Caan after being asked what was the stupidest question ever put to him in an interview)

Richard Gere is finally calling back for an interview. He must feel he has a flop movie coming out. (Andy Warhol)

I'd rather slit my throat than do an interview. (Jean Arthur)

Interviews are like therapy – but a lot cheaper. (Cybil Shepherd)

Intimidation

I wanted to marry her ever since I saw the moonlight shining on the barrel of her father's shotgun. (Eddie Albert)

If people don't sit at Charlie Chaplin's feet, he goes out and stands where they're sitting. (Herman Mankiewicz)

Tell me honestly, how did you love my picture? (Sam Goldwyn)

Introductions

How much would it cost to buy back my introduction to you? (Groucho Marx)

Making a film with Greta Garbo does not constitute an introduction. (Robert Montgomery)

The first time I met Glenda Jackson I found myself looking at her varicose veins instead of her face. (Ken Russell)

Introversion

Montgomery Clift always walks around the place as if he's got a Mix Master up his ass. (Marlon Brando)

I used to live alone. Then I got divorced. (Bob Hoskins)

Jealousy

I dated Elvis Presley to make Marlon Brando jealous. (Rita Moreno)

Steve McQueen always looked at people as if they'd just stolen his second helping of mashed potatoes. (Ali MacGraw)

This year we're showing the Oscar ceremonies in colour so you'll actually be able to see the losers turn green. (Bob Hope)

Jesus Christ

Jesus was an only child. Thank God for that. Who would want to be Jerry, his brother? 'Hi, I'm Jerry, the plumber in the family. No, I don't do miracles.' (Robin Williams)

The first time I saw a picture of Jesus riding into Jerusalem on Palm Sunday I thought: Hasn't he grown a lot since Christmas Day. (Bob Hope)

I want to play the role of Jesus. I'm a logical choice. I look the part. I'm a Jew. And I'm a comedian. (Charlie Chaplain)

Like most Catholic boys, I wanted to be Jesus Christ when I was young. But I could never get the turn-the-other-cheek thing down. (Jim Carrey)

The good news is Jesus is coming back. The bad news is that he's pissed off. (Bob Hope)

Joan of Arc

It's very difficult being married to Joan of Arc. (Roger Vadim on Jane Fonda)

I have two memories of Saint Joan. The first was being burned at the stake in the picture, the second being burned at the stake by the critics. The latter hurt more. (Jean Seberg)

Does she have to pray so much? (Sam Goldwyn as he watched the movie)

Jobs

I had the most boring office job in the world. I used to clean the windows on envelopes. (Rita Rudner on her pre-fame life)

When a woman says she wants to go out and get a job to express herself it usually means she's behind in the ironing. (Oliver Reed)

My father was unemployed for ten years. Then things finally took a turn for the better. He went out on strike. (Bob Hope)

I used to work for a living. Then I became an actor. (Roger Moore)

The best job I ever had was driving a forklift in a Guinness factory. (Liam Neeson)

Keyholes

I've never looked through a keyhole without finding someone was looking back. (Judy Garland)

By increasing the size of the keyhole, today's playwrights are in danger of doing away with the door. (Peter Ustinov)

Kidnapping

Frank Sinatra's son must have been kidnapped by music critics. (Oscar Levant)

I was kidnapped once and they sent a piece of my finger to my father. He said he wanted more proof. (Rodney Dangerfield)

Kissing

Kissing Marilyn Monroe was like kissing Hitler. (Tony Curtis)

Hollywood is a place where they'll pay you a thousand dollars for a kiss and fifty cents for your soul. (Marilyn Monroe)

People who throw kisses are hopelessly lazy. (Zsa Zsa Gabor)

Everyone kisses each other in this crummy business. It's the kissiest business in the world. If people making a movie didn't keep kissing, they'd be at one another's throats. (Ava Gardner)

Many a husband kisses with his eyes wide open. He wants to make sure his wife isn't around to catch him. (Anthony Quinn)

Harrison Ford is so famous he doesn't kiss with his own tongue anymore – he uses someone else's. (Carrie Fisher)

Some of my kissing scenes look like I've been sucking pain off my car. (Charlie Sheen)

It takes a lot of experience for a girl to kiss like a beginner. (Mae West)

I kissed the coalman when I was twelve and I haven't looked back since. (Zsa Zsa Gabor)

If you think Cairo was upset, you should have seen the letter I got from my Aunt Rose. (Barbra Streisand on kissing the Egyptian, non-Jewish, Omar Sharif in *Funny Girl*)

Cary Grant told, but he didn't kiss. (Ingrid Bergman)

I've been kissing Audrey Hepburn all day and my pucker is tuckered. (James Garner)

I've tried everything except coprophagia and necrophilia but I still like kissing best. (John Waters)

Kitchens

I was married in a kitchen that smelt of cabbage and a wasted preacher. (Robert Mitchum)

If you can't stand the heat, stay in the kitchen but move closer to the fridge. (Bill Cosby)

Language

Man invented language to satisfy his deep need to complain. (Lily Tomlin)

What I like about Hollywood is that one can get there by knowing only two words of English: swell and lousy. (Vicki Baum)

Keanu Reeves is going to play Superman in a new movie. The villains don't use kryptonite to stop him, they just use big words. (Conan O'Brien)

Lassie

Arnold Schwarzenegger is the only actor who's spoken less lines of dialogue in his film than Lassie. (Robin Williams)

Joan Crawford slept with every male on the MGM lot except Lassie. (Bette Davis)

Making a film with Marilyn Monroe was like directing Lassie. It took fourteen takes to get a print. (Otto Preminger)

Laughter

Being English, I always laugh at anything to do with lavatories or bottoms. (Liz Hurley)

An onion can make you cry. Show me a vegetable that can make you laugh. (Tallulah Bankhead)

When I first read the script of *Pearl Harbour* I vomited from laughter. (Steven Spielberg)

The first thing any comedian does on getting an unscheduled laugh is to verify the state of his buttons. (W.C. Fields)

Legacies

I hope I'm remembered for more important things than inventing a mouse. (Wald Disney)

What would I like to be remembered for? Not my acting. Just the fact that I make a really mean leak vinaigrette. (Jodie Foster)

Legends

Paul Newman isn't a legend to me because I go to the toilet with him. (Sidney Lumet)

If facts conflict with the legend, print the legend. (John Ford)

Robert Morley is a legend in his own lunchtime. (Rex Harrison)

Legs

Women are cleverer than men. Did you ever hear of a woman marrying a man because he had lovely legs? (Bette Davis)

My grandchildren take me to the beach and try to make words out of the veins in my legs. (Phyllis Diller)

Never trust a man with short legs. His brain is too near his bottom. (Noel Coward)

Lesbians

I once chased a woman for two years only to realise her tastes were exactly like mine. We were both crazy about girls. (Groucho Marx)

Sharon Stone is nothing but a paean to lipstick lesbianism. (William Baldwin)

My sex life is now reduced to fan letters from an elderly lesbian who wants to borrow $800. (Groucho Marx in 1974)

Lies

I've found the secret of eternal youth. I lie about my age. (Bob Hope)

I was brought up in a clergyman's household so I'm a first-class liar. (Dame Sybil Thorndike)

You lie to two people in your life: your girlfriend and the police. Everyone else you tell the truth to. (Jack Nicholson)

Hollywood columnists lie in the sun all day and when the sun goes down they go home and lie some more. (Frank Sinatra)

Never lie to a man unless you absolutely know you can get away with it. (Clara Bow)

Line Delivery

Her delivery of lines is rather like a grade-school pupil asking to be excused to go to the bathroom. (John Simon on Ali MacGraw in *The Getaway*)

He delivers every line with a monotonous tenor bark as if addressing an audience of deaf eskimos. (Michael Billington on Peter O'Toole in *Macbeth*)

Paul Newman delivers his lines in *The Silver Chalice* with the emotional fervor of a Putnam train conductor announcing local stops. (John Simon)

On some flashes of dialogue he talked as if he had a mouthful of lettuce leaves. (John Parker on Sean Connery in *The Anderson Tapes*)

Lips

Mick Jagger's lips are so big he could French kiss a moose. (Joan Rivers)

Joan Crawford's lips always reminded me of balloon tyres in wet weather. (John Betjeman)

Angelina Jolie's lips are one of the few natural phenomena viewable from outer space next to the Great Wall of China. (Shaun Cassidy)

Litigation

If you want justice, go to a whorehouse. If you want to get fucked, go to court. (Richard Gere)

I wish I could sue *The New York Post* but it's awfully hard to sue a garbage can. (Paul Newman)

What did the judge say to Heidi Fleiss when she was convicted? 'You're going down for a long time.' (David Letterman)

Fame is simple. First you get the three-piece suit and then you get the lawsuit. (Robin Williams)

For certain people after fifty, litigation takes the place of sex. (Gore Vidal)

Location Filming

Never shoot a film in Belgrade. There's nothing to do there. And Tito is always using the car. (Mel Brooks)

Cary Grant makes all his pictures in places like Monte Carlo, London, Paris and the French Riviera. I made mine in deserts with a dirty shirt and a two-day growth of beard. (Robert Ryan)

My main memory of *Ryan's Daughter* is of sitting on a hilltop in a caravan at six in the morning in the pissing rain wondering what the hell I was doing there. (Sarah Miles)

Conditions were somewhat primitive in the Sahara but I've shot a film in

Texas so I was somewhat used to it. (John Malkovich on *The Sheltering Sky*)

The reason I didn't produce *Brigadoon* in Scotland was because when I went there I found nothing that looked like Scotland. (Arthur Freed)

In the old days of Hollywood when you went on location they sent a limousine to your home. Now they give you a map. (James Stewart)

Most of my films were made in places I couldn't pronounce. (Roger Moore)

London

It was so cold in London once, I almost got married. (Shelley Winters)

When it's 3 o'clock in New York, it's still 1938 in London. (Bette Midler)

Loneliness

I think loneliness is a terrible thing. Especially when you're on your own. (Frankie Howerd)

I feel so lonely without my girlfriend it's almost as bad as having her here. (Joey Bishop)

It's lonely at the top, but you eat better. (Milton Berle)

Longevity

What have I done to achieve longevity? Woken up each morning and tried to remember not to wear my hearing aid in the bath. (Robert Morley)

Married men live longer than single ones – but they don't want to. (Sid Caesar)

And they said the marriage wouldn't last. Well they left the church together, didn't they? (Mel Brooks)

At the end of the world the two things that will be left will be cockroaches and Cher. (J. Randy Tarraborelli)

Looks

Walter Matthau looks like a half-melted rubber bulldog. (John Brien)

Liz Taylor looks like a Goodyear blimp pumped full of Chasen's chili instead of butane gas. (Rex Reed)

Marlene Dietrich looked like a Spanish Dracula with the body of a young boy. (Joe Eszterhas)

I look like a cross between my father, Mephistopheles, and an opium peddler on the Mexican border. (Groucho Marx)

It costs a lot of money to look as cheap as I do. (Dolly Parton)

I'm 54 years old. I weigh 220 pounds and look like the chief dispatcher of a long-distance hauling concern. (James Caan)

I look like a lampshade on legs. (Julia Roberts)

She got her good looks from her father – he's a plastic surgeon. (Phil Silvers)

The less I behave like Whistler's mother the night before, the more I look like her the morning after. (Tallulah Bankhead)

Los Angeles

Welcome to the City of Angels. You won't find many of them here. (Marlon Brando)

I don't want to live in a city where the only cultural advantage is the fact that you can make a right turn on a red light. (Woody Allen in *Annie Hall*)

Los Angeles is a very antibiotic city. I mean antiseptic. (Julie Christie)

In Los Angeles, by the time you're 35 you're older than most of the buildings. (Delia Ephron)

Los Angeles is 72 suburbs in search of a city. (Dorothy Parker)

The chief products of Los Angeles are novelisations, game show hosts, muscle tone, mini-series, rewrites and salad. (Fran Lebowitz)

There are two million interesting people in New York but only 78 in Los Angeles. (Neil Simon)

Los Angeles is a very transient town. It's the only place I know where you can actually rent a dog. (Rita Rudner)

Los Angeles is full of pale imitations of Pamela Anderson. And, worse still, Pamela Anderson herself. (Lisa Marchant)

Losers

I can't play a loser because I don't look like one. (Rock Hudson)

Show me a good loser and I'll show you a loser. (Paul Newman)

Love

I've been in love with the same woman for 41 years. If my wife ever finds out she'll kill me. (Henny Youngman)

Love is that delightful interval between meeting a beautiful girl and discovering that she looks like a haddock. (John Barrymore)

Not to know him was to love him. (Bert Kalmar on producer Herman Mankiewicz)

Love begins with a prince kissing an angel. It ends with a bald-headed man looking across the table at a fat woman. (Rodney Dangerfield)

Surely no one but a mother could have loved Bette Davis at the height of her career. (Brian Aherne)

If love is the answer, could you please rephrase the question? (Lily Tomlin)

My wife and I thought we were in love but it turned out to be benign. (Woody Allen)

Bud Abbott loves his wife and he's got three dogs. I don't love mine and I've got two children. Go figure. (Lou Costello)

John Ford's idea of a love story is Ward Bond and John Wayne. (Philip Dunne)

Love Scenes

Even when James Stewart made a genuine effort to play a love scene, he always gave the impression he was wearing only one shoe and busily looking for the other. (Marlene Dietrich)

I've been given love scenes to do that sound like political speeches. (Marcello Mastroianni)

Lovers

My wife has faith in me as a comedian and lover. I just wish she'd tell me when one stops and the other starts. (Buddy Hackett)

I asked my wife, 'On a scale of one to ten, how do you rate me as a lover?' She said, 'Come on, you know I'm no good at fractions.' (Rodney Dangerfield)

People ask me how come I'm such a great lover. The secret is, I practice a lot when I'm on my own. (Woody Allen)

Luddites

I'm such a Luddite I can't even load a CD onto an iPod. (Uma Thurman)

Machismo

I have a love interest in all of my films – a gun. (Arnold Schwarzenegger)

I'm not macho. I was once beaten up by Quakers. (Woody Allen)

If there hadn't been women, we'd still be squatting in caves eating raw meat. We made civilization to impress our girlfriends. (Orson Welles)

Macho does not prove mucho. (Zsa Zsa Gabor)

Make-Up

The relationship between the made-up man and the film actor is that of accomplices in crime. (Marlene Dietrich)

I don't wake up looking like Cindy Crawford. (Cindy Crawford)

There's nothing worse than reading a script where your character gets introduced with the words, 'A beautiful woman walks in.' You think: Oh God, two and a half hours in make-up. (Catherine Zeta-Jones)

I have this terrific make-up man but he's expensive. I have to bring him in from Lourdes. (Bob Hope)

I can't see myself still putting on make-up at sixty. I will more likely be on a camel train bound for Samrakand. (Glenda Jackson)

My face was always so made up it looked like I had the decorators in. (Shelley Winters)

It takes Joan Collins longer to put on her make-up than me, but then I only have one face. (Linda Evans)

Malapropisms

You don't realise what life is all about until you find yourself lying on the brink of a great abscess. (Sam Goldwyn)

A fat wife is a bird in a girdled cage. (Jerry Lewis)

Love flies out the door when money comes innuendo. (Groucho Marx)

My next film is going to start with a bang in Hollywood and then degenerate throughout the whole world. (Sam Goldwyn)

Marriage

I always say a girl should get married for love – and keep on marrying until she finds it. (Zsa Zsa Gabor)

Marriage is forever – with time off for bad behaviour. (Robert Downey Jr)

Why did I marry Artie Shaw? Everyone married Artie Shaw! (Ava Gardner)

For the first year of marriage I had a basically bad attitude. I tended to place my wife under a pedestal. (Woody Allen)

Marriage is a great institution but I'm not ready for an institution just yet. (Mae West)

A Hollywood marriage is a great way to spend a weekend. (Mort Sahl)

I'm married to not being married. (Al Pacino)

For marriage to be a success, every man and woman should have his and her own bathroom. The End. (Catherine Zeta-Jones)

Marriage Licences

I'm the only man who has a marriage licence made out to 'To Whom It May Concern.' (Mickey Rooney)

Zsa Zsa Gabor has been married so often, they don't issue her with a new marriage licence anymore. They just punch the old one. (Johnny Carson)

Marriage Problems

I was once married for 29 days, which was about 28 days too long. (Drew Barrymore on her 1994 marriage to Jeremy Thomas)

Marriage is a long dull meal with the dessert at the beginning. (Dean Martin)

In Hollywood all marriages are happy. It's trying to live together afterwards that's the problem. (Shelley Winters)

Marriage is difficult. Very few of us are fortunate enough to marry multi-millionaire girls with 39-inch busts who have undergone frontal lobotomies. (Tony Curtis)

No matter who you get married to, you wake up with someone else. (Marlon Brando)

Some stuff about being married bothers me. Like having a husband. (Roseanne Barr)

In Hollywood a marriage is successful if it outlasts milk. (Rita Rudner)

Marriage is a device of society designed to make trouble between two people who would otherwise get along very well. (Anthony Quinn)

My marriage to Max Reed ended after the bastard tried to sell me to a sheik for $20,000. (Joan Collins)

Marriage Proposals

When I proposed to Ava I was almost unconscious with passion. When I proposed to Betty Jane I was almost unconscious with booze. When I proposed to Martha, I was almost unconscious with despair. And when I proposed to Elaine I was almost unconscious, period. (Mickey Rooney)

Stick with me baby and you'll be farting through silk. (Robert Mitchum)

Marry me and I'll never look at another horse. (Groucho Marx)

Harrison Ford proposed to Calista Flockhart and then slipped the ring around her waist. (David Letterman)

The first time George Sanders met me he asked me who I was. When I told him he said, 'How very interesting. Will you marry me?' Then he fell asleep. (Marilyn Monroe)

I proposed to my wife from a payphone in New York. (Robert Redford)

Marriage by Elizabeth Taylor

Your heart knows when you meet the right man. There is no doubt that Nicky is the one I want to spend my life with.
Taylor after her marriage to Nicky Hilton in 1950.

I just want to be with Michael. This, for me, is the beginning of a happy end.
Taylor after she divorced Hilton to marry Michael Wilding in 1952.

This marriage will last forever. For me it will be third time lucky.
Her prophecy after divorcing Wilding to marry Mike Todd in 1957. Shortly afterwards he died in a plane crash.

I have never been happier in my life. We will be on our honeymoon for thirty or forty years.
Taylor after her marriage to Eddie Fisher in 1959.

I'm so happy you can't believe it. I love him enough to stand by him no matter what he might do.
After the first marriage to Richard Burton in 1964.

There will be bloody no more marriages or divorces. We're stuck like chicken feathers to tar – for always.
Taylor after her second marriage to Burton in 1975.

I don't think of John as Husband Number Seven. He's Number One all the way – the best lover I've ever had. I want to spend the rest of my life with him and I want to be buried with him.
Following her seventh wedding, this time to John Warner in 1976.

With God's blessing, this is it, forever.
Taylor after her 1991 marriage to Larry Fortensky. With or without God's blessing however, it wasn't.

Mascara
Don't wear mascara if you're in love with a married man. (Shirley MacLaine)

May-December Romances
The oldest woman he ever married was Paulette Goddard. She was an old bag of 21 or something. (Sydney Chaplin on his father's preference for young brides)

James Brolin marrying Barbra Streisand was a smart move. It's one way for an ageing TV star to get back in the spotlight without going the OJ Simpson route. (Morey Amsterdam)

I once thought *Tomb Raider* was a biopic of Anna Nicole Smith. (Frank Skinner)

Why aren't young girls attracted to poor old men? (Sophia Loren)

Men never get too old for the entertainment industry. I saw a Clint Eastwood movie recently. He's around 110 and they have him in bed with a 24-year old. I demand some parity. Let's have a film where Tom Cruise sleeps with Phyllis Diller. (Michele Balan)

The only men who are too young are the ones who write love letters in crayon, fly for half-fare, or wear pyjamas with feet on them. (Phyllis Diller)

Meals

My doctor has advised me to give up those intimate little dinners for four – unless there are three other people eating with me. (Orson Welles)

The average airplane is 16 years old. So is the average airplane meal. (Joan Rivers)

I ran into Howard Dietz last night. He was having dinner at my house. (Sam Goldwyn)

Memory

Bo Derek turned down the role of Helen Keller because she couldn't remember the lines. (Joan Rivers)

I never remember anyone's name. Where do you think the 'Dahling' thing started. (Zsa Zsa Gabor)

Your marriage is in trouble if your wife says, 'You're only interested in one thing' - and you can't remember what it is. (Milton Berle)

I remember the first time I had sex. I kept the receipt. (Groucho Marx)

An actor can remember his briefest notice long after he's forgotten his phone number and where he lives. (Jean Kerr)

I can't remember if my wife left me because of my drinking, or I started drinking because my wife left me. (Nicolas Cage)

What's this – a memory test? (Liz Taylor at her sixth wedding after being asked to name her previous husbands)

I never forget a face but in your case I'll make an exception. (Groucho Marx)

I have a bad memory for bad memories. (Dolores del Rio)

Being married to Greg Allman was like going to Disneyland on acid. You knew you had a good time but you couldn't remember why. (Cher)

All I remember of *The Miracle* is leading a parade of soldiers through the streets of Brussels in Rosalind's corset from *Auntie Mame*. (Roddy McDowall)

Men

Men should be like Kleenex: soft, strong and disposable. (Cher)

You know the problem with men? After the birth, we're irrelevant. (Dustin Hoffman)

The main difference between a dog and a man is that if you pick up a starving dog and make him prosper, he won't bite you. (Barbra Streisand)

The main problem with men is that God gave us a brain and a penis but only enough blood to run one of them at a time. (Robin Williams)

You never really know a man until you've divorced him. (Zsa Zsa Gabor)

I feel like a million tonight – but one at a time. (Mae West)

You could put everything I know about men on the head of a pin and still have room for The Lord's Prayer. (Cher)

He's the kind of man a woman would have to marry to get rid of. (Mae West)

When God made men she was only joking. (Whoopi Goldberg)

Man is the only rat who's always looking for cheesecake instead of cheese. (Groucho Marx)

Men are like parking spaces. The good ones are either too small or they're already taken. (Lily Tomlin)

Give a man a free hand and he'll run it all over you. (Mae West)

Men are basically two-faced, insatiable whoremongers. (Kim Cattrall)

There are no real men in Hollywood. They're either married, divorced, or want to do your hair. (Doris Day)

Men and Women

When he pushed that grapefruit in May Bush's face, Jimmy Cagney was epitomising one of the great mysteries of all time: Why do ladies prefer bastards? (Diana Dors)

Woman is made for man. Man is made for life. (Richard Burton)

When women go wrong, men go right after them. (Mae West)

Women have an unfair advantage over men. If they can't get what they want by being smart, they can get it by being dumb. (Yul Brynner)

The only time a woman really succeeds in changing a man is when he's in diapers. (Natalie Wood)

I'm the modern, intelligent type of woman. In other words, I can't get a man. (Shelley Winters)

The best way to get revenge on a man you hate is to marry him. (Ava Gardner)

Before marriage a girl has to make love to a man to hold him. After marriage she has to hold him to make love to him. (Marilyn Monroe)

Women who dress to please men should know that they don't have to dress to please men. (Mae West)

Menages-a-trois

My first and only three-way took place the night I took my Oscar home to the marital bed. (Halle Berry)
I only take Viagra when I'm with more than one woman. (Jack Nicholson)

Two is company. Three is $500. (Heidi Fleiss)

Sex is a wonderful thing between two people. If you can get between the right two people. (Woody Allen)

The Menopause

Don't worry about the menopause – worry about the men who don't. (Zsa Zsa Gabor)

Joan Collins' whole career is a testament to menopausal chic. (Joan Rivers)

Menstruation

When women get a period, it's very difficult for them to function as human beings. (Jerry Lewis)

Why was Marilyn Monroe unpredictable? My theory is that she started to menstruate every time the camera rolled. (Robert Mitchum)

In a world without men there would be no war – just intense negotiations every 28 days. (Robin Williams)

Smart secretaries never miss a period. (Bob Hope)

I had my first period at fourteen when staying with relatives. Not willing to ask them for assistance, I ended up stealing a pillow case from the airing cupboard and shoving it between my legs. I went home on the bus in some discomfort and got off it walking like John Wayne. (Julie Walters)

Women complain about PMS but I think of it as the only time of the month when I can be myself. (Roseanne Barr)

Better late than pregnant. (Natalie Wood)

Mental Health

In Hollywood everyone is either an analyst, going to an analyst, or an analyst going to an analyst. (Truman Capote)

Not everyone who wants to make a film is crazy but almost everyone who's crazy wants to make a film. (Clive James)

Method Acting

Robert De Niro only comes alive in other people's bodies. (Paul Schrader)

I worked with a Method actor once. He told the director he was having trouble working up motivation for a scene. The director said, 'Try your pay check.' (Spencer Tracy)

Method acting? There are quite a few methods. Mine involves a lot of talent, a glass, and some cracked ice. (John Barrymore)

This Method actor asked the director of the film he was making what was his motivation. The director replied, 'Asshole, if you don't do it like I tell you to do it, I'll get another asshole.' (Tony Curtis)

Before Burt Lancaster can pick up an ashtray he discusses motivation. Just pick up the ashtray and shut up. (Jeanne Moreau)

Middle Age

Middle age is the time of life when a man's fantasies revolve around a bank manager saying yes instead of a woman. (Jane Fonda)

Middle age is when your age starts to show round the middle. (Jackie Gleason)

The really frightening thing about middle age is the knowledge that one day you'll grow out of it. (Doris Day)

Millionaires

Marlon Brando told me I wrote plays as if I didn't know there were people starving to death. I'm told he's a millionaire now. (Noel Coward in the mid-fifties)

I was a millionaire at the age of 32 but it didn't mean much to me. You can only buy so many towels. (Oprah Winfrey)

Children at kindergarten in Hollywood learn to count like this: 'A million and one, a million and two, a million and three…' (Billy Crystal)

My ideal man would be kind and understanding. Is zat too much to ask of a millionaire? (Zsa Zsa Gabor)

I get increasingly disenchanted with acting. As the years totter past I find it ludicrous learning some idiot's lines in the small hours of the night so I can remain a millionaire. (Richard Burton)

Minimalism

The only piece of direction Alfred Hitchcock gave me on the set of *Marnie* was when I was listening to what somebody was saying in a scene with my mouth open, as I often do, and he thought it would look better shut. (Sean Connery)

I was doing a scene for Billy Wilder one day and he said 'Give me less'. I did that but on the next take he said the same again. When he said it for the third time I said, 'Billy, if I give you any less than that I'll be doing nothing.' He said, 'Now you're getting it.' (Jack Lemmon)

Don't just do something. Stand there. (Clint Eastwood)

Miracles

For two people in a marriage to live together day after day is unquestionably the one miracle the Vatican has overlooked. (Bill Cosby)

We need to puncture the idea that childbirth is a miracle. A miracle is raising a kid who doesn't talk at a movie. (Bill Hicks)

I've been dogged by the prettyboy tag so long, it's a miracle I didn't become a self-conscious blob of protoplasm. (Robert Redford)

Mirrors

Actors marrying actors play a dangerous game. They're always fighting over the mirror. (Burt Reynolds)

I think everyone should break all the mirrors in their house – one every year – to guard against vanity. You'd be left with just a tiny one above the kitchen sink to help you get the spinach out of your teeth. (Debra Winger)

Cliff Richard has love bites on his mirror. (Geoff Hyams)

What's the best way to drown Kevin Costner? Put a mirror at the bottom of his swimming pool. Pauline (Kael)

Miscasting

When Liz Taylor plays Cleopatra as a political animal she screeches like a ward heeler's wife at a block party. (*Time*)

The script demands a neurotic. Instead it gets a hockey captain with romantic leanings. (Kenneth Tynan on Julie Christie in *Darling*)

Eddie Murphy skulks through *Another 48 Hours* like a pasha who's been ordered to perform for his slaves. (Owen Gleiberman)

She picks at the part with the daintiness of a debutante called upon to dismember a stag. (Kenneth Tynan on Vivien Leigh in *Anthony and Cleopatra)*

Stewart Granger appears as Paganini and pretends to play the violin. He seems to be sawing wood with one hand and milking a cow with the other. (Elspeth Grant on Granger in *The Magic Bow*)

She was about as moving as Imelda Marcos pleading for a new pair of shoes. (Michael Redmond on Madonna's effort to portray a missionary in *Shanghai Surprise*)

Misconceptions
My father thought Hollywood was a small place somewhere on the other side of the Welsh mountains. (Richard Burton)

People saw James Dean as a little waif but in reality he was a pudding of hatred. (Elia Kazan)

I thought *Deep Throat* was about a giraffe. (Bob Hope)

I used to think lacrosse was something you found in la church. (Robin Williams)

Table For Five is a TV show? I thought it was a reference to Jennifer Lopez' ass. (Joan Rivers)

Misfires
Most of it played like a picnic at a cemetery. (Lee Server on *The Last Tycoon*)

It's like pushing a prune pit with my nose from here to Cucamonga. (Marlon Brando on Morituri)

If there's an afterlife and I'm to be punished for my sins, *Reunion in France* is one of the pictures they'll make me see over and over again. (Joan Crawford)

I have mixed feelings about my last movie. Half of me hates it and half of me detests it. (Lana Turner)

What did I think of *Titanic*? Frankly, I'd rather have been on it. (Miles Kruger)

I was once in a film called *Oh Dad, Poor Dad, Mama's Hung You in the Closet and I'm Feelin' So Sad*. Need I say more? (Rosalind Russell)

Mistakes

Hollywood is a place where people from Iowa mistake each other for stars. (Fred Allen)

By the time you reach my age you've made plenty of mistakes if you've lived your life properly. (Ronald Reagan in 1987)

If I had my life to live over again I'd make all the same mistakes, only sooner. (Tallulah Bankhead)

Every man makes mistakes but married men find out about them sooner. (Red Skelton)

Being born was my first big mistake. (Robbie Coltrane)

Keep quiet. You're always interrupting me in the middle of my mistakes. (Michael Curtiz)

I made a terrible mistake at the Fashion Café. I hung up my coat on Kate Moss. (David Letterman)

Mistaken Identity

Bogie's okay until he's had a few drinks. After that he thinks he's Humphrey Bogart. (Dave Chasen)

I was once in the Thalberg building and this woman backed into me on the elevator. I took her hat and lifted up the brim and it turned out it was Greta Garbo. I said, 'I'm terribly sorry, but I thought you were a fellow I knew from Kansas City.' (Groucho Marx)

I did not swing in the trees with fucking Tarzan. (Maureen O'Hara after being confused with Maureen O'Sullivan)

I think Gary Cooper and Greta Garbo are the same person. Have you ever seen them in a film together? (Ernst Lubitsch)

Otto Preminger is really Martin Bormann in elevator shoes with a facelift by a blindfolded plastic surgeon in Luxembourg. (Billy Wilder)

Mixed Blessings

Acting isn't very hard. The most important things are to be able to laugh or cry. If I have to cry, I think about my sex life. If I have to laugh, I think about my sex life. (Glenda Jackson)

The *Way We Were* is close to the top of movies men hate. All men want to look like Robert Redford, but not if they're going to end up with Barbra Streisand. (Joe Queenan)

Jessica Lange is like a delicate fawn crossed with a Buick. (Jack Nicholson)

Modernity

This isn't the age of manners. It's the age of kicking people in the crotch. (Ken Russell)

Let's bring this script up to date with some snappy 19th century dialogue. (Sam Goldwyn)

Moguls

Isn't God good to me? (Louis B. Mayer after hearing of the death of his rival Irving Thalberg)

Darryl F. Zanuck looked like a humanized ferret in a Disney film. (Tom Wiseman)

To understand Sam Goldwyn you must realise he regards himself as a nation. (Lillian Hellman)

To me, Louis B. Mayer's arm around your shoulder meant his hand was closer to your throat. (Jules Dassin)

Jack Warner has oilcloth pockets so he can steal soup. (Wilson Mizner)

In Hollywood you could make jokes about almost anything, including God and the Pope, but you could *not* make jokes about Louis B. Mayer. (Ruth Warrick)

I don't get ulcers – I give 'em. (Harry Cohn)

My understanding is that an assignment with you consists of three months work and six months recuperation. (Nunnally Johnson to David O. Selznick prior to a writing contract).

Sam Goldwyn, Louis B Mayer and Harry Cohn would all have sold their mothers, but Cohn would have delivered her. (Bob Hope)

Money

After acting with Joan Crawford I resolved never to make another movie no matter how much they paid me. And I like money. (Sterling Hayden, who'd been with Crawford in *Johnny Guitar*).

Most of my money went on gambling and women. The rest I spent foolishly. (George Raft)

He brought to all his roles the quality of needing the money. (Stephen Fry on Errol Flynn)

Cash And Cary. (Newspaper headline on the wedding of Cary Grant to the super-rich Barbara Hutton)

A little hush money can do a lot of talking. (Mae West)

I spent so much on my girlfriend when I was dating her that I decided to marry her for my money. (Richard Pryor)

With all that money Minnie Driver has, wouldn't you think she could afford a bigger car? (Bill Bailey)

If I can't take it with me, I'm not going. (Jack Benny)

Money can't buy happiness. That's why we have credit cards. (Red Skelton)

The two most beautiful words in the English language are 'Cheque .' (Dorothy Parker)

Men pay cash to women twice in their life. First to get them and second to get rid of them. (Hedy Lamarr)

On a fine day in December 1924 I was down to that essential starting place for actors: I was broke. (Gary Cooper)

Monogamy
Marriage requires a special talent, like acting, but monogamy requires genius. (Warren Beatty)
Isn't monogamy a kind of furniture? (Jayne Mansfield)

Marilyn Monroe
On screen she was the sexiest woman in the world but in real life she was blah. (Kirk Douglas)

To put it bluntly, I seem to be a whole superstructure without a foundation. (Marilyn Monroe)

Making a film with Marilyn was like going to the dentist – great when it was over. (Billy Wilder)

There goes a broad with a great future behind her. (Constance Bennett)

A vacuum with nipples. (Otto Preminger)

Copulation was Marilyn Monroe's uncomplicated way of saying thank you. (Nunnally Johnson)

Next to Marilyn Monroe, Lucrezia Borgia was a pussycat. (David Hall)

It wasn't Hollywood that killed Marilyn Monroe. It's the Marilyn Monroe's that are killing Hollywood. (Billy Wilder)

Moodiness
Oliver has three methods of acting: Moody One, Moody Two and Moody Three. (Ken Russell on Oliver Reed)

Clint Eastwood has two expressions on camera: sullen and angry. (Don Siegel)

My family wasn't The Brady Bunch. They were the Broody Bunch. (Sandra Bernhard)

Life with Maria was like living on the edge of a volcano. Except that she was much better-looking than the average volcano. (Jean-Pierre Aumont on Maria Montez)

Mothers

My mother has morning sickness *after* I was born. (Steve McQueen)

They say that life begins when the foetus can exist apart from its mother. By this definition many people in Hollywood are legally dead. (Jay Leno)

Motherhood didn't interest me so I didn't do it. I would have made a terrible parent. The first time my child didn't do what I wanted, I'd kill him. (Katharine Hepburn)

My only childhood contact with my mother was when she took me between her knees to pull lice out of my head. (Charles Bronson)

At the end of my career I would have played Frankenstein's mother to find work. (Bette Davis)

The world is not full of mother fuckers. It is full of fucking mothers. (Frances Farmer)

Mothers-In-Law

If Woody Allen ever married Soon-Yi, Mia Farrow would be his mother-in-law. (Cindy Adams)

My mother-in-law is very objective. She objects to everything. (Beverly D'Angelo)

Motivation

I'd been goofing around all my life so I thought I might as well get paid for it. (Mel Gibson)

There had to be something better than the bloody chemist's shop. (Glenda Jackson)

The reason I became an actress was to fuck that divine Gary Cooper. (Tallulah Bankhead)

I did it for the loot, honey, always the loot. (Ava Gardner)

I became a film director because I was hungry. (John Ford)

The only reason I went into films was to meet girls and qualify for health insurance. (Harrison Ford)

Why did I get into acting? No heavy lifting. (Sean Connery)

Mouths
My mouth is so dry they could shoot *Lawrence of Arabia* in it. (Dyan Cannon)

Julia Roberts has a very big mouth. When I was kissing her I was aware of a faint echo. (Hugh Grant)

I'm not saying Angelina Jolie has a big mouth but when she got pregnant it was the first time anyone saw lips on an ultrasound. (Paul Byrne)

Multi-Lingualism
Ingrid Bergman speaks five languages and can't act in any of them. (John Gielgud)

My son is bilingual and my daughter is tri-lingual. I'm not even lingual. (William Holden)

Multi-Tasking
Warren Beatty was sexually insatiable. He wanted to make love three, four times a day. And he was able to accept phone calls at the same time. (Joan Collins)

I like to drive with my knees. Otherwise how can I put on my lipstick and talk on the phone? (Sharon Stone)
Frederic March was able to do a very emotional scene and pinch my fanny at the same time. (Shelley Winters)

It's easy to direct while acting. There's one less person to argue with. (Roman Polanski)

Murder

Even if I did kill Nicole, doesn't that prove I loved her? (O.J. Simpson on his murdered wife)

Did you read about the woman who stabbed her husband 37 times? I admire her restraint. (Roseanne)

If I really did have a licence to kill, I would use it to kill the producer and director of *The Avengers*. (Sean Connery after making that movie).

All men are dogs and sooner or later they start barking. At least my character in *Basic Instinct* has the good sense to kill them after having sex so they won't go around spouting nonsense. (Sharon Stone)

We should put convicted killers in movies to punish them. 'Jeffrey Dahmer, your crimes against humanity of which you've been found guilty, I sentence you to Wes Craven's next picture.' (Bill Hicks)

I met some strange guys in my past but my mother was desperate to get me married. She'd say things like, 'Okay, so he's a murderer, but he's a *single* murderer. (Joan Rivers)

Music

The other night I thought Nancy had one of George Burns' records on but it turned out to be a spoon caught in the garbage disposal. (Ronald Reagan)

When Jack Benny played the violin it sounded as if the strings were still back in the cat. (Fred Allen)

Rock'n'roll is phony and smug and written and played for the most part by cretinous goons. (Frank Sinatra)

Talking about music is like dancing about architecture. (Steve Martin)

In *The Godfather* Marlon Brando's voice was like asthma set to music. (Sid Caesar)

I play piano just like Rachmaninov – with both hands. (George Burns)

The nicest thing you can say about *Human Highway* is that as a film-maker Neil Young is a great guitarist. (Entertainment Weekly)

I hate music, especially when it's played. (Jimmy Durante)

Music Scores

This is a good music score by Mahler. Has he done anything else lately? (Sam Goldwyn)

A film musician is like a mortician. He can't bring the body back to life, but he's still expected to make it look better. (Tony Thomas)

Names

I always felt I was meant to cross myself when I said Orson Welles' name. (Marlene Dietrich)

Always end the name of your child with a vowel so that when you yell it will carry. (Bill Cosby)

My sex life is so bad, they named a Jewish feast after me. The Passover. (Woody Allen)

It must be tough having a beautiful mother like Cher and being named Chastity. The only thing worse would be being beautiful and being called Slut. (Ava Gardner)

I've always hated my name. It rhymes with something beginning with 'C'. (Emily Blunt)

Tallulah Bankhead was named after a waterfall. First mistake. It should have been after a hurricane. (Denis Brian)

Groucho isn't my real name. I'm just breaking it in for a friend. (Groucho Marx)

I can't cast someone whose name sounds like a small Polynesian island. (Terence Davies on Keanu Reeves)

My mom never saw the irony in calling me a sonofabitch. (Jack Nicholson)

I'm the only man I know whose two names are synonyms for penis. (Peter O'Toole)

I never heard my father call my mother by another name than 'Hey, you'. (Kirk Douglas)

I usually refer to Dick Van Dyke as Penis Lorry Lesbian. (Stephen Fry)

My husband's name is Rip Torn. Our mailbox says 'Torn Page.' (Geraldine Page)

I'd hate to have Loretta Young's last name. What happens when you get old? (Bette Davis)

Name Changes
Barbra Streisand should have been called Barbra Strident. (Stanley Kaufman)

The world would not be in such a snarl, had Marx been born Groucho instead of Karl. (Irving Berlin)

When I started out in films they wanted me to change my name to Bettina Dawes. I told them I wouldn't go through life known as Between the Drawers. (Bette Davis)

The only reason Nelson Eddy became famous is because he turned his name around. He was born Eddie Nelson. Can you imagine a star called Eddie Nelson? (Billy Wilder)

John Revolting and Olivia Neutron Bomb. (Clive James on the cast of *Grease*)

Pamela Lee said her name is tattooed on her husband's penis. Which explains why she changed her name from Anderson to Lee. (Conan O'Brien)

Narcissists
Warren Beatty is the type of man who'll end up dying in his own arms. (Mamie van Doren)

Michael Wilding is in love with himself but he's not sure if it's reciprocated. (Richard Burton)

The last time I saw Peter Sellers he was walking down Lover's Lane holding his own hand. (Britt Ekland)

We had a lot in common. I loved him and he loved him. (Shelley Winters on Tony Franciosa)

It is good for man to love himself but for an actor it is absolutely essential. (Robert Morley)

In Hollywood the eternal triangle usually consists of an actor, his wife and himself. (John Updike)

I was born Hebrew but converted to narcissism. (Woody Allen)

Nationality

I'm British when I win an award and Irish when I'm found lying drunk at some airport. (Richard Harris)

My nationality is Turkish, Italian, Chinese, Hindustan, Japanese, Mongolian, Mexican, Irish, Aztec and Scandinavian. (Anthony Quinn)

The Welsh are the same as the Irish – a lot of goddam micks and biddies, only Protestant. (John Ford)

There are two things a Frenchman will always give you: good manners and directions to the nearest public toilet. (Ray Milland)

I knew Daniel Day-Lewis before he was Irish. (Stephen Frears)

I'm half English and half American. My passport has an eagle with a tea-bag in its beak. (Bob Hope)

Nature

Other people have analysts. I have Utah. (Robert Redford)

Beyond the Alps lies more Alps and the Lord Alps those that Alps themselves. (Groucho Marx)

Of all the wonders of nature, a tree in summer is perhaps the most remarkable, with the possible exception of a moose singing 'Embraceable You' in spats. (Woody Allen)

Nepotism

The reason I appeared in so many films with Charles Bronson wasn't because he was my husband. It was because nobody else would work with him. (Jill Ireland)

The son-in-law also rises. (Edwin Knopf on David O. Selznick after he married Louis B. Mayer's daughter)

Night Watchmen

It's one of the tragic ironies of the theatre that only one man in it can count on steady work – the night watchman. (Tallulah Bankhead)

Night watchmen in horror films have a life expectancy of about twelve seconds. (Sam Waas)

Non-Conformity

I'm an equal opportunity offender. (Nicolas Cage)

I wouldn't want to belong to any club that would have me as a member. (Groucho Marx)

If I could get my membership fee back I'd resign from the human race. (Fred Allen)

Noses

Whenever people tell me that what I'm looking for it right under my nose I always ask them to be more specific. (Jimmy Durante)

If anyone looked at him sideways he got a nosebleed. (Peter Biskind on Steven Spielberg as a youth)

Dean Martin's original nose made him look like he was permanently eating a banana. (Alan King)

No-Shows

Going to a school reunion would be pointless for me now. There wouldn't be anyone there. (Clint Eastwood at 80)

I'm afraid Warren Beatty can't be with us tonight. He's at the Cedars-Sinai hospital attending the birth of his next wife. (Jackie Mason)

I drank three bottles of vodka yesterday. It is not a good idea to drink so much. I shall miss all the marriages of my various children and they'll be angry because there'll be nobody around to make bad puns. (Richard Burton)

I'm afraid I can't make it, Mom, but I promise to come to your next one. (Liza Minnelli turning down an invitation to Judy Garland's fourth wedding)

Nouvelle Vague
There is no New Wave. There is only the sea. (Claude Chabrol)
Nuances
In Hollywood it's okay to be subtle so long as you make it obvious. (Alfred Hitchcock)

Nudity
I was disgusted when I saw the nudity in the musical *Hair*. I watched the whole performance with my hands over my ears. (Groucho Marx)

My peectures are getting nakeder and nakeder. (Maria Montez)

People who live in glass-houses shouldn't walk around naked. (Rita Rudner)

The sexiest thing in the world is to be totally naked with your wedding band on. (Debra Winger)

I think I'll slip into something more comfortable – like my skin. (Marilyn Monroe)

I don't see the point of nudity. My breasts aren't actresses. (Liv Ullman)

Nobody gives a monkey's uncle about nudity today, be it male or female, unless you've got three tits. (David Hemmings)

I'm not a tiny woman. When Sophia Loren is naked, there is a lot of nakedness. (Sophia Loren)

If I'm ever nominated for an Oscar I promise to turn up in the nude. (Raquel Welch)

I always tell film-makers I'm happy to run around in the buff if my co-star runs around with his willy hanging out. (Michelle Pfeiffer)

The only time you ever see a penis in the movies is if a pervert sits down next to you. (Elayne Boosler)

I think nudity is disgusting. But if I were 22, with a great body, it would be artistic, tasteful, patriotic and a progressive progressively religious experience. (Shelley Winters)

If God had meant people to go naked they would have been born that way. (Bob Hope)

It is disconcerting to be naked in a Japanese bath and to be massaged by a young girl who has picked up a few English phrases and remarks as she is walking up and down your spine, 'Changeable weather we are having lately.' (Peter Ustinov)

Nymphomaniacs

A Jewish nymphomaniac is a woman who will make love to a man on the same day she has her hair done. (Maureen Lipman)

If all the girls at Vasser were laid end to end, I wouldn't be at all surprised. (Meryl Streep)

One drink and she's anyone's. Two and she's everyone's. (Michael Johnson on Clara Bow)

There was an upside to the fact that I once played a nymphomaniac: I'm not married anymore. (Tea Leoni)

What's the difference between Madonna and McDonalds? McDonalds has only served 70 billion. (Internet Joke)

I'm tired. Send one of them home. (Mae West after being informed that ten men were waiting outside her dressing-room)

I like to wake up every morning feeling a new man. (Jean Harlow)

Obesity

You know you're fat when you can't get into the bath at the same time as the water. (Rodney Dangerfield)

I'm sometimes mistaken for a sumo wrestler when I travel. (Marlon Brando)

When Liz Taylor steps on an airplane there's only room for herself and the pilot. (Joan Rivers)

My grandmother used to take my mother to the circus to see the fat lady and the tattooed man. Now they're everywhere. (Joan Collins)

My tailor uses an elastic measuring tape. (Burl Ives)

Did you ever go up to a fat person for street directions? They say things like, 'Go right past Wendy's, McDonalds, Burger King, Taco Bell, Kentucky Fried Chicken. It's the chocolate brown building.' (Roseanne Barr)

Floating in his pool, Charles Laughton was the reverse of an iceberg: 90% of him was visible. (Peter Ustinov)

My tailor has three sizes: Small, medium and 'It's him again'. (Fatty Arbuckle)

Obscurity

Before Tom Hanks made *Big* he wasn't even a household name in his household. (Barry Norman)

For years I was able to walk the streets unrecognised ... except by people who thought I was Dustin Hoffman. (Al Pacino)

My grandfather was a humble man. At his funeral, the hearse followed the other cars. (Woody Allen)

Obsequiousness

It was easy enough to make Al Jolson happy. You just had to cheer him for breakfast, applaud wildly for lunch and give him a standing ovation for dinner. (George Burns)

You get to the point in Hollywood where you bump into walls and say, 'Excuse me' in case you might have offended someone who could get you a job. (Joe Pesci)

The key to getting ahead in Hollywood is to schmooze, but make sure you schmooze the right people. I once spent an hour and a half schmoozing the pool man. I didn't get the part but I had a free supply of chlorine for a year. (Jon Lovitz)

Octogenarians

I'm at the age where just putting my cigar into the holder is a thrill. (George Burns at 87)

Age is only a number. However, in my case it is a rather large number. (Bob Hope at 80)

The papers just said I was nearly eighty. What the hell. It's a better line than 'Services will be private.' (Jack Warner)

Oddballs

Paul Newman is an oddity in the film business. He loves his wife. (Gore Vidal)

I love her but her oars aren't touching the water these days. (Dean Martin on Shirley MacLaine apropos her reincarnation rantings)

When I drank heavily in my youth I used to think I was John the Baptist. I talked to the sea and it talked back to me. (Anthony Hopkins)

Off-Screen

You see girls doing things on the screen today that they used to do off the screen to get on screen. (Gene Autry)

On screen, Humphrey Bogart was a cigarette–toting legend. Off it he was just a crumpled old pensioner coughing his way through his favourite Lucky Strikes. (George Cockerill)

Old Age

These days when I go to the beauty parlour it's just for an estimate. (Gina Lollobrigida in her sixties)

Old age is when actions creak louder than words. (Jimmy Durante)

Zsa Zsa Gabor knew Howard Johnson when he had only two flavours. (Oscar Levant)

The only whistles I get these days are from the tea kettle. (Raquel Welch)

Inside, I am twelve years old. That's why I've never voted. I'm underage. (Sophia Loren on her 60th birthday in 1994)

I'm now at the age where I've got to prove that I'm just as good as I never was. (Rex Harrison)

When I wake up in the morning and nothing hurts, I know I must be dead. (George Burns)

There comes a time when you've got to face the fact that you're just another old broad. (Ava Gardner)

One-Night Stands

I'm not into that one-night thing. I think a person should get to know someone and even be in love with them before using and degrading them. (Steve Martin)

What I'm looking for is a meaningful one-night stand. (Dudley Moore)

The thing about one-night stands is, nobody is standing. (Billy Crystal)

Operations

Jackie Gleason had a big heart transplant in Chicago, a five-hour operation. Four of these were spent trying to get him on the operating table. (Bob Hope)

Make sure I don't have a curly tail when they take me out of the theatre. (John Wayne after he had a heart valve replaced with one from a pig in 1978)

Zsa Zsa Gabor had four operations on her nose but it got worse with each one. At the moment it looks like an electric plug. (Anita Ekberg)

Opportunists

Mike Todd was an open-hearted sort who would pass out salted nuts at his own hanging if he owned the beer concession. (*Time* magazine)

Dying was a good career move for James Dean. (George Stevens)

I'm not a star yet but she's going to make me one. I'm going to use her, that no-talent Hollywood nothing. (Richard Burton's alleged comment to Eddie Fisher about Liz Taylor shortly after meeting her).

Madonna looks like a whore and thinks like a pimp. In other words. she's the very best sort of modern girl. (Julie Birchill)

You gotta get up early in the morning to catch a fox and stay up late at night to get a mink. (Mae West)

Orphanages

They asked Jack Benny if he would do something for the Actor's Orphanage so he shot both his parents and moved in. (Bob Hope)

My mother hated me. She once took me to an orphanage and told me to mingle. (Phyllis Diller)

Oscars

Was she given the nod for her performance or her pout? (Mark Cagney on Kiera Knightley's nomination for *Pride and Prejudice*)

Oscars make nice doorstops. (Alfred Hitchcock)

I didn't wait until I won one to tell the Academy to jam it up their ass, like Marlon. (George C. Scott on Marlon Brando's Oscar refusal for *The Godfather*)

Oscars are nice but they don't make you a better actress. (Glenda Jackson)

Brenda Blethyn is an Oscar virgin. That's the only type of virgin she is. (Mike Leigh)

I'll never forget the night I took my Oscar home. My husband took one look at it and I knew my marriage was over. (Shelley Winters)

If you're nominated and you don't win everyone pretty much forgets it after a week. And if you're nominated and you do win, everybody pretty much forgets it after two weeks. (Tom Hanks)

I won an Oscar for *Butterfield 8* because I didn't die. (Elizabeth Taylor)

The Oscar ceremonies of 1983 went on longer than my career. (Julie Walters)

Kate Winslet should have got the Oscar for Best Bust in *Titanic*. Anyone with those two floaters doesn't need a lifeboat. (Camille Paglia)

I was glad to see John Wayne win the Oscar. I'm always glad to see the fat lady win the Cadillac on TV too. (Robert Mitchum)

I can't see what Jack Warner would want with an Oscar. It can't say yes. (Al Jolson)

The Academy Awards ceremonies. A night of great glitz, great glamour … great acting. (Bob Hope)

The reason I didn't marry Anjelica Huston is because I'd prefer to have more Oscars than marriages. Walt Disney got 32. I'd like to beat that. (Jack Nicholson)

Whoopi Goldberg should win the Oscar for 'Best Actress At Looking As Though She Slept In Her Dress.' (Mitchell Symons)

Just think what you could accomplish if you tried celibacy. (Shirley MacLaine to Warren Beatty after her received four Oscar nominations for *Heaven Can Wait*)

The security is heavy here tonight - and so is the insecurity. (Michael Caine at the 1984 Oscar ceremonies)

Anybody who plays a hunchback has got a better chance of getting an Oscar than a leading man. That's the revenge of the voters. They don't get the girls either. (Billy Wilder)

I'm a change of pace from the previous hosts. The Academy wanted someone completely devoid of humour. (Laurence Olivier at the 1958 Oscars)

Overkill
Marlon Brando made a lot of scratch from an itch. (Peter Evans)

The trouble with Cecil is that he always bites off more than he can chew – and then chews it. (William de Mille on his brother)

Actors only ever want one thing said to them after a performance: 'Hail to thee of God. Rise and lead thy people.' (Michael Simkins)

Over-Ratings
Laurence Olivier is the most over-rated actor on earth. Take away the wives and the looks and you have John Gielgud. (Oscar Levant)

Paparazzi
Leonardo Di Caprio may be getting sued because he hurled horse manure at the paparazzi while filming his latest movie. In his defence DiCaprio said, 'It wasn't horse manure. It was the script.' (Conan O'Brien)

The best way to fool the paparazzi is to have Halle Berry one night, Salma Hayek the next and then walk on a beach holding hands with Leonardo di Caprio. (George Clooney)

Parenting
How do I cope with my children? I have a big house. And I hide a lot. (Mary Ure)

My parents didn't like me as a child. They'd send me to the store for food, and then they'd move. (Richard Pryor)

I want to have children but I know my time is running out because I want to have them while my parents are still young enough to look after them. (Rita Rudner)

Parents are the bones upon which children sharpen their teeth. (Peter Ustinov)

Avenge yourself. Live long enough to be a problem to your children. (Kirk Douglas)

I keep them locked up in the attic and feed 'em dog food. (Mel Gibson on the secret of bringing up children successfully.)

I want a child very badly. Do you know anybody? (Dianne Wiest)

Parking

If I were God I would be quite ferocious. I would kill muggers, rapists and child killers for a start, and then people who park illegally. (Michael Winner)

Hollywood is like Disneyland staged by Dante. You imagine purgatory is like this, except the parking might not be as good. (Robin Williams)

Parties

I know a producer who throws a party when his film is a flop on the theory that people are only really happy with someone else's failure. (Arnon Milchan)

It is a matter of record that in 1959 I attended 336 parties, with invitations to more than 12 of them. (Groucho Marx)

On Rex Harrison's seventieth birthday I suggest we hire a telephone box and invite all his friends to a party. (Doug Hayward)

If I'd seen me at a party in my young days I'd never have gone up and met me. (Dustin Hoffman)

Maybe I've been married too many times. I love a good party abut I've recently realised that you can actually throw a party and not get married. (Whoopi Goldberg)

It's impossible to take a pee at a Hollywood bash. There are six people in every bathroom. You have to pretend you want to do drugs just to get into one of them. (Joel Silver)

If you go to a party in Hollywood and say something like, 'What do you think of the breakdown of the Iron Curtain?' the person you're speaking to will probably go, 'Oh, is that a new band?' (Loretha Jones)

I'm the kind of woman who, when she walks into a party, all the other women leave the room. (Lara Flynn Boyle)

At Hollywood parties if you didn't take the lady witting beside you upstairs between the soup and the *entrée*, you were considered a homosexual. (Walter Wanger)

Peeing

The only thing men really do better than women is peeing out a campfire. (Roseanne Barr)

Jack Warner went to the bathroom three times during a screening and told us our three piss picture' would be a stinker. Nobody could convince him he had a weak bladder. (Joe Eszterhas)

I drink too much. The last time I gave a urine sample it had an olive in it. (Rodney Dangerfield.)

Perfectionism

I gave up being serious about acting when I made a film with Greer Garson one time and it took her 125 takes to say 'No.' (Robert Mitchum)

Performances

My greatest performance was sitting through *Exodus* seven times and pretending I enjoyed it. (Peter Lawford)

Nicholson plays the role like the before half of a Dristan commercial, with his nasal passages blocked. (Charles Champlin of Jack Nicholson in *Goin' South*)

If I have occasionally given brilliant performances on the screen, this was entirely due to circumstances beyond my control. (George Sanders)

Marlon Brando's performance in *The Chase* is the worst thing that's happened to movies since Lassie played a war veteran with amnesia. (Rex Reed)

Permissiveness

They're doing things on the screen today that I wouldn't dare to do – even if I could. (Bob Hope)

The only pre-marital thing girls don't do nowadays is cook. (Omar Sharif)

When you look at the things that go on in movies nowadays, my story reads like Noddy. (Diana Dors)

In time audiences will get just as tired of people wrestling on a bed as they did of Tom Mix kissing his horse. (Mary Astor)

Remember when air was clean and sex was dirty? (George Burns)

We live in far too permissive a society. Never before has pornography been this rampant. And those films are *lit* so badly. (Woody Allen)

Phones
Show business is worse than dog eat dog. Its dog won't return other dog's phone calls'. (Woody Allen)

Ask not for whom the bell tolls – it's probably just a heavy breather. (Don Rickles)

I'm out now, but call me back in an hour. (Michael Curtiz on a phone call to a colleague)

Photographs
I don't have a photograph but you can have my footprints. They're upstairs in my socks. (Groucho Marx to a fan looking for a photo of him)

My photographs don't do me justice. They look just like me. (Phyllis Diller)

Raquel Welch is one of the few actresses in Hollywood history who look more animated in still photographs than on the screen. (Michael Medved)

My passport photograph only fits my nose. (Jackie Gleason)

I went into a bar and the bartender asked me what I'd have. 'Surprise me,' I said. He showed me a naked picture of my wife. (Rodney Dangerfield)

Pianos
When Phyllis Diller started to play the piano, Steinway came down personally and rubbed his name off it. (Bob Hope)

Pigs
Never wrestle with a pig. You both get dirty - and the pig likes it. (W.C. Fields)

Pick-Up Lines

A guy said to me once, 'That's a very nice dress you're wearing but it would look much better on my bedroom floor.' (Cameron Diaz)

I have socks older than you. (Harrison Ford's alleged pick-up line to Calista Flockhart)

What are you doing after the orgy? (Robert Mitchum)

Pills

In America you can buy a lifetime's supply of aspirin for a dollar and use it all up in two weeks. (John Barrymore)

I have more trouble getting a prescription for valium than I would having my uterus lowered and made into a penis. (Lily Tomlin)

Plagiarism

I've just come back from the Actor's Studio. I saw 17 Marlon Brandos and 13 James Deans. (Burt Reynolds)

I love copying myself. (Howard Hawks)

Most actors are like the very young. They long to rebel and conform at the same time. Now they do this by defying the public and copying each other. (Lorne Greene)

Plastic Surgery

I'm the female equivalent of a counterfeit $20 bill. (Cher)

If she stood beside a radiator she'd melt. (Joan Rivers on Pamela Anderson)

Victoria Principal married a plastic surgeon. Isn't that convenient? (Joan Rivers)

She's silicon from the knees up. (George Masters on Raquel Welch)

I've had so many things done to my body, when I die God won't even recognize me. (Phyllis Diller)

I was going to have cosmetic surgery until I noticed that the doctor's office was full of portraits by Picasso. (Rita Rudner)

A woman went to a plastic surgeon and asked him to make her like Bo Derek. He gave her a lobotomy. (Joan Rivers)

Playboy

I've never appeared as a *Playboy* centerfold. I couldn't stand the idea of having a staple put through my navel. (Diana Rigg)

If you're fourteen and worried about your appearance, listen carefully: Nobody looks like Miss January, not even Miss January. (Margot Kidder)

Barbra Streisand was once asked to appear in *Playboy* with her vital organ uncovered. Her mouth. (Walter Matthau)

Plays

I didn't like the play but then I saw it under adverse conditions: the curtain was up. (Groucho Marx)

Noel Coward was a terrible cunt and I never liked doing his plays because unless you were very careful you ended up sounding just like him. (Rex Harrison)

There's only one line in all of Tennessee Williams' plays that I consider memorable: a stage direction in *A Streetcar Named Desire*. (Richard Burton)

Two things in the play should have been cut: The second act and that youngster's throat. (Noel Coward)

Joan Crawford once asked me to take her to a play in L.A. 'But you've already seen it,' I said. 'Yes,' she said, 'but not in this dress.' (Clark Gable)

Plotlines

There are basically just two stories in movies: Going on a journey or the one where a stranger comes to town. (John Gardner)

It was a cute picture. They used the basic story of *Wuthering Heights* and worked in surf riders. (Neil Simon on *Last of the Red Hot Lovers*)

Frankenstein and *My Fair Lady* are really the same story. (William Holden)

These days plots are things directors sandwich in between the 15th car chase and the 27th explosion. If we're lucky. (Robert Downey Jr)

King Kong is the story of a dumb blonde who falls in love with a huge plastic finger. (Judith Crist)

Plumbers
Mae West was a plumber's idea of Cleopatra. (W.C. Fields)

The last plumber to visit me had obviously been told he looked like England's answer to Robert Redford. His jeans fitted so tightly there was hardly room for his tool kit. (Diana Dors)

Not only do I not believe in God, but try getting a plumber at the weekend. (Woody Allen)

Poets
If you're going to write, write one poem all your life, let nobody read it, and then burn it. (Jack Nicholson)

Roman Polanski

Polanski is a four foot Pole I wouldn't want to touch with a ten-foot pole. (Kenneth Tynan)

Asked by reporters about his upcoming marriage to a 42-year-old woman, Roman Polanski told reporters, 'The way I look at it, she's the equivalent of three 14-year-olds.' (David Letterman)

Politicians
A politician is a person who'll double-cross a bridge when he comes to it. (Oscar Levant)

I was married to both a communist and a fascist. Neither of them would take out the garbage. (Zsa Zsa Gabor)

If presidents don't do it to their wives they do it to their country. (Mel Brooks)

Ronald Reagan must have loved poor people because he made so many of them. (Edward Kennedy)

It's our fault. We should have given him better parts. (Jack Warner after hearing Reagan had been elected governor of California)

Politics

A woman could never be president of America. Candidates must be 35 or over. Where are you going to find a woman who'll admit to that? (Bob Hope)

Politics has produced more comedians than Hollywood ever did. (Jimmy Durante)

Harry Truman ruled the country with an iron fist – the same way he played the piano. (Bob Hope)

Some Californian people with a lot of money came to me and said they'd support me if I ran for politics. I said if I could play six weeks in Vegas and do two pictures a year, I'd do it. (Shirley MacLaine)

I always had a weakness for foreign affairs. (Mae West)

Today *The L.A. Times* accused Arnold Schwarzenegger of groping six women. I'm telling you, this guy is presidential material. (David Letterman)

The only way I'd be elected Governor is if all the drunks voted for me. (Dean Martin)

To err is Truman. (Jack Benny)

Politically speaking, Mel Gibson is somewhere to the right of Attila the Hun. (Susan Sarandon)

Ask not what you can do for your country, but what's for lunch. (Orson Welles)

The Pope

Must that silly old sod travel so much? He must cost each country he visits a bloody fortune. All for an idiot who says it's a sin for a man to lust after his own wife. (Richard Burton)

I worry about the Pope. He had a hip replacement. Now he has something in common with every little old lady on Miami Beach. Well, that and the hats and dresses. (Bette Midler)

I admire the Pope. I have a lot of respect for anyone who can tour without an album. (Rita Rudner)

Popularity

I'm Number 10 at the box office, right under Barbra Streisand. Can you imagine being under Barbra Streisand? Give me a bag. I may throw up. (Walter Matthau)

Are there sexy dead ones? (Sean Connery after being informed he was voted The Sexiest Man Alive in a poll)

Nobody likes my acting except the public. (John Wayne)

Pornography

It's a new low for an actress when you have to wonder what's between her ears instead of her legs. (Katharine Hepburn on Sharon Stone)

I once stole a pornographic book that was printed in Braille. I used to rub the dirty parts. (Woody Allen)

Billy Crystal is so cheap he likes to watch porn movies backwards so he can see the hustler giving back the money. (John Belushi)

I hate to think of this sort of book getting into the wrong hands. As soon as I've finished it, I shall recommend they ban it. (Tony Hancock on a pornographic novel he was reading)

After the first ten minutes watching a porn film I want to go home and screw. After twenty minutes, I never want to screw again as long as I live. (Erica Jong)

The late porn star Johnny Wadd claimed to have been laid 14,000 times. He died of friction. (Larry Brown)

In Irish porn films, the G-spot is guilt. (Cliodhna O'Flynn)

Real pornography is any movie starring Doris Day. (Al Alvarez)

Possessiveness

I loved my father when I was young but I also wanted him dead so I could have my mother to myself. (Anthony Perkins)

Ted Turner needs someone to be there 100% of the time. That's not love, it's babysitting. (Jane Fonda)

Poverty

I worked my way up from nothing to a state of extreme poverty. (Groucho Marx)

Love cures everything except poverty and toothache. (Mae West)

I come from a poor family. I never got an X-ray. My old man would just hold me up to the light. (Rodney Dangerfield)

When we moved to Cleveland there were people on the right side of the tracks and people on the wrong side of the tracks. We lived under the tracks. (Bob Hope)

My kids never had the advantages I did. They were born rich. (Michael Douglas)

I was once so poor I didn't know where my next husband was coming from. (Mae West)

Money is better than poverty, if only for financial reasons. (Woody Allen)

We were so poor my brother was made in Hong Kong. (Ronnie Corbett)

Preconceptions

People don't credit me with a brain so why should I disillusion them? (Sylvester Stallone)

If I played Hamlet, they'd call it a horror film. (Peter Cushing)

If I made *Cinderella,* the audience would be looking for the body in the coach. (Alfred Hitchcock)

Predictions

Gone With the Wind is going to be the biggest flop in Hollywood history. I'm just glad it'll be Clark Gable who's falling flat on his face and not me. (Gary Cooper in 1938)

Greta Garbo will be forgotten in ten years. (Clare Boothe luce in 1932)

My eighth grade class's prediction was that I would be the first lady ambassador to the moon. (Kathleen Turner)

When I was in junior high school the teachers voted me the student most likely to end up in the electric chair. (Sylvester Stallone)

Preference

I'd rather be a lamp-post in Denver than a dog in Philadelphia. (W.C. Fields)

I would rather have lighted matchsticks placed under my fingernails than make another film with Joan Crawford. (Bette Davis)

I'm not very keen on Hollywood. I'd rather have a nice cup of cocoa. (Noel Coward)

I would rather drink latex paint than be in a movie with Steven Seagal. (Henry Rollins)

I would give up everything I've ever achieved in acting to have played rugby for Wales. If we beat England at Twickenham, I'd die happy. (Richard Burton)

I love acting but it's much more fun taking the kids to the zoo. (Nicole Kidman)

I prefer going to films than plays. You can sneak out of a cinema easier if you don't like the film. (John Gielgud)

I prefer vegetables to human beings. (Lupe Velez)

I'd rather deal with a smart idiot than a stupid genius. (Sam Goldwyn)

I'd prefer to be married to five women for 7 years each than to one for 35. (John Cleese)

I'd rather be Frank Capra than God… if there is a Frank Capra. (Garson Kanin)

Pregnancy

Doing a movie is like being pregnant: You've got that terrible long wait to see if it's ugly. (Carol Burnett)

Marilyn Monroe wanted to get pregnant by Einstein. She figured if her baby had her looks and Einstein's brains it would be some achievement. But then somebody pointed out that it might be the other way round. (Sidney Skolsky)

What's really bad is going up to a friend you haven't seen in a while and saying 'Oh my God, you're pregnant' when they're not. I've done that, and I'll tell you – the look on his face! (Ellen DeGeneres)

After I got pregnant, all my son could say was, 'Wow, Mommy ate too much'. (Angelina Jolie)

When I told my daughter babies come from storks, she asked me how the storks got pregnant. (Phyllis Diller)

Making love in the morning got me through morning sickness. I found I could be happy and throw up at the same time. (Pamela Anderson Lee)

Premieres

When I first arrived in Hollywood there was some magic in it. Film premieres were regal occasions. We dressed to the nines. Today you see people in tennis shoes. (Peter O'Toole)

There's something about a crowd like that that brings a lump to my wallet. (Eli Walach at the premiere of *Baby Doll*)

My last movie spent so little time in the cinema they held the premiere at the video store. (Burt Reynolds)

Pre-Nups

My husband and I didn't sign a pre-nuptial agreement. We signed a mutual suicide pact. (Roseanne Barr)

Previews

It was a sneak preview. After half an hour everyone sneaked out. (Mel Brooks)

Priorities

I never forget that a woman's first job is to choose the right shade of lipstick. (Carole Lombard)

We're now living in an age where people are more concerned who shot JR than who shot JFK. (Larry Hagman)

What can you say about a society that says God is dead and Elvis is alive? (Ira Kupcinet)

Prison

How is this for logic: If you commit sodomy in Georgia they put you in a cell with another man, who's probably going to sodomise you. (Robin Williams)

Joan Crawford would have made an ideal prison matron. Possibly at Buchenwald. (Harriet van Horne)

People asked me if prison would change my attitude to Hollywood. It did. It made me realise it wasn't as good. (Robert Mitchum after being jailed for possession of marijuana)

They sent Oscar Wilde to Reading Jail for doing things today's actors get knighted for. (Wilfred Hyde-White)

Ten gets you twenty. (Elvis Presley on the consequences of under-age sex)

Problems

My main problem is reconciling my gross habits with my net income. (Errol Flynn)

My problems began before I was even born. (Steve McQueen)

My husband says, 'Roseanne, don't you think we ought to talk about our sexual problems?' Like I'm going to turn off 'Wheel of Fortune' for that? Roseanne Barr)

My problems all started with my early education. I attended a school for emotionally disturbed teachers. (Woody Allen)

Producers

In England a producer is a man who stages a play. On Broadway he's a man who finances a play. In Hollywood he's the man who interferes with a movie. (Orson Welles)

An associate producer is the only person who'll associate with a producer. (Fred Allen)

Hollywood producers are low grade individuals with the morals of a goat, the artistic integrity of a slot machine and the manners of a floorwalker with delusions of grandeur. (Raymond Chandler)

Most producers are failed directors. But then so are most directors. (Lyle Barnard)

A producer is a man who asks you a question, gives you the answer, and then tells you what's wrong with it. (Lamar Trotti)

Production Values

Hollywood's idea of production values is spending a million dollars dressing up a story that any good writer would throw away. Its vision of the rewarding movie is a vehicle for some glamour puss with two expressions and eighteen changes of costume, or some male model with a permanent hangover, six worn-out acting tricks, the build of a lifeguard and the mentality of a chicken strangler. (Raymond Chandler)

Products

What on earth is an Ashton Kutcher? It sounds like some useless item you see being sold on TV. In fact it is. (Bill Maher)

Actors are the only kind of merchandise allowed to leave the store at night. (Ava Gardner)

Progeny

Orlando Bloom sounds like the love child of Virginia Woolf and James Joyce. (Quentin Cooper)

Leonardo Di Caprio is patently the result of an unnatural act of passion between William Hague and the piglet from *Babe*. (A.A. Gill)

Prohibition

Once during Prohibition I was forced to live on nothing but food and water. (W.C. Fields)

I was T.T. until Prohibition. (Groucho Marx)

Projection

You know why I got so many dates? Because I have a forty-foot face. (Richard Dreyfuss)

The only way I'd work with Marlon Brando again is if he were in rear projection. (Joanne Woodward after completing *The Fugitive Kind*).

You can't fool a 70mm lens. It's terrifying what it picks up. You can see what time someone hobbled to bed. You can see the germs having a party in his eyeballs. (Peter O'Toole)

Promiscuity

Clara Bow was the kind of girl you'd always known, only you'd never known her as that kind of girl. (Adela Rogers St. John)

Michael Redgrave and Dirk Bogarde in *The Sea Shall Not Have Them*? I don't see why not. Everyone else has. (Noel Coward)

Psychiatrists

I told my wife I was seeing a psychiatrist. He said she was seeing an electrician, a plumber and two furniture repair technicians. (Rodney Dangerfield)

If you don't have a psychiatrist in Hollywood people think you're crazy. (Patrick Bergin)

The only reason I act is to make money to pay my psychiatrists. (Marlon Brando)

Couches are for one thing only. (John Wayne)

Publicity

Hollywood is the only place in the world where an amicable divorce means each party gets 50% of the publicity. (Lauren Bacall)

Bob Hope would go to the opening of a phone booth in Anaheim provided they had a camera and three people there. (Marlon Brando)

You can't shame modern celebrities. What used to be called shame and humiliation is now called publicity. (P.J. O'Rourke)

It's better to have loved and divorced than never to have had any publicity at all. (Ava Gardner)

Cesar Romero would attend the opening of a table napkin. (Jim Backus)

I don't care what they say about me as long as they spell my name wrong. (John Malkovich)

Publicity can be terrible, but only if you don't have any. (Jayne Mansfield)

Puns
I suppose you could live on boiled eggs and salad if the chips were down. (Richard Burton)

'Duck behind the sofa,' she said. 'There's no duck behind the sofa.' I told her. (Groucho Marx)

Dean Marin's been stoned more often than all the U.S embassies round the world. (Frank Sinatra)

At a hotel one time I asked the bellhop to handle my bag. He put his hand up my wife's dress. (Rodney Dangerfield)

Putdowns
Culturally and creatively, Jennifer Lopez is about as interesting as overheated meringue. (Barbara Ellen)

Debbie Reynolds wistful? She was about as wistful as an iron foundry. (Oscar Levant)

No more conscious than a side of beef. (John Boorman on Marcello Mastroianni)

He skulks through the picture like a pasha who's been ordered to perform for his slaves. (Owen Gleiberman on Eddie Murphy in *48 Hours*)

Playing a British spy dressed up as a German officer, he added to the confusion by sporting a pageboy hairstyle and giving his usual impersonation of a Welsh rugby forward who's just been told he's been dropped from the team. (Clive James on Richard Burton in *Where Eagles Dare*)

He overdrew on his intellectual bank account. (J.B Priestley on Tony Hancock)

Michael Caine's films are as disposable as Pampers. (William Wolf in *New York* magazine)

Tony Curtis is a passionate amoeba. (David Susskind)

Quentin Tarantino has the vocal modulation of a railway station announcer, the expressive power of a fence post and the charisma of a week-old head of lettuce. (Fintan O'Toole)

Pyjamas

Marriage is when a woman asks a man to remove his pyjamas because she wants to send them to the laundry. (Albert Finney)

That son of a bitch is acting even when he takes his pyjamas off. (Carole Lombard on William Powell)

My ideal day is sitting around the house in my pyjamas and laughing hysterically at very bad TV shows. (Jodie Foster)

I went to Moscow once. It was so cold at night one guy fell out of bed and broke his pyjamas. (Bob Hope)

Qualifications

John Ford may have been a son-of-a-bitch, but he was our son-of-a-bitch. (Ward Bond)

Louis B. Mayer may be a shit, but not every shit is Louis B. Mayer. (Herman Mankiewicz)

I'm a first rate second rate actor. (David Niven)

I have my standards. They may be low, but I have them. (Bette Midler)

I didn't leave my husband for another man. I left him for another woman – me. (Cher)

Questions

Have you chosen the subject of your next disaster yet? (Harry Cohn to Stanley Kramer after one of Kramer's films flopped)

Do you mind me asking what's on your mind, if you'll excuse the exaggeration? (Mel Brooks)

I'm busy now. Do you mind if I ignore you later? (Darryl F. Zanuck)

Queues

You had to stand in line to hate Harry Cohn. (Stanley Kramer)

Most men don't want to marry but the more you make it clear you don't want to marry *them,* there's a queue. (Shirley MacLaine)

In a multiplex the longest queue is always for the film you *don't* want to see. (Mitchell Symons)

Racism

I've never been racist. I hate everyone equally. (W.C. Fields)

Sammy Davis was told to get to the back of the bus one day. 'I'm not black,' he said, 'I'm Jewish'. The bus conductor said, 'Then get the hell off the bus'. (Frank Sinatra)

Rain

I'd prefer to produce than direct. I've noticed that when it starts to rain, the first person back at the hotel is the producer. (Michael Caine)

When I brought my mother to see Marlon Brando's house in Hollywood I thought she'd be impressed but all she said was, 'Someone left some washing out and I think it's going to rain'. (Gabriel Byrne)

Save a boyfriend for a rainy day. And another one in case it doesn't. (Mae West)

The only thing an actor saves for a rainy day is someone else's umbrella. (Lynn Bari)

If we re-made *Singin' in the Rain* today, Gene Kelly would be looking around on that street to make sure he wasn't going to get mugged. (Stanley Donen)

Range

My acting range consists of: Left eyebrow raised, right eyebrow raised. (Roger Moore)

Katharine Hepburn ran the gamut of emotions from A to B. (Dorothy Parker)

She played Emma as a mean-spirited bitch instead of a great-hearted whore, but I suppose that is her range. (Noel Coward on Glenda Jackson's portrayal of Emma Hamilton in *The Nelson Affair*)

When it comes to acting, Joan Rivers has the range of a wart. (Stewart Klein)

Rape

Rape is just assault with a friendly weapon. (Marlon Brando)

No man wanted me. Rapists would tap me on the shoulder and say, 'Seen any girls?' (Joan Rivers)

I was initially passed over for *The Accused*. They said I didn't look rapable enough. (Jodie Foster)

Every woman loves the idea of a sheikh carrying her off on his white horse and raping her in his tent. It's a basic feminine instinct. (Omar Sharif)

I've just rejected a script dealing with the rape of a 65-year old woman by an 18 year old. What's next – a 92 year old lesbian being raped by a fag? (Deborah Kerr)

Ratings

I'd be insulted if a picture I was in didn't get an X rating. (Mae West)

Movie ratings are simple. PG means the hero gets the girl. Over 15s means the villain gets the girl. Over 18s means everyone get the girl. (Michael Douglas)

If you cut a tit off with a sword it's a PG. If you suck it, it's an X. (Jack Nicholson)

Reading

Outside of a dog, a book is a man's best friend. Inside of a dog it's too dark to read. (Groucho Marx)

The only thing Californians read is the licence plate in front of them. (Neil Simon)

I always read the last page of a book first so that if I die I'll know how it turned out. (Nora Ephron)

Reality

Reality is just a crutch for people who can't cope with drugs. (Lily Tomlin)

Is a garbage can any more real than Buckingham Palace? (Cary Grant)

Reality Shows

Theatre actors look down on film actors. Film actors look down on TV actors. Thank God for reality shows as TV actors wouldn't have anything to look down on. (George Clooney)

When I entered *Celebrity Big Brother* I was misinformed. They should have called it *Nonentity Big Brother*. (Ken Russell)

Recluses

I'm allergic to humanity. (Brigitte Bardot)

I'm at the age where my back goes out more than I do. (Phyllis Diller)

Cary Grant was an aloof, remote person intent on being Cary Grant playing Cary Grant playing Cary Grant. (Frances Farmer)

Anytime I see my face on the cover of a magazine I go into remission. (River Phoenix)

I want to be alone. (Greta Garbo)

If Greta Garbo really wants to be alone, she should come to some of the screenings of her films in Dublin. (Hugh Leonard)

Reel Life and Real Life

The best role I ever played was that of Elizabeth Taylor's husband. (Richard Burton)

After I made *Silence of the Lambs* I could hardly stop at traffic lights without someone rolling down the window of their car, licking their lips and going, 'Had your dinner yet, Hannibal?' (Anthony Hopkins)

Love isn't like the movies. Walt Disney and Doris Day lied to us. I want my money back. (Jann Mitchell)

Errol Flynn had to play himself in some of his last movies instead of Robin Hood or Custer. Unfortunately, the task was beyond him. (Jack Warner)

Listen, buddy, I only *play* The Terminator: you married one. (Arnold Schwarzenegger to Tom Arnold about Roseanne Barr)

In *Some Came Running* I sat around most of the day playing cards with Frank Sinatra. The cameras stopped rolling and I sat around most of the day playing cards with Frank Sinatra. (Dean Martin)

In the movies when someone buys something, they never wait for their change. (George Carlin)

Every man I knew went to bed with Gilda…and woke up with me. (Rita Hayworth)

I wish I could remember the number of people who told me they 'were' Alfie, all the way from the Ravi Shankar to the Chief of Customs in Taiwan. (Michael Caine)

The trouble with life is the same as the trouble with movies: crap dialogue and bad lighting. (Elizabeth Taylor)

Refreshments

Why is it that the soda costs more than the tickets at movies these days? They serve you a cup of Coke so large, Ted Kennedy could drop an

Oldsmobile into it. Which means that halfway through the movie, you're so bloated you have to step outside for twenty minutes of dialysis. (Dennis Miller)

One of the golden rules of cinemas: If someone is eating popcorn from a bag rather than a bucket, they'll be sitting next to you. (Mitchell Symons)

Refusals

I once turned down the opportunity to direct a Barbra Streisand picture. I was afraid I'd break her nose. (John Cassavetes)

I'll be damned if I'll spend two years of my life on a camel. (Marlon Brando explaining why he refused *Lawrence of Arabia*)

It was only when George Raft turned down *Double Indemnity* that I knew I had a good picture. (Billy Wilder)

Regression

I have this overwhelming desire to return to the womb. Any womb! (Woody Allen)

Regrets

My one regret in life is that I'm not somebody else. (Woody Allen)

We had a small cyclone last week. It took one of the big trees in the backyard and blew it over onto Gabby Hayes' garage. My only regret is that Gabby was on the road. Otherwise it might have wiped out one of the most untalented actors in the movie industry. (Groucho Marx)

My only regret in the theatre is that I could never sit out front and watch myself. (John Barrymore)

Liz Taylor's getting married again. By now she must regret she didn't buy a time-share in Niagara Falls. (Johnny Carson)

If I had to live my life over again I would do two things differently. I wouldn't have married, and I'd have killed my father. (Marlon Brando)

Rehab

The last time a mosquito bit me it had to sign itself into the Betty Ford Clinic for detox. (Richard Harris)

Lindsay Lohan is in rehab. She's getting it out of the way before she's legally old enough to drink. (Jimmy Kimmel)

What clinic did Betty Ford go to? (George Carlin)

Reincarnation

Shirley MacLaine is the type of liberal that if she found out who she was going to be in her next life, she'd make a will and leave all her money to herself. (Colin Higgins)

I'd like to be reincarnated as Charlize Theron's shower soap. (Charlie Sheen)

Reinventions

I've had so many rebirths I should come with my own midwife by now. (Cher)

Jane Fonda is a woman who went from Barbarella to Stepford Wife. (David Frost)

It's hard for an old rake to turn over a new leaf. (John Barrymore)

Michael Jackson was a poor black boy who grew up to be a rich white woman. (Red Buttons)

Rejections

I can't imagine Clark Gable chasing you for ten years. (David O. Selznick rejecting Katharine Hepburn for the part of Scarlett O'Hara in *Gone With the Wind*)

When I was a little girl I only had two friends, who were imaginary. And they would only play with each other. (Rita Rudner)

When it comes to men, the only thing I turn down is the bedcovers. (Jayne Mansfield)

Relationships

I've never had a relationship with a woman that lasted longer than the one between Hitler and Eva Braun. (Woody Allen)

I had a love-hate relationship with one of my husbands. He loved me and I hated him. (Zsa Zsa Gabor)

The crux of Ashton Kutcher's relationship to Demi Moore is that age doesn't matter to him and size doesn't matter to her. (Brittany Murphy)

What comes first in a relationship is lust. After that there's more lust. (Jacqueline Bisset)

Relativity

When Elvis started making films, a critic wrote that now I was now only the second worst actor in the world. (Tony Curtis)

Success is relative in Hollywood. The closer the relative the greater the success. (Arthur Teacher)

I have my own theory of relativity. Never hire your relatives. (Jack Warner)

Religion

I'm a teleological existential atheist. I believe there's an intelligence to the universe, with the exception of certain parts of New Jersey. (Woody Allen)

I've tried Buddhism, Scientology, Numerology, Transcendental Meditation, Qabbala, tai-chi, feng shui and Depak Chopra but I still find straight gin works best. (Phyllis Diller)

Re-Marriage

The reason I didn't re-marry was because I didn't dislike anyone enough to inflict that kind of torture on. (Bob Fosse)

Would I consider re-marriage? Yes, if I could find a man who had $15 million, who would sign over half of it to me ... and guarantee he'd be dead within the year.' (Bette Davis)

Sure I've married a few people I shouldn't have, but then haven't we all? (Mamie Van Doren)

Clark Gable never married anyone, but a number of women married him. (Rona Barrett)

Every man should have the opportunity of sleeping with Elizabeth Taylor. And at the rate she's going, every man *will*. (Nicky Hilton after Taylor's fifth marriage)

Zsa Zsa Gabor got married as a one-off but it was so successful she turned it into a series. (Bob Hope)

Seventeen has always been my lucky number. (Rita Hayworth after being asked how many husbands a career woman should have)

My three husbands had twenty marriages between them. That made my three seem a bit tame. (Ava Gardner)

Why did I marry Elizabeth [Taylor] twice? Because the murderer always returns to the scene of the crime. (Richard Burton)

Repartee
Interviewer to John Wayne: Mr. Wayne, Do you look at yourself as an American legend?
Wayne: Not being a Harvard man, son, I look at myself as seldom as possible.'

Katharine Hepburn to John Barrymore after *A Bill of Divorcement* wrapped: "Thank God I don't have to act with you anymore."
Barrymore: "I didn't know you ever had, darling."

Hedda Hopper: Now that you've become a big star, Kirk, you're becoming a real son-of-a-bitch.
Kirk Douglas: 'Not so. I've always been a son-of-a-bitch. You just never noticed it before.'

My ex-husband said someday he'd go far. I said, 'I hope you stay there'. (Drew Barrymore)

Jill Bennett: 'Did you miss your chauffeur-driven limmo after your career slumped?'

Rachel Roberts: 'No, I missed the chauffeur.'

Old Cary Grant fine. How you? (Cary Grant in reply to a Chinese telegram asking, "How old Cary Grant?")

I just throw a gob of spit in the air and run under it. (Marlon Brando to Vivien Leigh when she asked him if he took baths)

Don't worry, I'll cut you down to size. (Spencer Tracy to Katharine Hepburn after Hepburn told him he was too short for her)

Two things. (Rita Hayworth after being asked what kept her dress up during the dance scene in *Gilda*)

Not anymore. (Tony Richardson to Edith Evans when she said to him, 'I don't look seventy, Tony, do I?')

It saves time. (Alleged comment by Ben Affleck to Jennifer Lopez after she asked him why so many people seemed to take an 'instant' dislike to her)

Boze Hadleigh: 'A quick question: What do you think of Nancy Reagan?'
Bette Davis: 'A quick answer. I never do.'

Fan of Rita Hayworth in 1972: 'How do you feel when you look in the mirror in the morning and no longer see the Love Goddess looking back?'
Hayworth: 'That's one problem I don't have, honey. I never get up until the afternoon.'

Reputations

My reputation as a wild man was exaggerated. Christ, my *mother's* had stranger things happen to her. (Lee Marvin)

I lost my reputation early in life but I never missed it. (Mae West)

They called me a scarlet woman for so long I'm almost purple. (Liz Taylor)

Gary Cooper got a reputation as a good actor just by thinking hard about the next line. (King Vidor)

Re-Runs

Watching *Lawrence of Arabia* recently I kept thinking things like, 'Weren't we shooting that bit when Omar Sharif got the clap?' (Peter O'Toole)

I never watch my old films. I have a blanket I carry around to cover the television in hotel rooms. (Sterling Hayden)

Resemblances

A guy at a gas station said to me once, 'Hey, you look like that Hugh Grant. No offence.' (Hugh Grant)

Emilio Estevez and Charlie Sheen both look like their dad but not each other. Go figure. (Chris Cain)

Broderick Crawford's face resembled an aerial view of the Ozarks. (Hugh Leonard)

He looks like an extra in a crown scene by Hieronymus Bosch. (Kenneth Tynan on Don Rickles)

Steve McQueen's features resembled a fossilized dishrag. (Alan Brien)

Robert Redford doesn't look like Robert Redford anymore. His face resembles a map of Argentina. (Rex Reed)

Restaurants

In Tulsa the restaurants have signs that say, 'Sorry, we're open.' (Roseanne Barr)

When Orson Wells is in a restaurant and they give him the menu he replies, 'Yes Please'. (Sid Caesar)

All social life in Hollywood revolves round six major studios and one restaurant. (Evelyn Waugh)

I used to go to a restaurant where you could eat as much as you wanted for a given fee. They closed down. (Harry Secombe)

Retirement

Retirement at 65? At 65 I still had pimples. (George Burns)

Once it was impossible to find any Bond villains older than myself, I retired. (Roger Moore)

I went on making films because I was too old to retire. (Bette Davis)

I don't have much time for actresses who retire when their beauty fades. That's not acting; that's modelling. (Rachel Roberts)

I've done my bit for motion pictures – I've stopped making them. (Liberace)

Reviews

Bad reviews don't really bother me. The cat pees on them the next day. (Reese Witherspoon)

I came into movies in 1961. The following year I stopped reading reviews. (Ann-Margret)

A favourable review from a critic is only a stay of execution. (Dustin Hoffman)

Those who can, do. Those who can't, teach. And those who can't teach, review. (Burt Reynolds)

I'm not going to do any more book reviews. It cuts in too much on my reading. (Dorothy Parker)

Revisionism

Revisionism has now reached the point where it would be possible to make a version of *Hamlet* without the prince. (John Gielgud)

An adult western is where the hero still kisses his horse at the end, only now he worries about it. (Milton Berle)

Richness

Some people get so rich they lose all respect for humanity. That's how rich I want to be. (Rita Rudner)

Zsa Zsa Gabor was socially inspiring to me. She did social work among the rich. (Oscar Levant)

And then there was the movie star who was so rich she had her initials monogrammed on the bags under her eyes. (Frank Muir)

Riddles

If truth is beauty, how come no one has their hair done in the library? (Lily Tomlin)

Why was Richard Burton's father the greatest carpenter in Wales? Because with just one screw he made the biggest shit-house in the country. (Diana Dors)

Role-Playing

I married a Kraut. Every night I get dressed like Poland and he invades me. (Bette Midler)

I was Margo Channing when what I wanted to be was Jezebel. Now I'm what's left of Baby Jane. (Bette Davis)

Smart girls know how to play tennis, piano…and dumb. (Lynn Redgrave)

Humphrey Bogart fell in love with the character Lauren Bacall played in *To Have and Have Not*, so she had to keep playing it for the rest of her life. (Howard Hawks)

Ever since *Harry Potter* I've become a role model. That means I have to stop being thrown out of nightclubs at two in the morning. (Robbie Coltrane)

Role Reversal

I originally planned to have one husband ad seven children, not the other way round. (Lana Turner)

The most embarrassing thing about my life at the moment is that the salad dressing is out grossing my films. (Paul Newman)

Men used to put women on pedestals and then look up their skirts. With Sharon Stone, they looked up her skirt first and then put her on a pedestal. (Douglas Thompson)

Treat every queen like a whore and every whore like a queen. (Anthony Quinn)

Romance

Marriage interferes with romance. Anytime you have a romance, your wife is bound to interfere. (Groucho Marx)

I'll quit acting the day I don't find romance in a loaf of bread. (Jack Lemmon)

I'm not an old-fashioned romantic. I believe in love and marriage, but not necessarily with the same person. (John Travolta)

Rumours

During a newspaper strike? I wouldn't even consider it. (Bette Davis referring to a rumour that she'd died in the 1970s)

They once said I wanted to eat my son's placenta. (Barbara Hershey)

Hollywood is the only place in the world where most of the population suffers from rumourtism. (Harvey Keitel)

You've all heard some rumours about me over the years so I guess the time has come to come clean. My name is Richard Gere and I am a lesbian. (Richard Gere)

Running Time

I only saw one of the *Lord of the Rings* films but it was the longest week of my life. (Mitchell Symons)

Cutting *Arch of Triumph* improved it greatly. It used to be terrible for four hours. Now it's only terrible for two. (Charles Boyer)

Sackings

Hollywood must be the only place on earth where you can get fired by someone wearing a Hawaiian shirt and a baseball cap. (Steve Martin)

I got to Hollywood on a Monday and was fired by Wednesday. The guy that hired me was out of town Tuesday. (Raymond Chandler on his screenwriting career)

I got fired by Universal as a young actress but it didn't bother me. There was a belief at the time that if you were fired from Universal you'd eventually make it to the top. (Bette Davis)

Salaries

Louis B. Mayer had the best ruse of all to stop people asking for salary hikes: he cried. (Louela Parsons)

Thank you, but for the same price I can get an actor with two eyes. (Harry Cohn rejecting the one-eyed Peter Falk's salary request for a movie)

Today, a million dollars is what you pay a star you *don't* want. (William Goldman)

The joke around Hollywood about Garbo was which is bigger: her salary or her feet. (Jack Benny)

Alfred Hitchcock said that actors were cattle. Show me a cow that can earn a million dollars a film. (David Lewin)

All I ever wanted was an honest week's work for an honest day's pay. (Phil Silvers)

When I first started working, I used to dream of the day when I might be earning the salary I'm now starving on. (Carol Burnett)

My salary for *Mona Lisa* was the proverbial two bob and a lollipop. (Michael Caine)

Santa Claus

I stopped believing in Santa Claus at an early age. Mother took me to see him in a department store and he asked me for my autograph. (Shirley Temple)

Sarcasm

There but for the grace of God goes God. (Herman Mankiewicz on Orson Welles)

Ken Russell is an arrogant, self-centered individual, but I don't say this in any demeaning way. (Bob Guccione)

Isn't it wonderful you've had such a great career when you had no right to have a career at all? (Katharine Hepburn to Dorothy Arzner)

Thank you. (Truman Capote to Gore Vidal after Vidal told him he passed Capote's hotel the previous day)

How clever of you to think of that. (George Jessel to an actor who told him he had his audience 'glued to their seats' at a performance)

Schadenfreude

I heard about a woman who's planning to divorce her husband as long as she can find a way to do it that doesn't make him happy. (Arnold Schwarzenegger)

The first time I read a *Dallas* script I knew it war for me. There wasn't a character in it with a shred of human decency. (Larry Hagman)

The best time I ever had with Joan Crawford was when I pushed her down the stairs in *Whatever Happened to Baby Jane.* (Bette Davis)

If my films make just one more person miserable, I'll feel I've done my job. (Woody Allen)

I would openly celebrate Quentin Tarantino's death. (Producer Don Murphy)

I hope that, the next time she's crossing a street, three drunk guys come along driving a truck. (Frank Sinatra on Kitty Kelley, who wrote a corrosive biography of him)

Tallulah Bankhead is always skating on thin ice. Everyone wants to be there when it breaks. (Beatrice Campbell)
Good old George Zucco, he of the Satanic smile and eyes that light up like neon's every time he conceives of something especially nasty. (William K. Everson)

I love being married. It's great to find that one special person you want to annoy for the rest of your life. (Rita Rudner)

The Irish humour of John Ford in his cavalry trilogy made me wish that Oliver Cromwell had done a more thorough job. (James Agate)

Schizophrenics

When we talk to God we're praying. If he talks back to us, we're schizophrenic. (Lily Tomlin)

Schizophrenia rules OK, OK. (Steve Martin)

Schizophrenics are at two with nature. (Woody Allen)

Which part is he playing now? (Somerset Maugham as he watched Spencer Tracy in *Dr. Jekyll and Mr. Hyde*)

At work Billy Wilder is two people: Mr. Hyde and Mr. Hyde. (Harry Kurnitz)

Schmaltz

Table for Five would have been an ideal movie to watch on a plane. At least they provide free sick bags. (Simon Rose)

My doctor won't let me watch Dinah Shore. I'm a diabetic. (Oscar Levant)

The effect is less one of whimsy than of being beaten to death with a toffee apple. (Peter John Dyer on Frank Capra's *A Pocketful of Miracles*)

After watching *The Good Ship Lollipop* you just have to go out and beat someone up. (Lee Marvin)

Forrest Gump is so insistently heartwarming it chilled me to the marrow. (Anthony Lane)

That silly horse, Jeanette MacDonald, yakking away at wooden-peg Nelson Eddy, with all the glycerin running down her Max Factor. (Judy Garland)

Norman Wisdom once said to me, 'That's where I put the pathos in,' as it were flour. (Tony Hancock)

Sometimes I'm so sweet, even I can't stand it. (Julie Andrews)

I would like to recommend *Random Harvest* to anyone who can stay interested in Ronald Colman's amnesia for two hours, and anyone who could with pleasure eat a bowl of Yardley's shaving soap for breakfast. (James Agee)

Science Fiction

In 1982 in *Blade Runner* I played a character who hunts down bloodthirsty humanoid life forms known as replicants. We were way ahead of our time. It was four years before anyone had heard of Jerry Springer. (Harrison Ford)

Did you hear about the new movie being made about an exhibitionist in outer space? It's
called *Flash Gordon*. (Jackie Mason)

When a bunch of people are put under a spell in a science fiction movie, how is it they always wake up at exactly the same moment? (Wally Cox)

Apparently the new *Star Wars* toys can talk and are interactive. This makes them easily distinguishable from *Star Wars* fans. (Conan O'Brien)

Screaming

When I had a baby I screamed and screamed. And that was just during the conception. (Joan Rivers)

I knew I was recovering from my mastectomy when I started shouting at the nurses. (Bette Davis)

In most of his later movies, Al Pacino is a food-fight actor: the kind who bawls lines like he's spewing a half-chewed hot dogs in your face. (Tom Carson)

I'd hate to have been next door to Monica Seles on her wedding night. (Peter Ustinov on the famous tennie grunter)

Screen Sizes

I don't think it will be a problem. I'll just put the paper in sideways. (Nunnally Johnson after being asked if he was concerned about the effect of Cinemascope on his screenwriting)

My girlfriend is a movie actress. I'd love to see her in 3D. That's the number of my hotel bedroom. (Benny Hill)

Screen Tests

Can't act, can't sing, can dance a little. (Studio reaction to Fred Astaire's first screen test)

When I saw my first screen test I ran from the projection room screaming. (Bette Davis)

At my first screen test I was asked about my previous experience. I told them I'd played two support roles to a dog.

Screenwriting

Hollywood always held a double lure for me. I was offered tremendous sums of money for work that required no more effort than a game of pinochle. (Ben Hecht)

Behind every successful screenwriter stands a woman and behind her stands his wife. (Groucho Marx)

Most screenwriters couldn't write 'fuck' on a dusty Venetian blind. (Frank Gannon)

The biggest obstacle to film writing is the necessity of changing the typewriter ribbon. (Robert Benchley)

A word is worth a thousand pictures. (Ernest Hemingway)

Screenwriting is an occupation akin to stuffing kapok in mattresses. (S.J. Perelman)

It took me fifteen years to discover I had no talent for writing but I couldn't give it up. By that time I was too famous. (Robert Benchley)

My best advice to screenwriters is as follows. First of all finish your script. Then drive to where the California State Line is. Then pitch your

manuscript across. No – first get them to toss the money over. Then get the hell out of there. (Ernest Hemingway)

Good screenplays are as rare in Hollywood as virgins. (Raymond Chandler)

In Hollywood, writers are only considered to be first drafts of human beings. (Frank Deford)

It's easy to be a screenwriter. You just sit in front of an empty page and wait for the beads of sweat to break out on your forehead. (Hugh Leonard)

Did you hear about the starlet who was so dumb she slept with the writer? (Joe Eszterhas)

They jerk off and we buy yachts. (Frank Sinatra on the difference between writers and actors)

If I was any worse of a writer, Hollywood wouldn't have called for me. If I was any better I wouldn't have come. (Raymond Chandler)

One man wrote *War and Peace*. 35 screenwriters wrote *The Flintstones*. Conclusions? (Joe Eszterhas)

Scripts

When the script is finished, then we add the dialogue. (Alfred Hitchock)

The script was easy to learn because it consisted of just one word. (Harry Secombe on the film *Rhubarb*, that being the word)

When in doubt, have two guys come through the door with guns in their fists. (Raymond Chandler)

No matter how good your script is, if the audience doesn't want to sleep with the star you might never be asked to write another one. (Richard Curtis)

This is a terrific script. All it needs is a complete re-write. (Alvin Sargent)

Even if Rock Hudson had been healthy when he was doing *Dynasty*, the scripts would have done him in. (Barbara Stanwyck)

Secrets

The secret of eternal youth is the saliva of young girls. (Tony Curtis)

Let me tell you a secret about *Ben-Hur*. The chariot race was fixed. (Charlton Heston)

I once touched Greta Garbo's vertebrae when I was posing as a vascular dermatologist in New York City. Her secret is that she is really a female iguana. (Auberon Waugh)

Self-Criticism

I have a face that would stop a sundial. (Charles Laughton)

I used to be Snow White but I drifted. (Mae West)

I'm everything you were afraid your little girl would grow up to be – and your little boy. (Bette Midler)

I have bursts of being a lady but they don't last long. (Shelley Winters)

I have so little regard for myself I didn't even invite myself to my own wedding. (Colin Farrell)

I have my moments – and they're all weak ones. (Mae West)

I'm a yin-and-yang Piscean, an extremist, an oxymoron of a dichotomy of a double-sided being. (Drew Barrymore)

When I was a freshman at Hamilton I was thrown into the college fount. In the early days of the last war I had to take care of the bedpans in an army hospital. But never have I been so humiliated as on my few appearances in the movies. (Alexander Woolcott)

I admit I'm paranoid, but that's only because people keep picking on me. (Billy Crystal)

I have more chins than the Chinese phone book. (Sydney Greenstreet)

If I'd been a ranch, they'd have named me Bar Nothing. (Rita Hayworth)

Other people have skeletons in their closet. I have a graveyard. (Sylvester Stallone)

I wouldn't say I invented tack, but I brought it to its present high popularity. (Bette Midler)

When you whittle it all down, I'm just a grown man who puts on make-up. (Brad Pitt)

Self-Destructiveness

Right now I'm moving through my personal life like a haemophiliac in a razor factory. (Robin Williams in 1988)

Show a Welshman a thousand doors, one of which is marked 'Self-Destruction,' and that's the one he'll choose. (Richard Burton)

Sequels

Basic Instinct 2 is not an erotic thriller. It's taxidermy. At this point there are inflatable toys livelier than Sharon Stone. (Kyle Smith)

I saw a poster for *Mission Impossible 3* the other day and thought to myself: It's not really impossible if he's already done it twice. (Mark Watson)

I hear Oliver Stone is making a new movie about the Titanic with a conspiracy theory in it. There's a second iceberg. (James Cameron)

I went to the sequel of *Clones* but it turned out to be the same movie. (Jim Samuels)

As long as there are sex-mad teenagers swimming in the nude at night, there will be another *Friday the 13th* movie. (Simon Rose)

Sets

When I started the screenplay for *Ben-Hur* all the sets had already been built, including Charlton Heston. (Gore Vidal0

Alfred Hitchcock's biggest problem with films begins when the actors appear on set. (Joe Stefano)

Directors don't like seeing writers on the set. It would be a bit like bringing the plumber on one's honeymoon. (David Mamet)

The scenery was beautiful but the actors got in front of it. (Alexander Woolcott)

Settling Down

Mother told me a couple of years ago, 'Sweetheart, settle down and marry a rich man.' I said, 'Mom, I *am* a rich man.' (Cher)

Sex

I was in Hollywood a week before I got laid. That may be a record. (John Garfield)

I believe sex is one of the most beautiful and wholesome things that money can buy. (Steve Martin)

Women need a reason to have sex. Men just need a place. (Billy Crystal)

For Steve McQueen, screwing groupies had all the emotional resonance of flossing his teeth. (Christopher Sandford)

Sex for a fat man is much ado about puffing. (Jackie Gleason)

With Greta Garbo, sex was a sacrament. With Norma Shearer it was emancipation. With Joan Crawford it was a commodity. With Jean Harlow, sex was just sex. (Mick Lasalle)

Don't have sex, man. It leads to kissing and, pretty soon, you have to talk to them. (Steve Martin)

I know nothing about sex because I was always married. (Zsa Zsa Gabor)

I consider sex a misdemeanor. The more I miss, de meaner I get. (Mae West)

I always like to screw my leading man on the first day of shooting a film to get it out of the way. Otherwise it can interfere with my performance. (Shelley Winters)

Sex Appeal

Gina Lollobrigida has the sex appeal of a waxwork. (Rossano Brazzi)

The only man who thinks Phyllis Diller is a ten is a shoe salesman. (Bob Hope)

Richard Chamberlain has the sex appeal of a sheep and the comic timing of a manatee. (Chris Peachment)

Sex appeal is 50% what you've got and 50% what people think you've got. (Sophia Loren)

I have so little sex appeal, my gynaecologist calls me ''Sir.' (Joan Rivers)

Sex Education

My father told me all about the birds and the bees. The liar – I went steady with a woodpecker till I was 21. (Bob Hope)

The reason I know so much about men is because I went to night school. (Mae West)

There was no discussion of sex during my upbringing. If a woman wanted to get pregnant, you'd squeeze her breasts. That was my sex education. (Bruce Dern)

Sex Maniacs

I've known so many men, the FBI ought to come to me first to compare fingerprints. (Mae West)

I could nearly have filled up Heidi Fleiss diary all on my own. (Charlie Sheen)

Chico didn't button his fly until he was over seventy. (Groucho Marx)

After Lizzie Taylor married Dick Burton, they stayed in bed for three years. (Groucho Marx)

Errol Flynn must have had the most overworked prostate gland in the business. (Ray Milland)

Sex Scenes
The sex scenes in *Fatal Attraction* are about as erotic as a pregnant belly dancer. (Noel Snell)

It's like dance steps or a fight scene. When she scratches your back, you have to arch two beats, then roll over, boom. (Michael Douglas)

The love scenes I did years ago were sensitive and romantic but in today's lovemaking couples are trying to swallow each other's tonsils. (Lillian Gish)

Darling, if I get excited during this scene, please forgive me. And if I *don't* get excited, please forgive me. (Tom Berenger)

Sex Symbols
If Marilyn Monroe spelt Mmm and Brigitte Bardot bebe, Sharon Stone spells Ssss – a hiss with a kiss, a cobra with a cause. She's where baby meets barbarian. (Julie Birchill)

Is Kim Novak a joke in her own time? (Robert Aldrich)

I still don't believe Raquel Welch actually exists. She was manufactured by the media to preserve the sexless plasticity of sex objects for the masses. (Andrew Sarris)

Sexism
A film in which I didn't end up in bed, in the sea or in a hot tub would have the same appeal as a Clint Eastwood film in which nobody got shot. (Bo Derek)

Sex is for men and marriage – like lifeboats – for women and children. (Carrie Fisher)

Things are looking really good for women in movies. In *Indecent Proposal* Demi Moore was sold to Robert Redford for $1 million. Uma Thurman went to Robert de Niro for $40,000 a year later. A few years on, in *Pretty Woman*, Richard Gere got Julia Roberts for $3,000. I'd say that was real progress. (Michelle Pfeiffer)

American men as a group are only interested in two things: money and breasts. (Hedy Lamarr)

Men don't really believe women exist. Marilyn Monroe died of this. (Lucy Ellman)

Sexual Frustration

Sex with Debbie Reynolds was about as exciting as a December afternoon in London. (Eddie Fisher)

Men reach their sexual peak at 18 and women at 35. Do you get the feeling God is into practical jokes? We're reaching our peak around the same time they're discovering they have a favourite chair. (Rita Rudner)

The conventional position leaves me claustrophobic. The others either give me a stiff neck or lockjaw. (Tallulah Bankhead)

My doctor told me my wife and I should enjoy sex every night. Fine, only now we'll never see each other, (Chevy Chase)

Once while we were making love a curious optical illusion occurred – it almost looked as though she were moving. (Woody Allen)

If sex is supposed to be so natural, how are there so many books on how to do it? (Lily Tomlin)

I thank God I was raised Catholic so sex will always be dirty. (John Waters)

The worst lay in the world – she was always drunk and never stopped eating. (Peter Lawford on Rita Hayworth)

Once the female has used the male for procreation, she turns on him and literally devours him. (Cary Grant)

I asked my husband why he didn't call out my name when he was making love to me. He said, 'I didn't want to wake you up.' (Joan Rivers)

Shoes

I always thought platform soles were something Alan Ladd wore to make kissing easier. (Erma Bombeck)

I own 698 pairs of shoes. (Lana Turner)

The Smithsonian Museum found my wife's shoe. On the basis of its measurements they constructed a dinosaur. (Woody Allen)

I'm so fat, when I have my shoes cleaned I have to take the shoeshine boy's word for it. (Stubby Kaye)

The best directing advice I ever got came from Steven Spielberg. He told me to wear comfortable shoes. (Bob Balaban)

I was so poor as a child, shoes were seen as a status symbol. (Bob Hope)

Shootings

I heard on the news last night that two innocent people were shot in Hollywood. That surprised me because I didn't know there were two innocent people in Hollywood. (Chris Farley)

They should shoot less films and more actors. (Walter Winchell)

If someone were to come from another planet and see the world through movies, they'd think it was populated by white men in their thirties who shoot a lot. (Bonnie Bedelia)

I have no respect for gangs today. They just drive by and shoot people. At least in the old days, like in *West Side Story*, they used to dance with each other first. (Robert Lee)

I had to shoot a guy in a movie. The director said to shoot first and ask questions later. I was going to ask him why I had to shoot him but I forgot. (John Wayne)

Shopping

I used to buy clothes in thrift shops but I don't go to them since I became famous because too many people recognise me. And they've gone up in price. (Barbra Streisand)

My wife will buy anything that's marked down. Yesterday she came home with two dresses and an escalator. (Henny Youngman)

I only went out to get an ice cream. (Kim Basinger after buying the town of Braselton, Georgia in 1989)

Shoulders

I'm not taking off my shirt in front of her. She's got bigger shoulders than I have. (Elvis Presley on starring opposite Ursula Andress)

The tie for the biggest shoulders in Hollywood history has to be between Joan Crawford and Anthony Perkins – both of them psychos. (Joan Hackett)

Sibling Rivalry

I married before Olivia, won an Oscar before her, and if I die first, she'll undoubtedly be livid because I beat her to it. (Joan Fontaine on her sister Olivia de Havilland)

We're getting closer together as we get older, but there would be a slight problem of temperament. In fact it would be bigger than Hiroshima. (Joan Fontaine on the same sister,.. and the same problem)

Significance

I pride myself ón tghe fact that work has not socially redeeming value. (John Waters)

I suppose it beats stealing hubcaps. (Steve McQueen ón his film career)

Yesterday I looked at a beautiful sunset and thought: How insignificant I am. But then I thought that the day before as well, and it rained. (Woody Allen)

Silent Movies

I wish some bright spark would re-invent the silent movies. (Jack Hawkins after he lost his voice from throat cancer)

The movie people didn't want anything to do with me until they heard me speak in a play. Then they all wanted to sign me. For the silent movies. (W.C. Fields)

Similarities

I got married at the same age Christ died. We both suffered. (James Woods)

Clint Eastwood and I are so alike. If, for instance, I'm threatened by such awesome thugs as the wife and her mother, I resort to the old Apache Indian trick of screaming and begging for mercy. (Lee Dawson)

Darling, you remind me of Marilyn Monroe. Not in looks, of course, but in lack of talent. (Otto Preminger to Kim Cattrall after meeting her for the first time when she was 17)

My doctor said I looked like a million dollars – all green and wrinkled. (Red Skelton)

Sincerity

You can take all the sincerity in Hollywood, place it in the navel of a fruit fly and still have room for three caraway seeds and the heart of a producer. (Fred Allen)

Acting is all about sincerity. Once you've learned to fake that, you're in. (Sam Goldwyn)

Singers

I love to sing and to drink Scotch. Most people would prefer to hear me drinking Scotch. (George Burns)

You have a wonderful voice. Don't spoil it by singing. (Sammy Davis Jr)

I love the way Elvis sings but if he ever gets rid of the hiccups he's out of business. (Bob Hope)

You'll make a lot of money with this record, especially if you don't release it. (Groucho Marx)

Drew Barrymore sings so badly, deaf people refuse to watch her lips move. (Woody Allen)

The two loudest things I've ever heard are a freight train going by and Bob Dylan. (Marlon Brando)

As a singer you're a great dancer. (Amy Leslie to George Primrose in *They All Sang*)

I can sing as well as Fred Astaire can act. (Burt Reynolds)

You should hear her sing. She's like a female Lena Horne. (Joe Pasternak)

Her singing was mutiny ón the high Cs. (Hedda Hopper)

Marlon Brando has a singing voice like the wail of a bagpipe oozing through a pile of wet tissue, or the mating call of a yak in heat. (Frank Sinatra)

Skin

A bit of lusting after someone does wonders for the skin. (Liz Hurley)

Movie stars take their skin from their ass and stick it onto their face so it won't wrinkle. You can see them walking round the place with buttock faces. (Charles Bukowski)

Humphrey Bogart's skin was so rough, you felt you could have lit a match on his jaw. (Peter Ustinov)

Sleep

If the líon lies down with the lamb, the lamb won't get much sleep. (Woody Allen)

I envied my feet because they were asleep. (Hedda Hopper ón a boring movie she saw)

Merle Oberon had so much plastic surgery, she had to sleep with her eyes open. (James Agate)

I'm the kind of guy who refuses to go to sleep until my eyes shut by themselves. I'm afraid I'll miss something. (Mickey Rourke)

Modern stars bitch about their hotel rooms. When I started in this business we slept in tents. (John Wayne)

I don't wake up until eleven. Then it's time for my nap. (Bob Hope)

Slips of the Tongue

Isn't Halle Berry beautiful? I have a film I'd like to be in her with. I mean with her in. (Ewan McGregor)

Steve McQueen looked so good in that movie he must have made it before he died. (Yogi Berra)

Go see that movie for yourself and see for yourself why you shouldn't see it. (Sam Goldwyn)

I was asked to come to Chicago because it's one of our 52 states. (Raquel Welch)

What do I think of Kierkegaard. I don't know. What movies was he in? (Pamela Anderson)

When I see the pictures you play in that theatre, it makes the hair stand on the edge of my seat. (Michael Curtiz)

I'm the Hiroshima of love. (Sylvester Stallone)

I believe there would be people alive today if there was a death penalty. (Nancy Reagan)

Smiles

The width of a producer's smile in my direction is usually commensurate with how much my last picture grossed. (Marlon Brando)

He was the only man I ever knew who seemed as if he had to think before he smiled. (Billy La Massena on Robert de Niro)

Raquel Welch has a smile like a razorblade. And a personality to match. (Terry Wogan)

Warren Oates' most successful films are probably those in which the morality is as cockeyed as his grin. (Neil Sinyard)

Start each day with a smile and get it over with. (W.C. Fields)

Melanie Griffith is just about bearable now that her face has been so worked over by plastic surgeons she can't stretch to a smile any more. (Martina Devlin)

Shirley Temple had a smile that could melt the glue out of a revolving bookcase. (S.J. Perelman)

Smoking

I smoke when I drink. And every other time as well. (Marlene Dietrich)

I never smoked a cigarette until I was nine. (W.C. Fields)

I don't believe in giving up smoking. I've never been a quitter. (Peter O'Toole)

Nicotine Anonymous is for people who want to stop smoking. When you get a craving for a cigarette you call another member. He comes over and you get drunk together. (Henny Youngman)

If you smoke after sex you're probably doing it too fast. (Woody Allen)

Smoking kills. If you're killed, you've lost a very important part of your life. (Brooke Shields)

Where there's smoke there must be someone smoking. (Eva Ebert)

My New Year's resolution is that I intend to smoke a lot more. (Jeremy Irons)

I smoke fifteen cigars a day. At my age I need to hold ón to something. (George Burns)

Sobriety

Be careful, sport, that is libel of the very worst kind. (Errol Flynn to a journalist who said he was going to write a story suggesting Flynn had finally stopped drinking)

I gave up drinking once. It was the worst afternoon of my life. (Humphrey Bogart)

Somnambulance

Paint eyeballs ón my eyelids and I'll sleepwalk through any picture. (Robert Mitchum)

Soubriquets

Clara Bow was the It Girl. She probably caught 'It' from receiving too many passes from too many football players. (Susan Hayward)

In his bodybuilding days, Arnold Schwarzenegger was known as the Austrian Oak. Then he started acting and came to be known as ... the Austrian oak. (Jack Dee)

Spaghetti Westerns

I went to a spaghetti western last night. Everyone spent so long looking at each other without saying anything I thought we'd all miss the last bus home. (Milton Berle)

Clint Eastwood is called The Man with No Name in the spaghetti westerns. He should really be called The Man With No Dialogue. (Douglas Thompson)

Like its villains, *A Fistful of Dollars* was shot in Spain. It's a pity it wasn't buried there. (*Time*)

Special Effects

When Sharon Stone parted her legs in *Basic Instinct* without wearing any underwear it was the screen's greatest Special Effect since Charlton Heston parted the Red Sea in *The Ten Commandments*. (Steve Rebello)

Madonna is going to play Joan of Arc – a virgin. And you thought the special effects in *Independence Day* were good. (Jay Leno)

When they used to do my face up in the old days before a movie it was called make-up. Now it's called Special Effects. (Bob Hope)

The thing about the Special Effects in *Jurassic Park* is that you can't tell where the computer models finish and the real dinosaurs begin. (Laura Dern)

I don't need to make Special Effects films. I *am* a Special Effect. (Gerard Depardieu)

In any movie where the Special Effects are good, the acting is always crap, even if it's directed by Stanley Kubrick. (Erich Canetti)

Speech

You always talk as if you have a feather up your anus. (Spencer Tracy to Katharine Hepburn)

Marlon Brando spoke English as if it was a foreign language he acquired by sleep-teaching from a gramophone record running at the wrong speed. (Clive James)

When I first came to Hollywood, the only thing I knew how to say was, 'I want to make a movie with Johnny Depp'. (Penelope Cruz)

The only reason I'm seen as the strong silent type is because I find it difficult to speak when I'm holding in my stomach. (Robert Mitchum)

Speed

I read *War and Peace* in eight minutes after doing a speed-reading course. It's about Russia. (Woody Allen)

My friend got a microwave television. He can now watch a three-hour movie in five minutes. (Shaun Connors)

I won't say the train travelled slow but as it was coming into town a man leaned out of the window to whistle at a girl and by the time it pulled out of the station he'd met her parents, bought a ring, had a chaplain marry them and was standing on the platform waving goodbye to his son. (Bob Hope)

Stalkers

Did you hear about the stalker who broke into Sharon Stone's bedroom? He now sings soprano for a living. (Jackie Mason)

When someone follows you all the way to the shop and watches you buy toilet roll, you know your life has changed. (Jennifer Aniston)

Stamina

I have spent between 12,000 and 14,000 nights of my life making love. (Errol Flynn)

Last night Sammy Davis asked me what I'd like to drink to. I replied, 'To about four in the morning. (Dean Martin)

Stardom

Being a star has made it possible for me to get insulted in places where the average negro could never hope to get insulted. (Sammy Davis Jr)

Until you're known as a monster in my profession, you're not a star. (Bette Davis)

You're doing it the wrong way round, my boy. You're a star but you don't know how to act. (Cecil Hardwicke to Richard Chamberlain)

Robert Redford is even a star in the shower. No water spray would dare give him hassle. The water would never be too hot or too cold and the eggs at breakfast would always come out of the pan perfect. (Paul Newman)

Superstar? Jesus Christ. (Clive James ón Tom Cruise)

The word 'star' spelled backwards is 'rats.' Go figure. (Joe Eszterhas)

You're not a star until they can spell your name in Karachi. (Humphrey Bogart)

Wet, she was a star. Dry, she ain't. (Joe Pasternak ón bathing belle Esther Williams)

How can I take pride in my work when the biggest stars in the world are a shark and two robots? (Paul Newman after the release of *Jaws* and *Star Wars*)

Star Profiles

Anita Ekberg is the thinking mans dunce cap. Two of them. (Ethel Merman)

Jimmy Stewart from Mars. (Mel Brooks on David Lynch)

A plump sensualist succumbing to terminal flab. (John Baxter ón Shelley Winters)

Anne Bancroft was an undergraduate. (Mike Nichols)

A moron with less on. (Totie Fields ón Raquel Welch)

A fag with a pussy. (Ava Gardner on Mia Farrow)

Jerry Springer with a vagina. (Scott Marks on Oprah Winfrey)

A testicle with legs. (Pauline Kael on Bob Hoskins)

Nothing more than a dope with fat ankles. (Frank Sinatra on Nancy Reagan)

A bowling ball looking for an alley. (Simon Blackwell on Roseanne Barr)

A puppet on mogadon. (Barney Hoskyns on Montgomery Clift)

Statistics

Half the population is aged over 40, not under. (Lauren Bacall)

Half of all marriages end in divorce and then there are the unhappy ones. (Joan Rivers)

Human beings only use 10% of their brains. Imagine how much we could accomplish if we used the other 60%. (Ellen Degeneres)

Strippers

My wife and I don't think alike. She donates money to the homeless and I donate it to the topless. (Rodney Dangerfield)

Don't just stand there – undo something. (Bob Hope to the stripper Gypsy Rose Lee)

Natalie Wood will be sensational in *Gypsy*. She plays a stripper. (Rosalind Russell)

Studios

All they ever did for me at MGM was change my leading men and the water in my swimming pool. (Esther Williams)

Working for Warner Brothers was like fucking a porcupine. A hundred pricks against one. (Wilson Mizner)

The biggest moneymaker in Hollywood last year was Colombia. Not the studio – the country. (Johnny Carson on the drug-riddled movie industry in 1981)

Sixteen Century Fucks. (Yul Brynner's description of Twentieth Century Fox)

Bring back the cult of personality. Studios today are owned by underarm odour companies. (Laurence Harvey)

I'd rather sell peanuts in Mexico than make films at Fox. (Jean Renoir)

The lunatics have taken charge of the asylum. (Richard Rowland on the takeover of United Artists by Charlie Chaplin, Mary Pickford, Douglas Fairbanks and D.W.Griffith)

She works at Paramount all day and at Fox all night. (Mae West on a promiscuous starlet)

In case of a nuclear attack, go to RKO. They haven't had a hit in years. (David Niven)

If I'd been fucked by my husband as much as I was by Warner Brothers I'd still be married.
(Cher)

Stunts

I'll get out of any stunt I can – except the love scenes. (Paul Hogan)

I wouldn't even stand on a wet step. (Victor Mature)

Success

The only way to succeed is to make people hate you. That way they remember you. (Joseph von Sternberg)

Sylvester stallone's success is more mysterious than cot death. (Rex Reed)

I climbed the ladder of success wrong by wrong. (Mae West)

I became successful because I'm an average-looking fella who's often been mistaken for somebody someone knew back in Podunk. (Gary Cooper)

There's no formula for usccess but there is one for failure – trying to please everybody. (Nicholas Ray)

Many a man owes his success to his first wife and his second wife to his success. (Jim Backus)

If at first you don't succeed...you're about average. (Sid Caesar)

A successful man is one who makes more than his wife can spend. A successful woman is someone who can find such a man. (Lana Turner)

I attribute the success of the Marx Brothers largely to me. I quit the act. (Gummo Marx)

The worst part of success is trying to find someone who's happy for you. (Bette Midler)

The ladder of success in Hollywood is usually: press agent, actor, director, producer, leading man. You're a star if you sleep with each of them in that order. (Hedy Lamarr)

You have to stay on your toes to succeed in the film business, like a midget at a urinal. (Leslie Nielson)

If you want to be a success in Hollywood, go to New York. (Bert Lahr)

For an actor, success is simply delayed failure. Graham Greene)

Success has gone to my stomach. (Sydney Greenstreet)

Suicide

Marilyn Monroe committed suicide yesterday. The usual overdose. Poor silly creature. I'm convinced that what brought her to that final foolish gesture was a steady diet of intellectual pretentiousness pumped into her over the years by Arthur Miller and 'The Method'. She was, to begin with, a fairly normal little sexpot with exploitable curves. (Noel Coward)

Suicide bombers believe that when they die as martyrs they will be given 72 virgins. I don't know what they plan to do with 72 virgins. One would be enough for me. (Kirk Douglas)

Surprises

I saw *The Crying Game* last night and was blown away by the surprise. Who would have thought: Forest Whitaker with an accent? (Tim Sims)

Swearing

Loretta Young has a curse box that she brings onto the set. You have to put fifty cents into it if you say 'Hell' and a dollar if you say 'Damn'. I asked her what she charges for a fuck. (Robert Mitchum)

Bullshit. (Mel Brooks after being accused of swearing)

Any girl who swears she's never been made love to has a right to swear. (Sophia Loren)

I say 'Fuck' 183 times in *Scarface*. That's more than most get in a lifetime. (Al Pacino)

I've stopped swearing. Now I just say 'Zsa Zsa Gabor.' (Noel Coward)

Syllogisms

All men are mortal. Socrates was mortal. Therefore all men are Socrates. Which means that all men are homosexuals. (Woody Allen)

Molecules are made from atoms. Atoms are made from energy. Energy is made from Wheaties. (Roseanne)

I'm a nobody. Nobody's perfect. Therefore I'm perfect. (J.C. Flippen)

Synopses

The Thomas Crown Affair is a love story between two shits. (Norman Jewison)

Erin Brockovich is really a film about a push-up bra. (Eric Roberts)

An affair between a mad rocking horse and a rawhide suitcase. (Noel Coward on Jeanette MacDonald and Nelson Eddy in *Bittersweet*)

The First Wives Club had strong American themes: divorce, alcoholism, plastic surgery and revenge. (Bette Midler)

Talent

Rudolph Valentino had the acting talent of the average wardrobe. (Jeremy Pascall)

I believe God felt sorry for actors so He created Hollywood to give them a place in the sun and a swimming pool. The price they had to pay was to surrender their talent. (Cecil Hardwicke)

I kiss the feet of talent and kick the ass of those who don't have it. (Harry Cohn)

It's just a talent I have. (Steve McQueen's response when asked how he managed to dump on those he professed to love)

Barbra Streisand has as much talent as a butterfly's fart. (Walter Matthau)

I could feel my lack of talent like a cheap dress. (Marilyn Monroe)

You could put all the talent I had into your left eye and still not suffer from impaired vision. (Veronica Lake)

Hollywood is one of the few places on earth where a person with absolutely no talent can make a million dollars and a genius starve to death. (Dan Dailey)

You can be a shit and be talented. Conversely, you can be the nicest guy in the world and not have any talent. Stanley Kubrick is a talented shit. (Kirk Douglas)

There has been one slight impediment to my acting career and it's probably important that I mention it now: I had no talent. (Audie Murphy)

The Talkies

The talkies made me sound as if I'd been castrated. (Tallulah Bankhead)

Nevair, nevair will I make a talkie. I zink zey are tairribble. (Dolores Del Rio)

They really had distinctive voices in the early talkie films. Nowadays you go to a movie and you can't tell one from the other. Jane Fonda sounds like Tatum O'Neal. (Bob Dylan)

Taste

To me, bad taste is what entertainment is all about. (John Waters)

His life was a fifty-year old trespass against good taste. (Leslie Mallory on Errol Flynn)

Popcorn is the last area of the movie business where good taste is still a concern. (Vincent Canby)

I like Don Pickles – but that's because I have no taste. (Frank Sinatra)

Tax

All capitalists shoud be forced to pay taxes except Welsh actors. (Richard Burton)

My age is 39 plus tax. (Liberace)

I've been hit so hard by the IRS, anytime a doorbell rings now I say 'Income' instead of 'Come in.' (Bob Hope)

Last year I had difficulty with my income tax. I tried to take my analyst off as a business deduction. The government said it was an entertainment. We finally compromised and made it a religious contribution. (Woody Allen)

Taxis

An empty taxicab drove up and Louis B. Mayer got out. (Marshall Neilan)

Clark Gable's ears make him look like a taxicab with the doors open. (Howard Hughes)

One time I went to a drive-in in a cab. The movie cost me $95. (Steven Wright)

Teenagers

Teenagers are God's punishment for having sex. (Steve Martin)

Trying to bring up a teenager today is a bit like hanging onto an aircraft as it's taking off. (Gabriel Byrne)

Teeth

My teeth used to stick out so far I once ate a kid's candy bar by accident. (Rita Rudner)

I hear George Bush went to the dentist. He wanted to have a wisdom tooth put in. (Joey Bishop)

When I go to the dentist, he's the one who has to have the anaesthetic. (Phyllis Diller)

Jayne Mansfield always dressed to the teeth, assuming that her teeth were situated in her abdomen. (Oscar Levant)

Teetotallers

I'd hate to be a teetotaller. Imagine getting up in the morning and knowing that's as good as you're going to feel all day. (Dean Martin)

I don't trust any bastard who doesn't drink. (Humphrey Bogart)

These days I'm a teetotal, mean-spirited, right-wing, narrow-minded, conservative Christian bigot. (Jane Russell)

Television

I used to write TV reviews when I was in college. They were somewhat hampered by the fact that I never watched TV. (Michael Winner)

Television has brought murder back into the home where it belongs. (Alfred Hitchcock)

I find TV very educational. Everytime someone switches it on I go to another room and read a book. (Groucho Marx)

Why should people go out and pay money to see bad films when they can stay home and see bad television for nothing. (Sam Goldwyn)

Us movie people were delighted with the advent of television. It finally gave us something we could look down on. (Billy Wilder)

I prefer TV to movies. It's not as far to the bathroom. (Jackie Gleason)

Raymond Burr was the same shape as the TV screen – deliberately I think, so that nothing else was needed to fill in the background. (Quentin Crisp)

Acting on television is like being asked by the captain to entertain the passengers while the ship goes down. (Peter Ustinov)

Watching movies on TV today means fighting, violence and foul language. And that's just deciding who gets to hold the remote. (Donna Gephart)

Television is called a medium because it is neither rare nor well done. (Ernie Kovacs)

Television isn't something you watch; it's something you appear on. (Noel Coward)

Never miss an opportunity to have sex or appear on TV. (Gore Vidal)

Television has raised writing to a new low. (Sam Goldwyn)

After I did my first TV show, five million sets were sold. The people who couldn't sell them gave them away. (Bob Hope)

Temper

I have two temperamental outbursts a year – each lasting six months. (Tallulah Bankhead)

Ida Lupino lost her hair. Lana Turner lost her eyebrows. All I lost was my temper. (Bette Davis)

When I lose my temper, honey, you can't find it any place. (Ava Gardner)

Temptation
I generally avoid temptation unless I can't resist it. (Mae West)

Tennis
I'm not saying John Travolta's trailers are big, but you could play tennis in them. (Stephen Frye#)

Pavarotti is very difficult to pass at the net in tennis – with or without a racquet. (Peter Ustinov)

Sean Connery gets a call from his agent one day. 'I've got a job for you,' he says, 'It starts tomorrow early. You'll have to be there by 10-ish'. 'Tennish?' Connery replies, 'but I don't even have a racquet'. (Internet joke)

Tennis is the new rage among Hollywood stars now. Since adultery's been accepted, they need another pastime. (Phyllis Diller)

Half the marriages in Hollywood are like tennis. Love means nothing. (Jerry Colonna)

Terminology
Whoever named it necking was a poor judge of anatomy. (Groucho Marx)

When the church guys says, 'I now pronounce you man and wife,' it's like life has only changed for the woman. Now she's a wife. But he's still a man. Is he not a husband yet? (Drew Barrymore)

Hollywood got into trouble when the town started making films instead of movies. (Richard Widmark)

Thanksgiving
I love Thanksgiving turkey. It's the only time in Los Angeles that you see natural breasts. (Arnold Schwarzenegger)

My cooking was so bad my kids thought Thanksgiving was to commemorate Pearl Harbour. (Phyllis Diller)

Theatre
Nobody is more dedicated to Broadway than an actor who never had a Hollywood offer. (Jack Lemon)

Playwrights are like men who've been dining for a month in an Indian retaurant. After eating curry night after night, they deny the existence of asparagus. (Peter Ustinov)

Theft
Winona Ryde's shoplifting trial was postponed. Apparently she couldn't find anything to wear that wasn't eveidence. (Jay Leno)

A man convicted of stealing a petticoat defended himself by saying it was his first slip. (Red Skelton)

What contemptible scoundrel stole the cork out of my breakfast? (W.C. Fields)

Fifteen minutes after meeting her I wanted to marry her. After half an hour I completely gave up the idea of stealing her purse. (Woody Allen)

Thinness
The best way to look thin is to hang out with people fatter than yourself. In my case this is not easy. (Shelley Winters)

I don't want my girl to be so skinny she can knife me with her knee. (Laurence Harvey)

Calista Flockhart will appear on the big screen this year. She'll play an underweight woman who's locked in a cage and force-fed mass quantitites of high-fat dairy products. It's called *Ally McVeal*. (Richard Belzer)

I'm too skinny. In fact if it wasn't for my Adam's apple I'd have no shape at all. (Phyllis Diller)

Threats
If I ever get my hands on that hag I'll tear every hair out of her moustache. (Tallulah Bankhead on Bette Davis)

Burt Lancaster once dragged me to the edge of a cliff with a 1000 foot drop and threatened to throw me over unless I agreed he'd done a take

properly. People later told me it was a very good sign. They said he only threatened to kill his friends. (Michael Winner)

Tightfistedness

Fred MacMurray held on to a dollar as if it was an endangered species. (Mitchell Leisen)

He was so mean, it hurt him to go to the bathroom. (Britt Ekland on Rod Stewart)

Gary Cooper is as tight with money as a hog's ass in flytime. (Ernest Hemingway)

I'm not mean. I'm Scottish. (Sean Connery)

Time

It's not the time it takes to take the take that takes the time. It's the time it takes between the takes that takes the time. (Steven Spielberg)

Joan Crawford is like that old joke about Philadelphia. First prize, four years with her; second prize, eight. (Franchot Tone)

A day away from Tallulah Bankhead is like a week in the country. (Howard Dietz)
One must live in the present tense, but I have always lived in the present tensely. (Bette Davis)

We've all passed a lot of water since then. (Sam Goldwyn)

Timing

I got my first part because I was able to belch on cue. (Charlesw Bronson)

I'm worth $4 million more today than yesterday. (Richard Burton after sleeping with Elizabeth Taylor for the first time)

In Hollywood, men get married in the morning. That way, if it doesn't work out, you haven't wasted a whole day. (Mickey Rooney)

If Mel Brooks had come up in my time he wouldn't have qualified as a busboy. (Joseph L. Mankiewicz)

Over in Hollywood once they almost made a great picture but they caught it in time. (Wilson Mizner)

Every film is a wonderful success until it comes out. (Stanley Baker)

Six Weeks came out one Christmas but it wasn't very good timing. We didn't stop to consider the fact that people might not wish to spend the holidays going to a film about a girl with just over a month to live. (Dudley Moore)

Titles

We once had a meeting to discuss whether there should be two 'f's' or three in the title of the film *Pffft*. And you're surprised it bombed? (Jack Lemmon)

Anne Robinson: 'In which film did Dudley Moore star as the title character?'
Contestant: '*10.*' (*The Weakest Link*)

The reason I called my movie *Bananas* was because there were no bananas in it. (Woody Allen)

When *Dr No* went to Japan, they translated it as *No Need For Any Doctors*. (Sean Connery)

Toilets

No one in the movies ever goes to the toilet to perform the usual bodily functions. Instead they use the bathroom to take illegal drugs, commit suicide, make a criminal deal, kill someone in a stall, get killed, or sneak out through the window. (Eugene Accardo)

In movies since 1980 with office settings, all major decisions made by men of power are conducted while standing next to urinals in the men's restroom. (Donna Martin)

Marilyn Monroe's visits to powder rooms lasted as long as elephants pregnancies. (Truman Capote)

Men who consistently leave the toilet seat up secretly want women to get up to go to the bathroom in the middle of the night and fall in. (Rita Rudner)

Howard Hughes said to me, 'My God, Mitch, you're just like a pay toilet – you don't give a shit for nothin.' (Robert Mitchum)

It came as something of a shock to me when I was directing Elizabeth Taylor in *Zee & Co.* that she had to go to the toilet just like the rest of us. Up until then I imagined fairies came and took it away in toothpaste tubes. (Brian Hutton)

Tough Guys

I could never understand how Joe Louis was the world boxing champion when everyone knew Humphrey Bogart was really the toughest guy in the world. (Jack Nicholson)

Tough? He was about as tough as Shirley Temple. (James Cagney on Bogart)

I've made a career, more or less, out of playing sons of bitches. (Kirk Douglas)

With his broken nose and ditch-digger's shoulders, nobody was ever going to mistake him for Frederic March. (Lee Server on Robert Mitchum)

He entered rooms as if he were challenging their contents. (William McIlvanney on John Garfield)

If Charles Bronson had lived in my neighbourhood, he would've been a *Playboy* bunny. (George Carlin)

In his best vein he can make Ernest Hemingway look like a Vassar girl in a daisy chain. (Orson Welles on Harry Cohn)

Tales of my toughness are exaggerated. I never killed an actor. (John Huston)

Tragedies

The greatest tragedy is to marry a man for love and then find out he has no money. (Zsa Zsa Gabor)

The only Greek tragedy I know is Spyros Skouras. (Billy Wilder)

Transience
They put your name on a star in the sidewalk on Sunset Boulevard. You walk down afterwards and find a pile of dog manure on it. That tells the whole story, baby. (Lee Marvin)

I was driving up to the Warner Brothers gate one night when the guard refused me entry. I said to him, 'I once made a movie here called *The Horn Blows at Midnight*. Did you see it?' 'See it?' he said, 'I directed it.' (Jack Benny)

Five stages in the life of an actor: 1. Who's Mary Astor? 2. Get me Mary Astor. 3. Get me a Mary Astor type. 4. Get me a young Mary Astor. 5. Who's Mary Astor? (Mary Astor)

Keir Dullea, gone tomorrow. (Noel Coward)

Travel
I just got back from a pleasure trip. I took my mother-in-law to the airport. (Henny Youngman)

I've been to almost as many places as my luggage. (Bob Hope)

When in Rome, stay there. (John Huston)

Trousers
I wear the trousers in my house – right under my apron. (George Burns)

Trust
Once the trust goes out of a relationship, it takes all the fun out of lying to your girlfriend. (John Belushi)

Trust your husband. Adore your husband. And get as much as you can in your own name. (Joan Rivers)

I distrust camels and anyone else who can go a week without a drink. (Joe E. Lewis)

Do you know how they say 'Fuck you' in Hollywood? 'Trust mé.' (Kirk Douglas)

Even though I was born in Washington I was conceived in Hollywood, so my distrust of the place is actually pre-natal. (Alexander Mackendrick)

Never trust a thin cook. (John Candy)

Never trust anyone who wears a beard, a bow tie, two-toned shoes or sunglasses. (Michael Caine)

Of course I can be trusted. Ask any of my husbands. (Mae West)

Turkeys

If *Jupiter's Darling* had been my first picture, there wouldn't have been a second. (Esther Williams)

I had to pay people not to go to *The Phantom Pirate*. (Robert Stack)

Jimmy Cagney and myself both reached the bottom with *The Bride Came C.O.D.* He spent most of his time in the picture removing cactus quills from my behind. (Bette Davis)

The Escape Artist played in theatres for about two minutes before going into airplanes. (Teri Garr)

My biggest mistake on *The Horn Blows at Midnight* was putting film in the camera. (Jack Warner)

Wilfred Sheed once said than no film is so bad that you can't find some virtue in it. He mustn't have seen *Hurry Sundown*. (Rex Reed)

Vendetta wasn't released – it escaped. (George Dolenz)

This movie makes as much sense as a rat fucking a grapefruit. (Marlon Brando on *'The Night of the Following Day'.*)

A stinker like *Showgirls* comes along so seldom that calling it one in a million seems an understatement. (Michael Sauter)

Turns of Phrase

He was so desperate he scraped the top of the barrel. (Gore Vidal on a producer)

Love means never having to say you're single. (Rupert Everett)

Carpe per diem. (Robin Williams)

A word to the wise ain't necessary. It's the stupid ones that need the advice. (Bill Cosby)

He who hesitates is bossed. (Jackie Gleason)

Marry in haste, repent in Reno. (Mae West)

What shall it profit a man if he gains the whole world, and then there's a recession? (Mel Brooks)

If at first you don't succeed, you're not the eldest son. (Stephen Fry)

The good die young because they see it's no use living if you've got to be good. (John Barrymore)

Never give a sucker a lollipop. (W.C. Fields)

Uneasy is the head that wears the curlers. (Bette Midler)

Marriages are made in heaven, but so is thunder and lightning. (Clint Eastwood)

Twins
When I was born my mother looked at me and then looked at the afterbirth and screamed 'Twins!' (Joan Rivers)

Typecasting
If I've still got my pants on in the second scene of a movie I start thinking they've sent me the wrong script. (Mel Gibson)

Some day I'd like a part where I can lean my elbow against a mantlepiece and have a cocktail. (Charles Bronson)

I kept the same suit and the same dialogue for six years once. We just changed the title of the picture and the leading lady. (Robert Mitchum)

I made a career out of being the girl who was left behind. (Alice Faye)

I'm tired of playing the lecherous middle-aged chap who's forever vaulting the generation gap. (James Mason)

Who else can I play? (Spencer Tracy after being asked why he always played himself).

After *The Wizard of Oz* I was typecast as a lion. There aren't that many parts for lions. (Bert Lahr)

Ubiquitousness

I sometimes think that I shall never view a French film lacking Gerard Depardieu. (John Updike)

Someone told me I was in more films with Dean Martin than Jerry Lewis. Forget that. I was in more films than Dean Martin than Dean Martin. (Shirley MacLaine)

Every day of the week, 24 hours a day, it is possible to find a movie somewhere on cable TV starring either Michael Caine or Gene Hackman. (Roger Ebert)

Ugliness

All you have to do is look crap on film and everyone thinks you're a brilliant actress. (Helen Mirren)

I was so ugly that when I was born, the doctor slapped my mother. (Phyllis Diller)

She was a really bad-looking girl. Facially she resembled Louis Armstrong's voice. (Woody Allen)

Ultimatums

I only agreed to appear in a Harry Potter film becaue my children threatened to disown me if I didn't. (Ricard Harris)

She will only make another picture if she needs the money and someone comes up with a script about a girl who falls in love with a seal. (Colleague on Brigitte Bardot)

A man wins the lottery. He says to his wife, 'Start packing your clothes.' She goes, 'Am I packing for cold weather or warm?' He says,

'How the hell should I know? Just be out of here when I get back.' (Red Buttons)

Underwear

What do I look for in women? Clean knickers. (Michael Caine)

I don't know whether this is a problem for wardrobe, make-up or hairdressing. (Alfred Hitchcock after hearing that Tallulah Bankhead wasn't wearing panties during a scene in *Lifeboat*.

If Superman is so super, how come he wears his underpants outside his trousers? (Diana Dors)

I don't know what the big deal about edible underwear is. After you wear them for a couple of days they taste just like the other ones. (Tom Arnold)

She had the bloom of youth in her cheeks and the cheeks of youth in her bloomers. (Buddy Hackett)

People keep asking me what evil lurks in the characters I play. I tell them there's no evil. I just wear tight underwear. (Dennis Hopper)

I don't believe in an afterlife but I'm still bringing a change of underwear. (Woody Allen)

Undressing

According to a new survey, women say they feel more comfortable undressing in front of men than they do in front of other women. They say that women are too judgemental. Whereas men, of course, are just grateful. (Robert de Niro)

Unpunctuality

I'll come and make love to you at five o'clock. If I'm late, start without me. (Tallulah Bankhead)

Films only startr on time when you're late. (Mitchell Symons)

When he's late for dinner I know he's either having an affair or is lying dead in the street. I always hope it's the street. (Jessica Tandy)

Unpunctuality of Marilyn Monroe

Marilyn Monroe was never on time on the set. I have an aunt in Vienna who told me she'd be on the set at six every morning and know her lines backwards. But who'd go and see her? (Billy Wilder)

Oh, do you have that word in England too? (Monroe to Laurence Olivier on the set of *The Prince and the Showgirl* when her lateness on set caused him to fume, "Why can't you get here on time, for fuck's sake?')

I've been on a calendar, but never on time. (Marilyn)

Vacations

I hear Otto Preminger's on holiday. In Auschwitz. (Billy Wilder)

Valedictions

The last time Clark Gable left his studio, the only peron to say goodbye to him was the guy at the gate. (Robert Stack)

All Welles that ends Welles. (Rita Hayworth after her marriage to Orson Welles collapsed)

I got tired of singing to turtles. (Elvis Presley on why he gave up films)

It's a pity it had to end on a stinker. (Marlon Brando on *The Freshman* which he thought was going to be his final film)

Goodbye Mr. Zanuck. It certainly has been a pleasure working at 16th Century Fox. (Jean Renoir)

The reason I left Hollywood was because they wanted me to play Elvis Presley's mother. (Joan Fontaine)

I have no intention of uttering my last words on the stage, darling. Room service and a couple of depraved young women will do me quite nicely for an exit. (Peter O'Toole)

I have to go now, Clarice. I'm having an old friend for dinner. (Anthony Hopkins as Hannibal the Cannibal in *The Silence of the Lambs*)

Videos

We film-makers don't bury our dead. With video we keep them around smelling badly. (Billy Wilder)

It's true that our mistakes come back to haunt us. Especially with video. (Peter O'Toole)

I've got the new *Star Wars* video with a bonus 15 minutes taken out. (Marcus Gibb)

I bought all these Jane Fonda fitness videos. I love to eat cookies and watch 'em. (Dolly Parton)

I hate renting at Blockbuster because I'm a single guy. I don't feel comfortable with that five-day commitment. That's way too long. Renting a video should be like a one-night stand. You pick it up, take it home to a darkened room and the next morning bring it back to where you found it. (Joel Warshaw)

Know how you can tell if you're Jewish? You're watching a Pamela Anderson Lee video of *Baywatch* and you think, 'Nice boat!' (Gary Shandling)

Vietnam

These women who go around saying 'Freedom now! Liberation for women! Equality! Give them a gun and send them to Vietnam. (Peter Fonda)

What's the difference between Dan Quayle, Jane Fonda and Bill Clinton? Jane Fonda went to Vietnam. (John Simmons)

The Vietnam war finally ended in an agreement neither side ever intended to honour. It was like one of Zsa Zsa Gabor's weddings. (Bob Hope)

Villains

If it wasn't for villains there'd be no heroes. (Peter Ustinov)

I'd love to do a movie where the girl kissed me voluntarily. (Ray Liotta)

I'm all for any movie where the lead character keeps a grenade-launcher in his living-room. (James Woods on Al Pacino in *Scarface*)

At the end of every action-adventure movie the villain must fall from a great height onto a hard surface. If possible he should also crash backward through a plate galss window and land on an automobile. (Stephen Dargitz)

Violence

Violence in real life is terrible but in the movies it's just another colour to work with. (Quentin Tarantino)

Do violent films make us violent? I don't know. I haven't seen any of them and I'm violent, particularly at the January sales. I don't buy anything. I just go round hitting people. (Jo Brand)

I went on to one of those 'Speak Your Weight' machines. It said, 'Promise you won't get violent'. (Jackie Gleason)

The real violence in Hollywood isn't what's on the screen. It's what you have to do ot raise the money. (David Mamet)

Violence Against Children

Experts say you should never hit your children in anger. When is a good time – when you're feeling festive? (Roseanne)

Never raise your hand to your kids. It leaves your groin unprotected. (Red Buttons)

Violence of Frank Sinatra

Manners, like hats, do not suit everyone and I do not think they suit Frank Sinatra. He has found a straight left more effective. It goes better with his ties. (Tom Wiseman)

Make yourself at home, Frank. Hit somebody. (Don Rickles to Sinatra after he visited him once)

Virginity

Madonna has a song called 'Like a Virgin'. The only thing Madonna will ever do like a virgin is give birth in a stable. (Bette Midler)

I've been around so long I knew Doris Day before she was a virgin. (Oscar Levant

They chose me to play the Virgin Mary in *The Song of Bernadette* because I was the only real virgin in Hollywood at the time. (Linda Darnell)

I had to marry a virgin – I hate criticism. (Seymour Cassell in *In the Soup*)

Virginity Loss

I wanted to find out what sex was all about so I just did it with the guy next door. When we finished I said, 'Is that it?' He said 'Yeah' and I said, 'Okay, you can go home now.' (Cher)

My dad told me anything worth having was worth waiting for. I waited until I was fifteen. (Zsa Zsa Gabor)

Virtue

Virtue isn't photogenic. What is it to be a nice guy? Nothing, that's what – a big fat zero with a smile for everyone. (Kirk Douglas)

Virtue may be its own reward but it has no sale at the box office. (Mae West)

The problem with people who have no vices is that, generally, you can be damn sure they're going to have some pretty annoying virtues. (Elizabeth Taylor)

Voices

In *The Godfather* Marlon Brando sounds as if his mouth is full of wet toilet paper. (Rex Reed)

My voice sounds like walnuts being crushed under water. (Debra Winger)

John Gielgud's brains are in his voice. (Truman Capote)

Goldie Hawn has the squeaky-voiced persona of a vaguely disturbed chipmunk. (Sue Heal)

Susan Hayward spoke in a voice like black coffee without sugar. (Tom Wiseman)

I don't think I could ever make a movie with Rosie Perez. Her voice would drive me back to heroin. (Charlie Sheen)

Walkers

People say I have an interesting walk . Hell, I'm only trying to keep my stomach in. (Robert Mitchum)

He moves with the athletic grace of a constipated warthog in clogs. (Simon Crook on Anthony Hopkins in *Bad Company*)

I walk like a giraffe. (Sophia Loren)

I'd worship the ground she walked on if she came from a better neighbourhood. (Don Rickles)

War

My stand-up comedy act was so bad, I qualified for combat pay even during peace time. (Bob Hope)

We fight wars which we lose and then we make films showing how we won them. And the films make more money than the wars lost. (Gore Vidal)

In any war movie, never share a foxhole with a character who carries a photo of his sweetheart. (Del Close)

My military status is 3T. That means I go to war when the Japs are in the lobby. (George Jessel in 1943)

I don't think any movies are being daring and original when they say war is bad. That takes as much courage as hitting grandma behind the neck with a two-by-four. (Charles Bukowski)

Bo Derek doesn't understand the concept of Roman numerals. She thought America fought in World War Eleven. (Joan Rivers)

Who was she? (Alleged comment by Joan Crawford after she heard Pearl Harbour had been attacked)

My marriage to Joan Fontaine roughly coincided with World War II. Enough said. (Brian Aherne)

Wardrobe

Jane Russell isn't going to wear many clothes in her next picture. It's a story of the wide open spaces. (Sam Goldwyn)

No matter how many films I made, all they changed was my swimsuit. (Esther Willliams)

Marilyn Monroe spent most of *Bus Stop* in a hideous green costume that made her look like a cross between a mermaid and a peacock. (Sam Kashner)

I sweat a lot in my movies on purpose. That way the wardrobe department don't aske for the clothes back. (Bill Murray)

James Dean is wearing my last year's talent and my last year's wardrobe. (Marlon Brando after seeing *East of Eden*)

Weddings

It wasn't so much a shotgun wedding as a flasbulb one. (Eddie Fisher on heing married to Debbie Reynolds)

My wedding night was a disaster. My husband tried to get the garter off over my head. (Phyllis Diller)

In Hollywood it's not unheard of for actors to wake up the day after a wedding and phone for divorce papers before getting out of bed. (Jane Kelly)

What did Liz Taylor say at her last wedding?
I did, I did, I did, I did, I did, I did, I did, I do. (Michael Harkness)

Wedding Cakes

In any movie comedy invovling a wedding, the cake will inevitably bedestroyed. (John Weckmueller)

One of my marriages was so short we even had cake left. (Troy Donahue)

Wedding Dresses

When Liz Taylor married Larry Fortensky, he was younger tahn her first wedding dress. (A.A. Gill)

Wedding Rings

Wid dis ring I dee wed. (Sylvester Stallone at his wedding to Brigitte Nielson)

If a romance breaks up, never give him back the ring. Swallow it first. (Joan Rivers)

Weight

I wasn't being free with my hands. I was trying to guess her weight. (W. C. Fields)

My husband is almost as heavy as I am. We were married in adjoining churches. (Roseanne Barr)

I am not overweight. I'm just nine inches too short. (Shelley Winters)

A lot of nice things happen to you when the weight starts coming off. I got in a plane today and had absolutely no problem getting the lap strap on. (Robbie Coltrane)

If you're going to dedicate your career to ranting about the excesses of American capitalism, you probably shouldn't weight 450 pounds. (Greg Giraldo on Michael Moore)

It's pretty sad when a person has to lose weight to play Babe Ruth. (John Goodman)

Weighing Scales

My mother is so fat, when she gets on the scales its says, 'To Be Continued'. (Damon Wayans)

Whodunits

Watching the movie I thought: I bet Paul Newman is the murderer. Then I realised Paul Newman wasn't in the movie. And then I thought: What an alibi! (Steven Wright)

Whorehouses

To Raoul Walsh, a tender love scene is burning down a whorehouse. (Jack Warner)

Sidney Lumet is so fast he could double-park in front of a whorehouse and still not get a ticket. (Paul Newman)

Whores

A woman should be a chef in the kitchen and a whore in bed. (Oliver Reed)

The trouble with my ex-wife is she was a whore in the kitchen and a chef in bed. (Groucho Marx)

Warren Beatty took me to lunch and he said, 'Courtney, in the movies there are wives and there are whores. You have to learn to play a wife.' (Courtney Love)

If you woke up in a motel with a dead whore who'd been stabbed, who would you call? Sam Spiegel. (Billy Wilder)

Widows

Come on, there had to be some wives wiping their hands with glee at being widowed after 9/11. It's the law of averages. (Joan Rivers)

I'm not upset about my divorce. I'm upset I'm not a widow. (Roseanne Barr)

Wigs

Lee J. Cobb always wore a wig in his movies. For *Lawman* I said, 'Do me a favour, don't wear a wig. You look marvellous without it.' He said, 'If I don't wear a wig I may never work again.' I said, 'Lee, you're doing a film with me. You'll never work again anyway.' (Michael Winner)

Burt Reynolds and myself have two things in common. We both have 40-inch chests and we both wear wigs. (Dolly Parton)

Wives

Since I got married I haven't looked at another woman. My wife put me off them. (Bob Hoskins)

Before I met my wife I never understood what women wanted. All I knew was that it wasn't me. (Alfred Hitchcock)

I'm not a real movie star. I still have the same wife I started otwith twenty years ago. (Will Rogers)

I should have known something was wrong with my first wife when I brought her home to meet my parents and they approved. (Woody Allen)

I hink husbands and wives should live in separate houses. If there's enough money the children should live in a third. (Cloris Leachman)

In Hollywood, if a guy's wife looks like a new woman, she probably is. (Dean Martin)

They say I'm a committed wife. I've been married so many times now I should *be* committed. (Elizabeth Taylor)

Women

The last time I was inside a woman was when I visited the Statue of Liberty. (Woody Allen)

The practice of putting women on pedastals began to die out when it was discovered they could give orders better from that position. (Betty Grable)

Last night there was a woman banging on my dressing-room door for 45 minutes – but eventually I let her out. (Dean Martin)

Women are divided inot those who think they're always right. (Danny DeVito)

I was a woman at six. (Jill St. John)

Women are like elephants. I like to look at 'em but I'd sure hate to own one. (W.C.Fields)

They all start off as Juliets and end up like Lady Macbeths. (William Holden)

Women's Liberation

I have no time for broads who want to rule the world. Without men, who'd do the zipper on the back of your dress? (Bette Davis)

Women have a right to work wherever and whenever they want to, so long as they have the dinner ready when you get home. (John Wayne)

I want women to be liberated but to still be able to have a nice ass and shake it. (Shirley MacLaine)

I saw a crowd of feminists buring their bras yesterday. It was a very small fire. (Woody Allen)

I'm all for Women's Lib. If there's a war, for example, and a man has enlisted, I think his wife should take his job. (Groucho Marx)

Work
Say anything you like about me but don't say I like to work. That sounds like Mary Pickford, that prissy bitch. (Mabel Normand)

The physical labours in which actors have to engage wouldn't tax an embryo. (Neil Simon)

I was reluctant to work in Hollywood. I was afraid the neighbours might think I was showing off. (Emlyn Williams)

Anyone who works is a fool. I prefer to inflict myself on the public. (Robert Morley)

I would like to amend the old actor's dictum of 'Never work with children or animals' to 'Never work with children, animals, or Denholm Elliot.' (Gabriel Byrne)

Writer's Block
Writer's blcok is a fancy term made up by whiners so they can have an excuse to drink alcohol. (Steve Martin)

I used to think I was an interesting person until I got to page 35 of my autobiography and realised I had nothing else to say. (Roseanne Barr)

Writing
Jackie Collins did about as much for writing as her sister Joan did for acting. (Campbell Grison)

I write like a drunk spider. (Elvis Presley)

I wrote this book called *How to Get Along With Everybody*. Not by myself, but with this other asshole jerk. (Steve Martin)

I've now written seven books. Not bad for someone who's only read three. (George Burns)

I started my writing career on a lavatory wall. (Michael Winner)

I don't use a pen. I write with a goose quill dipped in venom. (Clifton Webb in *Laura*)

X-rays

Audrey Hepburn is a walking X-ray. (Oscar Levant)

I was sick last year but it passed off. I paid the doctor 50 bucks to touch up the X-rays. (Joey Bishop)

Yes-Men

If there's one thing I can't stand, it's yes-men. When I say no, I want you to say no too. (Jack Warner)

I don't want yes-men around me. I want people to tell me the truth, even if it costs them their jobs. (Sam Goldwyn)

Of course I'd prefer to have people agree with me all the time. But that's no way to make a movie so I just surround myself with people I'd like to strangle instead. (Sylvester Stallone)

I talked to a couple of yes-men at Metro. They said no. (Billy Wilder)

Youth

If you want to find your lost youth, cut off his inheritance. (George Burns)